THE

W9-BIZ-463

A PHILOSOPHICAL ENQUIRY

EDMUND BURKE (1729–97) was born in Dublin, the son of a Protestant Irish father who was an attorney, and an Irish Catholic mother. He took a BA degree at Trinity College, Dublin (1744–9) and went to London in 1750 to read for the bar, but abandoned his legal studies in 1755, establishing himself in literary London with two publications, *A Vindication of Natural Society* (1756) and the *Philosophical Enquiry* (1757).

Burke began his political career in 1759 as Private Secretary to William Hamilton who, as Irish Chief Secretary, employed Burke twice in Ireland (1761–2, 1763–4). Breaking with Hamilton in 1765, Burke became Private Secretary to the Whig Marquis of Rockingham, and became MP for Wendover. In 1770 he published his important pamphlet *Thoughts on the Cause of the Present Discontents*. He became MP for Bristol in 1774 and allied himself with Fox to oppose Lord North's administration. In 1780 he lost his Bristol seat, and when Rockingham gained office in 1782 he was not a member of the cabinet. During this period he was committed to exposing the injustice of British administration in India, culminating in the impeachment of Warren Hastings (1788). Events in France prompted his greatest writing, the *Reflections on the Revolution in France* (1790). Burke's passionate denunciation of the Revolution led to a final breach with Fox in 1791, the year in which he published his fine *Appeal from the New to the Old Whigs*.

In 1794 Burke retired from Parliament and his seat was given to his son Richard, who died in the same year. In his overwhelming grief at the end of his life he published the *Letter to a Noble Lord* (1796) and the *Letters on a Regicide Peace* (1796–7). Disturbed by the victories of revolutionary France and the tragedies in Ireland, he died in 1797.

ADAM PHILLIPS is Principal Child Psychotherapist at Charing Cross Hospital in London. He has edited Charles Lamb's *Selected Prose* for Penguin and Walter Pater's *The Renaissance* for The World's Classics. His study, *Winnicott*, is published in the Fontana Modern Masters series.

THE WORLD'S CLASSICS

EDMUND BURKE

A Philosophical Enquiry into the Origin of our Ideas of the Sublime and Beautiful

Edited with an Introduction by
ADAM PHILLIPS

Oxford New York

OXFORD UNIVERSITY PRESS

Oxford University Press, Walton Street, Oxford OX2 6DP

Oxford New York
Athens Auckland Bangkok Bombay
Calcutta Cape Town Dar es Salaam Delhi
Florence Hong Kong Istanbul Karachi
Kuala Lumpur Madras Madrid Melbourne
Mexico City Nairobi Paris Singapore
Taipei Tokyo Toronto

and associated companies in
Berlin Ibadan

Oxford is a trade mark of Oxford University Press

First published as a World's Classics paperback 1990

British Library Cataloguing in Publication Data

Data available

Library of Congress Cataloging in Publication Data
Burke, Edmund, 1729-1797.
A philosophical enquiry into the origin of our ideas of the
sublime and beautiful / Edmund Burke; edited with an introduction
by Adam Phillips.
p. cm.—(The World's classics)
Includes bibliographies.
1. Aesthetics—Early works to 1800. 2. Sublime, The—Early works
to 1800. I. Phillips, Adam. II. Title. III. Series.
BH181.B8 1990 111'.85—dc20 89-35936

ISBN 0-19-281807-4

5 7 9 10 8 6

Printed in Great Britain by
BPC Paperbacks Ltd
Aylesbury, Bucks

CONTENTS

CONTENTS

ACKNOWLEDGEMENTS

The following people have given me invaluable help in the preparation of this edition. I would like to thank Mary Mackintosh for deft translations, and Kate Weaver for architectural information on the period that reinforced Burke's point that perhaps the body is not a very good analogy for buildings. Hugh Haughton managed to keep faith with my interest in the eighteenth century, and Geoffrey Weaver encouraged clarity despite Burke's misgivings. Michael Neve's interest and breadth of knowledge were inspiring.

ACKNOWLEDGEMENTS

The following people have given me invaluable help in the preparation of this edition. I would like to thank Shirley McConnell, David Robertson, and Colin Weaver for specialized information on the period that have forced books to point that perhaps the body is not always good enough.

INTRODUCTION

I

> A true artist should put a generous deceit on the specta-
> tors.
>
> Burke, *Enquiry*

THE *Enquiry* is a book that has always been overshadowed by
Burke's great book *Reflections on the Revolution in France*, and by his
subsequent career as a Whig politician. As a study of the
relationship between strong feelings and forms of art it seems
far removed from Burke's later political commitments, despite
the fact that those commitments were always characterized by
his distinctive eloquence and intensity. Even though the
influence of the *Enquiry* is clearly identifiable in many of the
most important works of the Romantic period it has either been
dismissed as an interesting but derivative piece of juvenilia, or
deemed to be negligible, indeed amateurish compared with
Kant's powerfully serious *Analytic of the Sublime* published in
1790. Though radically different, in accessibility and method,
both books share what was to become a fundamental modern
preoccupation; for Burke and Kant the Sublime was a way of
thinking about excess as the key to a new kind of subjectivity.
Beauty, Burke hoped to show in his *Enquiry*, was something more
reassuringly tempered.

But as one of the greatest counter-revolutionary writers of the
eighteenth century there is a sense in which Burke has not been
taken sufficiently on his own terms. Reception of the *Enquiry* has
suffered from the paradoxes inherent in the counter-revolution-
ary position. As George Steiner describes it in his essay 'Aspects
of Counter Revolution':

It is precisely abstract political theory and attempts to impose analytic
and systematic projections on the essentially irrational, instinct-
ual, contingent flux of human affairs which the counter revolutionary
scorns and repudiates. The psychological and stylistic components of
the counter-revolutionary sensibility are those of an ardent remem-

brance (often embellished and Arcadian) of things past; of a profound distrust of voluntarist, cerebrally inspired innovations in the inherited weave of communal life; they are those of instinctive pietas and of an intuition of the organic in the very pulse and structure of history.[1]

Despite Burke's explicit commitment to a version of continuity, the *Enquiry* was not seen as continuous with his later work.[2] And his principled critique of theory—as though abstract speculation and ideas about the past were separable—began with a philosophical enquiry evidently concerned with the workings of theory. For Burke, throughout his life, ambition would be bound up with speculation in its several senses.

There was certainly a degree of opportunism in Burke's choice of subject in the *Enquiry*. The nature of the passions and the idea of the Sublime were suitably fashionable and grandiose subjects for a young man trying to find a place in literary London in the 1750s. In fact, by the early eighteenth century the Sublime was what we might call a piece of jargon, a term that would identify, and could therefore be used to caricature, the modish or university educated. Addison, whom Burke first reports having read in 1744 while at Trinity College, had written a series of articles in his influential magazine *The Spectator* on what he called 'the pleasures of the imagination' (nos. 409, 411–21). Addison emphasized that despite the neoclassical virtues of decorum and the unities in dramatic poetry, there was 'still something more essential to the art, something that astonishes and elevates the fancy, and gives a greatness of mind to the reader, which few of the critics besides Longinus have considered'. This quality was sublimity, and the treatise ascribed to Longinus, *On the Sublime*—that Johnson defined in his dictionary as 'the grand or lofty style'—had acquired something of a cult status among the literary. A treatise on the inspired persuasiveness of certain kinds of writing, Burke's *Enquiry* would link the experience of certain kinds of 'great' literature with the experience of that other recently fashionable

[1] From *The Permanent Revolution: The French Revolution and its Legacy*, ed. Geoffrey Best (London, Fontana, 1988).

[2] Hazlitt, it should be said, was a notable exception to this tendency.

eighteenth-century pleasure, the natural landscape. What, it could be asked, in an age newly sceptical of certain religious and epistemological assumptions was Nature, at its most dramatic, trying to persuade us of? ('The Sublime', as Thomas Weiskel reminds us, 'revives as God withdraws from an immediate participation in the experience of man.') In Burke's *Enquiry*, with its relatively cursory references to Christianity, we find the beginnings of a secular language for profound human experience: in rudimentary form an erotic empiricism. No other philosophical enquiry takes stroking as seriously.

In his rag-bag of eighteenth-century speculation Burke tries to connect a pagan rhetorical theory with an introspective empiricism deriving from Locke and modified significantly by Hume. The *Enquiry* is obsessed by bodily representations of experience—as in Burke's descriptions of tortured faces and faces in love—and the experience of representations, such as words and other art forms. As Boulton, the finest modern editor of the *Enquiry* writes: 'throughout the *Enquiry* Burke is principally concerned with the responses of the human mind to emotive objects and experiences.' The increasing interest of the age in the idea of 'sympathy' is reflected in Burke's commitment to 'a growing reliance on feeling as a means of insight'. It is a theory, that is to say, about the power of evocation. Both the Beautiful and the Sublime, in Burke's view, had an immediacy about them. They were in different ways apparently irresistible and this inevitably linked them with the passions, with some notion of what was essential or irreducible in human experience.

Burke's attempt in the *Enquiry* to establish standards of Taste and find laws for the Passions was however in the mainstream of eighteenth-century intellectual preoccupation. Newton's God had set a limit to the void. If the universe was rule-bound like a clock, regulated by discernible laws as Newton had shown, then the presiding question was whether the idea of laws of nature could be applied to human nature. Could there be a science, a principled code, of ethics or aesthetics? Or, as Burke put it in the Preface to his *Enquiry*, was it possible through 'a diligent examination of our passions in our own breasts' to find 'an exact theory of our passions'?

With no explicit reference to Hume, whose profoundly sceptical *A Treatise on Human Nature* (1739–40) was the main precursor of his own work, Burke began his more modest *Enquiry* with a sense, or rather a threat of the ridiculousness of the task: 'for if Taste has no fixed principles, if the imagination is not affected according to some invariable and certain laws, our labour is like to be employed to very little purpose; as it must be judged an useless, if not an absurd undertaking, to lay down rules for caprice, and to set up for a legislator of whims and fancies.' It could indeed be a quixotic project, but the implications of the redundancy of rational enquiry, or the impossibility of consensus, could have grave social consequences. It would be part of the ferocious eloquence of his later speeches and writings—on the impeachment of Warren Hastings, on the divisions among the Whigs, and especially on the French Revolution—to quell such doubts.

The *Enquiry* announces, in a sense, Burke's anxiety about theory, his lifelong fear about where it might end, or that there may be no end to it. 'It is not the extent of the subject that must prescribe our bounds,' he writes compactly, 'for what subject does not branch out to infinity?', when bounds are both leaps and limits, and there is only an odd sense, a disjointed sense, in which a tree branches out to infinity. In the *Enquiry* Burke senses the infinite possibilities of human subjects and a complementary terror of endless confusion and uncertainty. It is the beginning of his always paradoxical search for confining formulations. Samuel Johnson would insist throughout his own work that madness—to which there are several references in the *Enquiry*—always lurked as the consequence of the increasingly fashionable commitment to the imagination unbound. In the equivocal text of the *Enquiry*, packed as it is with images of constraint and release, Burke asks the characteristic questions of his age. Could passions, or their representative the imagination, be curbed by rational examination and description, or was passion itself a method of deception? In what sense were men divided against themselves, as well as others?

2

> In an enquiry, it is almost everything to be once in a right
> road.
>
> Burke, *Enquiry*

The legacy of the questions Burke asks in the *Enquiry* are, ironically, reflected in the reputation he acquired after his death. It is one of the enduring ironies of Burke's posthumous career that despite the fact that he was always vigorously partisan in his political views he has come to be seen as potentially on both sides of any argument. What C. B. Macpherson has called 'the Burke problem' is that his writings have been used to support diametrically opposed political positions; that they can, it seems, 'properly be enlisted by conservatives or liberals today'. Burke asserts, in one of the many striking sentences in the *Enquiry,* that 'our natural and common state is one of absolute indifference', using 'natural' to signify that which we are obliged to have in common, and hinting that a common state can be one without differences. This brief critique of Original Sin and Rousseau's benign state of nature crops up in a discussion about taking snuff. But it is not, of course, indifference, or eccentricity, that makes Burke's writing so improperly adaptable.

In fact, modern commentators have turned to the concept of ambivalence, the Freudian opposite of indifference, to explain the ease with which Burke's writings have been appropriated by rivals. The title of one of the most interesting recent studies of Burke, *The Rage of Edmund Burke: Portrait of an Ambivalent Conservative* (by Isaac Kramnick) suggests Burke's covert sympathy with the French and British radicals he attacked so vehemently. From a psychoanalytic point of view they simply carried views of his own that he had had to repudiate and punish when he found them enacted and spoken by other people. This makes Burke, albeit furtively, more generous in his sympathies and reminds us, more particularly, of his Irish origins ('I have read some history,' he writes on 12 July 1746 to his friend Richard Shackleton, 'I am endeavouring to get a little into the accounts of this our own poor country'). In his counter-revolutionary *Reflections on the Revolution in France* (1790),

published 33 years after the *Enquiry*, Burke was, in Conor Cruise O'Brien's view, 'partially liberating—in a permissible way—a suppressed revolutionary part of his own personality. These writings, which appear at first sight to be an integral defence of the established order, constitute in one of their aspects—and this to Burke not the least important—a heavy blow against the established order in the country of Burke's birth, and against the dominant system of ideas in England itself.'[3] O'Brien's sense of Burke's always divided duty alerts us to the amount of work any of Burke's keywords may be doing in any given context. So when in the *Enquiry*, for example, Burke writes that the Sublime 'in all things abhors mediocrity', or that in the experience of the Sublime 'the mind is so entirely filled with its object, that it cannot entertain any other, nor by consequence reason on that object which employs it', we are compelled to think of notions of social hierarchy and colonization as well as aesthetics. The son of an Irish Catholic mother and an Irish Protestant father, trying to establish himself in English society, Burke's considerable ambition was inevitably fuelled by complicated sympathies and grievances. The *Enquiry* turns out to have been, among many other things, a prospective autobiography.

Burke's talent for being complicitous with his adversary—always underwritten by the fear of getting muddled up with him—was evident in his first publication. *A Vindication of Natural Society* (1756), published the year before the *Enquiry*, was assumed by everyone to have been written by Bolingbroke, the man that Burke was satirizing. He had so successfully identified with the writer he opposed—and the theory, derived from Rousseau, of a natural as opposed to a civil society—that he had become stylistically indistinguishable from the object of his contempt. Nine years later, in the Preface to a second edition, Burke had to explain his ironic intentions. So when Hazlitt praised Burke's style as 'forked and playful as the lightening, crested like the serpent', there was perhaps an intimation that the resentful ingenuity of the double agent could also be at work in Burke's astonishing eloquence. And Burke is politically

[3] *Reflections on the Revolution in France*, ed. Conor Cruise O'Brien (Harmondsworth, Penguin, 1982).

instructive because his work reveals the potential for confusion that strong allegiances appear to resolve.

Because by inclination Burke was not duplicitous he tried to turn the paradoxes of his life into contradictions. He needed to find opposition in order to do battle. After the curious triumph of the *Vindication* came the *Enquiry*, in which Burke's wish to sort out the Sublime from the Beautiful and insist on their difference became his serious theme, foreshadowing all the many oppositions of his later work. It would, for example, become Burke's virtual obsession, from the late 1760s onwards, to found his political beliefs on a story of continuity—a myth of a traditional British Constitution dating back to Magna Carta—that he felt was under continual threat from subversion by radicals and other 'theorists', as he disparagingly referred to them. In his first and only work of aesthetic theory, the *Enquiry*, Beauty as a category could be seen as part of a discernible history of Taste: the Sublime was that which ruptured the continuity of experience and tradition, a disordering like 'the spirit of liberty' he would describe in the *Reflections* in which 'the fixed air is plainly broke loose'. But the Sublime is also bound up with the idea of authority as a species of mystification. 'It is our ignorance of things', Burke writes, 'that causes all our admiration.' So Kings are sublime. He praises in Milton 'the power of a well managed darkness', and suggests that 'a clear idea is another name ... for a little idea' which in itself questions the value of the *Enquiry*. Enquired into, both Beauty and Sublimity, he finds, become quite unmanageable. The Sublime and the Beautiful, like the (putatively) Traditional and Radical, were not the true contraries that they seemed. The methodical study of the passions revealed ironic complicities. Burke was drawn to the clarity of opposition, but the *Enquiry* became an ominous critique of the possibility of clarity.

3

Smooth things are relaxing.
Burke, *Enquiry*

'Perhaps it is true', the 15-year-old Edmund Burke wrote to his friend Shackleton, 'our Passions have springs that we are utterly unacquainted with . . .' (*Letters*, p. 48). Thirteen years later a less tentative and more earnest author of the *Enquiry* would write that 'a consideration of the rationale of our passions seems to me very necessary for all who would affect them upon solid and sure principles'. The 'we' referred to here, and in the title of the *Enquiry*, were those literate or university-educated intellectuals that the young *arriviste* Burke wished to identify himself with in London. 'We' may be a more coercive word than 'I'. As a young man, in flight from a career in law that his father, a lawyer himself, had intended for him, Burke was in search of new intellectual principles and keen to ally himself with a tradition of inquiry that was trying to establish foundations for knowledge and belief. Burke's father was, by all accounts, a man of fierce tempers, and Burke's wonderful remark in the *Enquiry*, 'It is impossible to suppose a giant the object of love' may be a veiled allusion to him as well as to other dominating figures on a more public stage that Burke was soon to enter. The Preface to the second edition of 1759 is a lucid examination of the associated problems of the foundation of knowledge and the nature of authority. The impossibility, that is to say, of finding a position beyond criticism, a position such as a king or an aristocracy may wish to enjoy in a feudal society.

Through the reception of the first edition of his *Enquiry* Burke had discovered how vulnerable a text always is to any kind of fault-finding mission or the misgivings of ordinary disagreement (later he would realise how precarious the constitutions of France and Britain were to any kind of radical critique). In the first paragraph of the Preface Burke tries to establish what constitutes legitimate criticism, but he is forced to acknowledge that the possibility of having the last word, or of providing a total view, was a false lure. That method—and this would be true of political as well as aesthetic theory—involves selection, and selection involves exclusion. 'People accustomed to studies

of this nature', he writes, referring to the people he wants to address, 'know that while the mind is intent on the general scheme of things, some particular parts must be neglected.' This would be Burke's criticism of all abstract political theory apart from his own. The limits of enquiry were chastening, but no one was exempt from it. 'It is impossible', he writes in the Conclusion to Part One, 'to avoid an attempt at such reasoning.' Not because such reasoning was an irresistible temptation, but because it was a virtual description of language itself.

Theory, Burke sensed, was the medium of aspiration, and language was too easily synonymous with theory. Throughout the *Enquiry*, as indeed throughout Burke's career, there is a continual conflict between ambition and the fear of overreaching, the terror of possibility. And this is initially worked out, in the apparently apolitical atmosphere of the *Enquiry*, at the level of theory. But Burke's flair for insistence, even in his Preface, makes him both excessively tentative and excessively firm: 'We must make use of a cautious, I had almost said, a timorous method of proceeding. We must not attempt to fly, when we can scarcely pretend to creep ... the condition of our nature binds us to a strict law and very narrow limits.' By saying what he almost says Burke says a good deal more. 'Timorous' is a word that has lost some of its edge, but it fits accurately into an eighteenth-century discussion of sublimity, meaning, as it did then, 'causing fear or dread: dreadful, terrible' (*OED*). What is there to dread in an Enquiry? In this hyperbole of risk one might aspire to be Icarus while in fact being that most dependent of creatures, a baby. For Burke in the *Enquiry*, as in the *Reflections on the Revolution in France*, speed—the sudden, the urgent, the hurried—always signifies risk and is to be distrusted. He counterposes to this, as analogies in his later political writing, images of 'organic' growth like trees and children. So we also find childhood, which we tend to associate with the Romantics, being used frequently in the *Enquiry* as a reference point, apparently setting 'natural' limits to speculation. There is a sometimes Wordsworthian apprehension of childhood—though with Burke's telling reservations—particularly in the Introduction on Taste, that is of a piece with Burke's later elegiac political theory.

Like Icarus, and the author of a philosophical enquiry, the child of course has pretentions: but to 'scarcely pretend' could be not to pretend very much, or not to pretend very well. And it is, after all, Satan in *Paradise Lost* who both creeps and flies and pretends to a great deal. This choice between creeping and flying announces the dilemma of the Sublime: does it bring us down to earth, or link us with the divinity of the skies? Does it enlarge us or diminish us? In the *Enquiry* Burke is obsessed by the size and extent of things: man, he writes, 'is not designed . . . to live at large'. Perhaps it is only in theory, Burke intimates, that men can become gods, or turn the world upside down.

To deal with this anxiety Burke proposes a necessary form of theoretical self-defeat. If it is the condition of our nature that his method is attempting to discover—his stated aim, after all, is to 'investigate the springs and trace the courses of our passions'—then the whole procedure is ironically pre-empted from the start. What should have been the conclusion has become the premiss, the regulating fiction of the *Enquiry*. The text is riddled with images of sometimes punitive constriction—and flight, although 'a bird on the wing', he writes provocatively, 'is not so beautiful as when it is perched'—while Burke tries to impose strict laws and very narrow limits on the recalcitrant material of the passions, and of language itself.

As Burke realizes, words have no end to them. Subject to various kinds of association they cannot be pinned down. Language, like the 'spirit of freedom, leading in itself to misrule and excess' of the *Reflections*, Burke regards with an eloquent wariness. Writing of poetic illustrations, of which there are many in the *Enquiry*, Burke alerts us to the always indeterminate relationship between argument and example in a text; and the significance of the difference between 'and' and 'or' in a text so concerned about what to keep together and what to set apart. 'The task would be infinite', he writes, 'if we could establish no principle until we had previously unravelled the complex texture of every image or description to be found in poets and orators.' An excess of implication could be paralysing; every text would be an impossible labyrinth. What would happen to rational enquiry if there were no discernible principles to guide

it? It is Burke's sense of the complexity of verbal texture that in.forms his rage for distinctions.

Words could be used to evoke the passions but also to investigate them; in the curious final section of the *Enquiry* Burke emphasizes the special 'influence over the passions' that only words have. 'Eloquence and poetry are as capable', he writes, distinguishing them from philosophy and natural science, 'nay indeed much more capable of making deep and lively impressions than any other arts, and even than nature itself in very many cases.' Language is uniquely powerful, Burke suggests, because it is, unlike the realist painting of his day, non-mimetic, what we would now call an arbitrary system of signs. Words are not windows we look at the world through. And it is the absence of this visual notion of clarity that stirs our most intense feelings. Clarity, for Burke, and not its more conventional antagonist Reason, is the antithesis of passion. Reason, despite its pursuit of clarity in science, is always potentially mystifying, since it is written in a medium instinct with obscurity. 'In reality', he writes, making us wonder about the other places he may have in mind, 'a great clearness helps but little towards affecting the passions, as it is in some sorts an enemy to all enthusiasms whatsoever.'

Are the passions merely the products of mystification or the cause of it? Is Burke, in the *Enquiry*, on the side of the enemy? After the 'enthusiasm' of the Civil War it was to be Reason that would sustain the Restoration: and the picture of Reason was of daylit sense. Passions could be like creatures that live on the sea-bed and implode in sunlight. Affecting the passions is, of course, different from trying to write 'something not unuseful towards a distinct knowledge of our passions', just as natural science, it was assumed, was quite different from poetry and oratory. And yet language, Burke insists, is the medium of passion. One of the remarkable implicit proposals of the *Enquiry* is that there may be something paradoxical and self-defeating in attempting such a project; that the passions could be evoked but not informed on. It would be one of the essential contradictions of the *Reflections on the Revolution in France* that it was at once a fierce critique of 'warm and inexperienced enthusiasts' and yet defends

co .stitutional monarchy as a way of 'following nature which is wisdom without reflection'. Burke's profound ambivalence about reflection and enquiry, indeed about reason itself, begins with the confusions of the *Enquiry*, with its patches of closely argued dullness, its curious distinctions and extraordinary sentences. A clearer sense, a 'distinct knowledge', of the passions could be a contradiction in terms. Burke was to become, after his foray into Reason, the greatest political orator of his day.

4

Uncertainty is so terrible that we often seek to be rid of it, at the hazard of a certain mischief.

Burke, *Enquiry*

To a modern reader two things are immediately striking in Burke's attempt to categorize the passions. First, passion is used as a generic term for what we would now think of as a great variety of different states of mind, some of which would loosely be called feelings. Burke refers to love, fear, grief, anger, joy, astonishment, terror, ignorance, inattention, rashness, levity, obstinacy, prejudice, among others, all as passions despite their varying intensity: so classification is immediately threatened by abundance. Like the gardens Burke refers to in his discussion of Beauty in which 'nature has at last escaped from their [the designer's] discipline and their fetters', ideas of order are essentially precarious. Adam and Eve, it should be remembered, in *Paradise Lost* which provides the backdrop to the *Enquiry*— spent their time before the Fall gardening. The difficulties of keeping things in place are, so to speak, prelapsarian.

Secondly, Burke makes an idiosyncratic case for the notion that pain and pleasure, traditionally the regulators of the passions, may not be complementary; he tries to separate them by suggesting that they are different rather than opposites. So he makes the interesting point, for example, that pleasure cannot be forced upon us, while pain can. Pleasure, as he puts it, has to be 'stolen', whereas pain is stronger, in his view, because it can be imposed; which implies that the greater strength is

always beyond us. 'For my part I am rather inclined to imagine', he writes with that muted sense of theatre that pervades the *Enquiry*, 'that pain and pleasure in their most simple manner of affecting, are each of a positive nature, and by no means necessarily dependent on each other for their existence.' They are of a 'positive nature' in that one is not simply the absence of the other; that there are, as he uses the categories of the Sublime and the Beautiful to explore, 'pleasures and pains of a positive and independent nature'. His attempt to 'range and methodize some of our most leading passions' as a 'good preparative to such an enquiry' proves, what he already knows: that passions range beyond method and have a tendency towards melodrama as the contemporary genres of the romantic and gothic novel were revealing to an increasingly avid audience.

It is the apparent contradictions of our nature, revealed by involuntary sympathies, that fascinate Burke in the *Enquiry*. Tragedy in the theatre, or our pleasure in the execution of criminals, are so compelling because, Burke writes, 'we delight in seeing things, which so far from doing, our heartiest wishes would be to see redressed'; where the erotic suggestion, often oblique but always insistent in the *Enquiry*, is that redressed is the deferred opposite of undressed. The Sublime, which always includes something of the terrible, is an important category for Burke because it is such an odd mixture, revealing, as it can, the overlap between pain and pleasure. Because terror, which is the heart of the Sublime, is a passion which, Burke writes, 'always produces delight when it does not press too close'. And it is this that makes artistic representations, like tragedy, the tolerable and even thrilling Sublime. This kind of 'delight', he suggests, in a dubious distinction, is not exactly a pleasure because it 'turns on pain'; delight is produced when 'the idea of pain and danger' is staged, thereby providing sufficient distance. Whatever 'excites this delight'—a phrase that itself pulls in opposite directions—Burke refers to as the Sublime.

But if the Sublime in art is productive of delight, the Sublime in nature is a form of paralysis, a literally stunning invasion. 'No passion', Burke writes, 'so effectually robs the mind of all its powers of acting and reasoning as fear'; the Sublime makes

reasoning impossible and is the antithesis of philosophical enquiry because it is always that which is in excess of any kind of limit or boundary. It is the category for a power or 'greatness' that is beyond categorization. It is an experience of intolerable but inescapable scepticism, what Burke calls 'terrible uncertainty'. 'Hardly anything can strike the mind with its greatness', he writes, 'which does not make some sort of approach towards infinity: which nothing can do whilst we are able to perceive its bounds.' 'Knowing' is implicitly defined as the setting of limits, and the 'Sublime' as the impossibility of knowledge. So certain kinds of absence, what Burke calls privation, are Sublime—vacuity, darkness, solitude, silence—all of which contain, so to speak, the unpredictable; the possibility of losing one's way, which is tantamount, Burke implies, to losing one's coherence.

It is, however, in what Burke proposes as the opposite of the Sublime that this apparently aesthetic category becomes unavoidably politicized. The counter-sublime he defines as 'a strength that is subservient and innoxious'. The sublime object is beyond doubt or criticism; the sublime experience is one of domination. Bulls are sublime, oxen are not. Wolves are sublime, but dogs are not. Kings, and God, are sublime, ordinary people, presumably, are not, because objects of contempt and use never can be. So the horse of ordinary employment has 'in every social useful light . . . nothing of the sublime': but the horse described in the book of Job that 'swalloweth the ground with fierceness and rage' is 'terrible and sublime'. Whatever acts 'in conformity to our will', Burke writes, 'can never be sublime'. Humour and cheerfulness—the ludicrous, the ridiculous, the burlesque—are the enemy of the sublime. Smells, Burke says, can never be sublime. As a category the Sublime begins to include the sacred and the serious, the transcendent and the aristocratic, the privilege of an 'incomprehensible darkness' that reason cannot, or as Burke will increasingly believe, must not, dispel.

The experience of Beauty—'that quality or those qualities in bodies by which they cause love, or some passion similar to it'—is, like sublimity, immediate, and not subject to reason. It is not, he writes, unwittingly ironizing his own book, the result of 'long attention and enquiry'. Beauty, like sublimity, is not easily

subject to formal classification; it cannot be measured, it is not the consequence of reasoned proportion as he shows, for example in the section entitled 'Proportion not the cause of Beauty in Vegetables' (the titles of the sections are one of the real pleasures of the *Enquiry*). 'No certain measures', he writes, 'operating from a natural principle, are necessary to produce it.' Beauty, which is, he demonstrates, not proportion, perfection, nor virtue, is 'no creature of our reason'. Beauty and Sublimity turn out to be the outlaws of rational enquiry. Both are coercive, irresistible, and a species of seduction. The sublime is a rape, Beauty is a lure. Though Burke lucidly asserts their difference in a series of neat oppositions—the Sublime involving pain, admiration, and greatness, the Beautiful entailing positive pleasure, love, and often smallness—a certain similarity becomes impossible to ignore. Both the Sublime and the Beautiful induce a state of submission that is often combined with the possibility of getting lost. They disorientate and undermine purpose. In one of several erotic sections in the *Enquiry* Burke describes the experience of looking at a beautiful woman's body: it is, he writes, like a 'deceitful maze, through which the unsteady eye glides giddily, without knowing where to fix, or whither it is carried'. It is the drift of the erotic that sabotages method and by the same token makes it imperative. The intoxication of the 'unsteady eye' will find its echo thirty years later in Burke's description of the mob during the French revolution.

There is then the 'agreeable relaxation' of Beauty and the 'something so over-ruling' of the Sublime. And it is the Sublime, in the antagonism he needs to create between them, that is the stronger. Paralysis and tyranny—the equivalence of the potentially fatal and the unknown, that Burke would come to associate with the idea of Revolution—win over the sometimes dizzying mobility that Beauty can inspire. Just as Hume had produced a devastating critique of causality in the *Treatise on Human Nature*, as part of the great drift of eighteenth-century scepticism Burke had discovered in the *Enquiry* the impossibility of rational classification, of 'knowing where to fix'. Nearly two hundred years later Freud would describe something comparable as the war between Thanatos, the Death Instinct, and Eros.

NOTE ON THE TEXT

The *Philosophical Enquiry* was first published by Robert
and James Dodsley in London in 1757. A second edition
was published in 1759 with an additional Preface and the
new Introduction on Taste. The present text is of the
second edition and based on Boulton's fine edition listed
in the Bibliography.

SELECT BIBLIOGRAPHY

I. EDITIONS, LETTERS, BIOGRAPHIES

BURKE, Edmund, *A Philosophical Enquiry into the Origin of our Ideas of the Sublime and Beautiful*, Second Edition, facsimile (Menston, Scolar Press, 1970).

——edited with an Introduction and Notes by J. T. Boulton (London, Routledge and Kegan Paul, 1958).

—*The Correspondence of Edmund Burke*, Vol. 1 April 1744–June 1768, edited by Thomas W. Copeland (Cambridge, Cambridge University Press; Chicago, University of Chicago Press, 1958).

AYLING, Stanley, *Edmund Burke: His Life and Opinions* (London, John Murray, 1988).

KRAMNICK, Isaac, *The Rage of Edmund Burke: Portrait of an Ambivalent Conservative* (New York, Basic Books, 1977).

2. BOOKS AND ESSAYS ABOUT BURKE AND THE SUBLIME

I have included in this section books that make useful reference to Burke's *Enquiry*.

BLAKEMORE, Steven, *Burke and the Fall of Language: The French Revolution as Linguistic Event* (New Haven, University Press of New England, 1988).

BLOOM, Harold, *Agon* (New York, Oxford, Oxford University Press, 1982).

ENGELL, James, *The Creative Imagination: Enlightenment to Romanticism* (Cambridge, Massachusetts; London, Harvard University Press, 1981).

HARTMAN, Geoffrey H., *The Fate of Reading and Other Essays* (Chicago, University of Chicago Press, 1975).

HERTZ, Neil, *The End of the Line: Essays on Psychoanalysis and the Sublime* (New York, Columbia University Press, 1985).

ICA Documents 4/5: Postmodernism, edited by Lisa Appignanesi (London, Institute of Contemporary Arts, 1986).

KNAPP, Steven, *Personification and the Sublime: Milton to Coleridge* (Cambridge, Massachusetts; London, Harvard University Press, 1985).

LYOTARD, Jean-François, *Peregrinations: Law, Form, Event* (New York, Columbia University Press, 1988).

MACPHERSON, C. B., *Burke* (Oxford, Oxford University Press, 1980).

MITCHELL, W. J. T., *Iconology: Image, Text, Ideology* (Chicago, University of Chicago Press, 1986).

MONK, Samuel H., *The Sublime* (Ann Arbor, University of Michigan Press, 1960).

NANCY, Jean-Luc (ed.), *Du Sublime* (Paris, Editions Belin, 1988).

PALEY, Morton D., *The Apocalyptic Sublime* (New Haven; London, Yale University Press, 1986).

PAULSON, Ronald, *Representations of Revolution (1789–1820)* (New Haven; London, Yale University Press, 1983).

WEISKEL, Thomas, *The Romantic Sublime* (Baltimore; London, Johns Hopkins University Press, 1976, 1986).

WILTON, Andrew, *Turner and the Sublime* (London, British Museum Publications, 1980).

WOOD, Neal, 'The Aesthetic Dimension of Burke's Political Thought', *Journal of British Studies*, 4 (1964), 41–64.

A CHRONOLOGY OF EDMUND BURKE

1729 Edmund born in Dublin, the son of Richard Burke, an Attorney of the Irish Court of Exchequer; a member of the Protestant Church of Ireland, he married a Catholic, Mary Nagle, from County Cork in 1724.

1733 Brother Richard born.

1741–4 Attends the boarding-school of the Yorkshire-born Quaker Abraham Shackleton.

1744–9 Attends Trinity College, Dublin.

1750 Studies for the bar at the Middle Temple, London; in 1755, after serious wrangles with his father, he relinquishes his legal studies.

1756 Publishes *A Vindication of Natural Society*.

1757 Marries Jane Mary Nugent (1734–1812), daughter of an Irish Catholic doctor; publishes *A Philosophical Enquiry into the Origin of our Ideas of the Sublime and Beautiful*, and contracts to write *An Abridgement of English History*.

1758 Contracts to edit the Annual Register, a yearly review of political, social, and artistic events; birth of his sons Richard (Feb., *d.* 1794) and Christopher (Dec., died in infancy).

1759–64 Private Secretary to William Hamilton, Irish Chief Secretary; he employs Burke twice in Ireland, 1761–2, 1763–4.

1763 Burke's brother Richard appointed Collector and Receiver General in Grenada, West Indies.

1764 Burke founds 'The Club' with Johnson, Reynolds, and others; stops working for Hamilton.

1765 Appointed Private Secretary to the second Marquis of Rockingham who had just been appointed First Lord of the Treasury; elected MP for Wendover (re-elected 1768).

1767 Receives Freedom of the City of Dublin.

1768 Borrows money to buy estate at Beaconsfield called 'Gregories'.

1769 Indirectly but seriously involved in heavy losses in East India stock.

1770 Publishes *Thoughts on the Cause of the Present Discontents*; becomes Agent to the General Assembly of New York.

1774 Speech on American Taxation; elected MP for Bristol.

1775 Speech on Conciliation with America.

1780 Speech on Economic Reform.

1781 Becomes leading member of the Commons Select Committee on Indian Affairs.

1782 Appointed Paymaster-General in the second Rockingham Ministry which lasts three months; his Civil Establishment Act passed; resigns with Fox and his followers.

1783 9th Select Committee Report on Indian Affairs published; appointed Paymaster again but loses office with the defeat of Fox's India Bill in the House of Lords and the government's dismissal.

1785 Speech on the Nabob of Arcot's Debts.

1788 Opens the proceedings of the impeachment of Warren Hastings.

1790 Publishes *Reflections on the Revolution in France*.

1791 Breaks publicly with Fox and the Whigs; publishes *Appeal from the New to the Old Whigs*.

1794 Deaths of his brother and his son; final speech in Hastings impeachment (Hastings was acquitted in 1795).

1796 Publishes *Letter to a Noble Lord*, *Thoughts on Scarcity*, and the two *Letters on a Regicide Peace*; founds school for emigré boys at Penn in Buckinghamshire.

1797 Dies 9 July, buried at Beaconsfield.

A Philosophical
Enquiry

THE PREFACE TO THE FIRST EDITION

THE author hopes it will not be thought impertinent to say something of the motives which induced him to enter into the following enquiry. The matters which make the subject of it had formerly engaged a great deal of his attention. But he often found himself greatly at a loss; he found that he was far from having any thing like an exact theory of our passions, or a knowledge of their genuine sources; he found that he could not reduce his notions to any fixed or consistent principles; and he had remarked, that others lay under the same difficulties.

He observed that the ideas of the sublime and beautiful were frequently confounded; and that both were indiscriminately applied to things greatly differing, and sometimes of natures directly opposite. Even Longinus,* in his incomparable discourse upon a part of this subject, has comprehended things extremely repugnant to each other, under one common name of the *Sublime*. The abuse of the word *Beauty*, has been still more general, and attended with still worse consequences.

Such a confusion of ideas must certainly render all our reasonings upon subjects of this kind extremely inaccurate and inconclusive. Could this admit of any remedy, I imagined it could only be from a diligent examination of our passions in our own breasts; from a careful survey of the properties of things which we find by experience to influence those passions; and from a sober and attentive investigation of the laws of nature, by which those properties are capable of affecting the body, and thus of exciting our passions. If this could be done, it was imagined that the rules deducible from such an enquiry might be applied to the imitative arts, and to whatever else they concerned, without much difficulty.

It is four years now since this enquiry was finished;* during which time the author found no cause to make any material alteration in his theory. He has shewn it to some of his friends, men of learning and candour, who do not think it wholly unreasonable; and he now ventures to lay it before the public, proposing his notions as probable conjectures, not as things certain and indisputable; and if he has any where expressed himself more positively, it was owing to inattention.

THE PREFACE TO THE SECOND EDITION

I HAVE endeavoured to make this edition* something more full and satisfactory than the first. I have sought with the utmost care, and read with equal attention, every thing which has appeared in publick against my opinions; I have taken advantage of the candid liberty of my friends; and if by these means I have been better enabled to discover the imperfections of the work, the indulgence it has received, imperfect as it was, furnished me with a new motive to spare no reasonable pains for its improvement. Though I have not found sufficient reason, or what appeared to me sufficient, for making any material change in my theory, I have found it necessary in many places to explain, illustrate and enforce it. I have prefixed an introductory discourse concerning Taste; it is a matter curious in itself; and it leads naturally enough to the principal enquiry. This with the other explanations has made the work considerably larger; and by increasing its bulk has, I am afraid added to its faults; so that notwithstanding all my attention, it may stand in need of a yet greater share of indulgence than it required at its first appearance.

They who are accustomed to studies of this nature will expect, and they will allow too for many faults. They know that many of the objects of our enquiry are in themselves obscure and intricate; and that many others have been rendered so by affected refinements or false learning; they know that there are many impediments in the subject, in the prejudices of others, and even in our own, that render it a matter of no small difficulty to shew in a clear light the genuine face of nature. They know that whilst the mind is intent on the general scheme of things, some particular parts must be neglected; that we must often submit the style to the matter, and frequently give up the praise of elegance, satisfied with being clear.

The characters of nature are legible it is true; but they are

3

THE SUBLIME AND BEAUTIFUL

not plain enough to enable those who run, to read them. We must make use of a cautious, I had almost said, a timorous method of proceeding. We must not attempt to fly, when we can scarcely pretend to creep. In considering any complex matter, we ought to examine every distinct ingredient in the composition, one by one; and reduce every thing to the utmost simplicity; since the condition of our nature binds us to a strict law and very narrow limits. We ought afterwards to re-examine the principles by the effect of the composition, as well as the composition by that of the principles. We ought to compare our subject with things of a similar nature, and even with things of a contrary nature; for discoveries may be, and often are made by the contrast, which would escape us on the single view. The greater number of these comparisons we make, the more general and the more certain our knowledge is like to prove, as built upon a more extensive and perfect induction.

If an enquiry thus carefully conducted, should fail at last of discovering the truth, it may answer an end perhaps as useful, in discovering to us the weakness of our own understanding. If it does not make us knowing, it may make us modest. If it does not preserve us from error, it may at least from the spirit of error, and may make us cautious of pronouncing with positiveness or with haste, when so much labour may end in so much uncertainty.

I could wish that in examining this theory, the same method were pursued which I endeavoured to observe in forming it.* The objections, in my opinion, ought to be proposed, either to the several principles as they are distinctly considered, or to the justness of the conclusion which is drawn from them. But it is common to pass over both the premises and conclusion in silence, and to produce as an objection, some poetical passage which does not seem easily accounted for upon the principles I endeavour to establish. This manner of proceeding I should think very improper. The task would be infinite, if we could establish no principle until we had previously unravelled the complex texture of every image or description to be found in poets and orators. And though we should never be able to reconcile the effect of such images to our principles, this can never overturn the theory itself, whilst it is founded on certain

4

and indisputable facts. A theory founded on experiment and not assumed, is always good for so much as it explains. Our inability to push it indefinitely is no argument at all against it. This inability may be owing to our ignorance of some necessary *mediums*; to a want of proper application; to many other causes besides a defect in the principles we employ. In reality the subject requires a much closer attention, than we dare claim from our manner of treating it.

If it should not appear on the face of the work, I must caution the reader against imagining that I intended a full dissertation on the Sublime and Beautiful. My enquiry went no further than to the origin of these ideas. If the qualities which I have ranged under the head of the Sublime be all found consistent with each other, and all different from those which I place under the head of Beauty; and if those which compose the class of the Beautiful have the same consistency with themselves, and the same opposition to those which are classed under the denomination of Sublime, I am in little pain whether any body chuses to follow the name I give them or not, provided he allows that what I dispose under different heads are in reality different things in nature. The use I make of the words may be blamed as too confined or too extended; my meaning cannot well be misunderstood.

To conclude; whatever progress may be made towards the discovery of truth in this matter, I do not repent the pains I have taken in it. The use of such enquiries may be very considerable. Whatever turns the soul inward on itself, tends to concenter its forces, and to fit it for greater and stronger flights of science. By looking into physical causes our minds are opened and enlarged; and in this pursuit whether we take or whether we lose our game, the chace is certainly of service. *Cicero*, true as he was to the Academic philosophy, and consequently led to reject the certainty of physical as of every other kind of knowledge, yet freely confesses its great importance to the human understanding: "*Est animorum ingeniorumque nostrorum naturale quoddam quasi pabulum consideratio contemplatioque naturæ.*"* If we can direct the lights we derive from such exalted speculations, upon the humbler field of the imagination, whilst we investigate the springs and trace the courses of our passions, we may not

5

only communicate to the taste a sort of philosophical solidity, but we may reflect back on the severer sciences some of the graces and elegancies of taste, without which the greatest proficiency in those sciences will always have the appearance of something illiberal.

THE
CONTENTS

7

CONTENTS

PART II

PART III

8

PART IV

CONTENTS

PART V

*INTRODUCTION ON TASTE**

ON a superficial view, we may seem to differ very widely
from each other in our reasonings, and no less in our
pleasures: but notwithstanding this difference, which I think
to be rather apparent than real, it is probable that the standard
both of reason and Taste is the same in all human creatures.
For if there were not some principles of judgment as well as of
sentiment common to all mankind, no hold could possibly be
taken either on their reason or their passions, sufficient to
maintain the ordinary correspondence of life. It appears indeed
to be generally acknowledged, that with regard to truth and
falsehood there is something fixed. We find people in their
disputes continually appealing to certain tests and standards
which are allowed on all sides, and are supposed to be estab-
lished in our common nature. But there is not the same obvious
concurrence in any uniform or settled principles which relate
to Taste. It is even commonly supposed that this delicate and
aerial faculty, which seems too volatile to endure even the
chains of a definition, cannot be properly tried by any test, nor
regulated by any standard. There is so continual a call for the
exercise of the reasoning faculty, and it is so much strengthened
by perpetual contention, that certain maxims of right reason
seem to be tacitly settled amongst the most ignorant. The
learned have improved on this rude science, and reduced those
maxims into a system. If Taste has not been so happily cul-
tivated, it was not that the subject was barren, but that the
labourers were few or negligent; for to say the truth, there are
not the same interesting motives to impel us to fix the one,
which urge us to ascertain the other. And after all, if men
differ in their opinion concerning such matters, their difference
is not attended with the same important consequences, else I
make no doubt but that the logic of Taste, if I may be allowed
the expression, might very possibly be as well digested, and we

might come to discuss matters of this nature with as much certainty, as those which seem more immediately within the province of mere reason. And indeed it is very necessary at the entrance into such an enquiry, as our present, to make this point as clear as possible; for if Taste has no fixed principles, if the imagination is not affected according to some invariable and certain laws, our labour is like to be employed to very little purpose; as it must be judged an useless, if not an absurd undertaking, to lay down rules for caprice, and to set up for a legislator of whims and fancies.

The term Taste, like all other figurative terms, is not extremely accurate: the thing which we understand by it, is far from a simple and determinate idea in the minds of most men, and it is therefore liable to uncertainty and confusion. I have no great opinion of a definition, the celebrated remedy for the cure of this disorder. For when we define, we seem in danger of circumscribing nature within the bounds of our own notions, which we often take up by hazard, or embrace on trust, or form out of a limited and partial consideration of the object before us, instead of extending our ideas to take in all that nature comprehends, according to her manner of combining. We are limited in our enquiry by the strict laws to which we have submitted at our setting out.

> ———*Circa vilem patulumque morabimur orbem*
> *Unde pudor proferre pedem vetat aut operis lex.**

A definition may be very exact, and yet go but a very little way towards informing us of the nature of the thing defined; but let the virtue of a definition be what it will, in the order of things, it seems rather to follow than to precede our enquiry, of which it ought to be considered as the result. It must be acknowledged that the methods of disquisition and teaching may be sometimes different, and on very good reason undoubtedly; but for my part, I am convinced that the method of teaching which approaches most nearly to the method of investigation, is incomparably the best; since not content with serving up a few barren and lifeless truths, it leads to the stock on which they grew; it tends to set the reader himself in the track of invention, and to direct him into those paths in which

the author has made his own discoveries, if he should be so happy as to have made any that are valuable.

But to cut off all pretence for cavilling, I mean by the word Taste no more than that faculty, or those faculties of the mind which are affected with, or which form a judgment of the works of imagination and the elegant arts. This is, I think, the most general idea of that word, and what is the least connected with any particular theory. And my point in this enquiry is to find whether there are any principles, on which the imagination is affected, so common to all, so grounded and certain, as to supply the means of reasoning satisfactorily about them. And such principles of Taste, I fancy there are; however paradoxical it may seem to those, who on a superficial view imagine, that there is so great a diversity of Tastes both in kind and degree, that nothing can be more indeterminate.

All the natural powers in man, which I know, that are conversant about external objects, are the Senses; the Imagination; and the Judgment. And first with regard to the senses. We do and we must suppose, that as the conformation of their organs are nearly, or altogether the same in all men, so the manner of perceiving external objects is in all men the same, or with little difference. We are satisfied that what appears to be light to one eye, appears light to another; that what seems sweet to one palate, is sweet to another; that what is dark and bitter to this man, is likewise dark and bitter to that; and we conclude in the same manner of great and little, hard and soft, hot and cold, rough and smooth; and indeed of all the natural qualities and affections of bodies. If we suffer ourselves to imagine, that their senses present to different men different images of things, this sceptical proceeding will make every sort of reasoning on every subject vain and frivolous, even that sceptical reasoning itself, which had persuaded us to entertain a doubt concerning the agreement of our perceptions. But as there will be very little doubt that bodies present similar images to the whole species, it must necessarily be allowed, that the pleasures and the pains which every object excites in one man, it must raise in all mankind, whilst it operates naturally, simply, and by its proper powers only; for if we deny this, we must imagine, that the same cause operating in the same

manner, and on subjects of the same kind, will produce different effects, which would be highly absurd. Let us first consider this point in the sense of Taste, and the rather as the faculty in question has taken its name from that sense. All men are agreed to call vinegar sour, honey sweet, and aloes bitter; and as they are all agreed in finding these qualities in those objects, they do not in the least differ concerning their effects with regard to pleasure and pain. They all concur in calling sweetness pleasant, and sourness and bitterness unpleasant. Here there is no diversity in their sentiments; and that there is not appears fully from the consent of all men in the metaphors which are taken from the sense of Taste. A sour temper, bitter expressions, bitter curses, a bitter fate, are terms well and strongly understood by all. And we are altogether as well understood when we say, a sweet disposition, a sweet person, a sweet condition, and the like. It is confessed, that custom, and some other causes, have made many deviations from the natural pleasures or pains which belong to these several Tastes; but then the power of distinguishing between the natural and the acquired relish remains to the very last. A man frequently comes to prefer the Taste of tobacco to that of sugar, and the flavour of vinegar to that of milk; but this makes no confusion in Tastes, whilst he is sensible that the tobacco and vinegar are not sweet, and whilst he knows that habit alone has reconciled his palate to these alien pleasures. Even with such a person we may speak, and with sufficient precision, concerning Tastes. But should any man be found who declares, that to him tobacco has a Taste like sugar, and that he cannot distinguish between milk and vinegar; or that tobacco and vinegar are sweet, milk bitter, and sugar sour, we immediately conclude that the organs of this man are out of order, and that his palate is utterly vitiated. We are as far from conferring with such a person upon Tastes, as from reasoning concerning the relations of quantity with one who should deny that all the parts together were equal to the whole. We do not call a man of this kind wrong in his notions, but absolutely mad. Exceptions of this sort in either way, do not at all impeach our general rule, nor make us conclude that men have various principles concerning the relations of quantity, or the Taste of things. So that when it is

said, Taste cannot be disputed, it can only mean, that no one can strictly answer what pleasure or pain some particular man may find from the Taste of some particular thing. This indeed cannot be disputed; but we may dispute, and with sufficient clearness too, concerning the things which are naturally pleasing or disagreeable to the sense. But when we talk of any peculiar or acquired relish, then we must know the habits, the prejudices, or the distempers of this particular man, and we must draw our conclusion from those.

This agreement of mankind is not confined to the Taste solely. The principle of pleasure derived from sight is the same in all. Light is more pleasing than darkness. Summer, when the earth is clad in green, when the heavens are serene and bright, is more agreeable than winter, when every thing makes a different appearance. I never remember that any thing beautiful, whether a man, a beast, a bird, or a plant, was ever shewn, though it were to an hundred people, that they did not all immediately agree that it was beautiful, though some might have thought that it fell short of their expectation, or that other things were still finer. I believe no man thinks a goose to be more beautiful than a swan, or imagines that what they call a Friezland hen excels a peacock. It must be observed too, that the pleasures of the sight are not near so complicated, and confused, and altered by unnatural habits and associations, as the pleasures of the Taste are; because the pleasures of the sight more commonly acquiesce in themselves; and are not so often altered by considerations which are independent of the sight itself. But things do not spontaneously present themselves to the palate as they do to the sight; they are generally applied to it, either as food or as medicine; and from the qualities which they possess for nutritive or medicinal purposes, they often form the palate by degrees, and by force of these associations. Thus opium is pleasing to Turks, on account of the agreeable delirium it produces. Tobacco is the delight of Dutchmen, as it diffuses a torpor and pleasing stupefaction. Fermented spirits please our common people, because they banish care, and all consideration of future or present evils. All of these would lie absolutely neglected if their properties had originally gone no further than the Taste; but all these, together with tea and

15

coffee, and some other things, have past from the apothecary's shop to our tables, and were taken for health long before they were thought of for pleasure. The effect of the drug has made us use it frequently; and frequent use, combined with the agreeable effect, has made the Taste itself at last agreeable. But this does not in the least perplex our reasoning; because we distinguish to the last the acquired from the natural relish. In describing the Taste of an unknown fruit, you would scarcely say, that it had a sweet and pleasant flavour like tobacco, opium, or garlic, although you spoke to those who were in the constant use of these drugs, and had great pleasure in them. There is in all men a sufficient remembrance of the original natural causes of pleasure, to enable them to bring all things offered to their senses to that standard, and to regulate their feelings and opinions by it. Suppose one who had so vitiated his palate as to take more pleasure in the Taste of opium than in that of butter or honey, to be presented with a bolus of squills; there is hardly any doubt but that he would prefer the butter or honey to this nauseous morsel, or to any other bitter drug to which he had not been accustomed; which proves that his palate was naturally like that of other men in all things, that it is still like the palate of other men in many things, and only vitiated in some particular points. For in judging of any new thing, even of a Taste similar to that which he has been formed by habit to like, he finds his palate affected in the natural manner, and on the common principles. Thus the pleasure of all the senses, of the sight, and even of the Taste, that most ambiguous of the senses, is the same in all, high and low, learned and unlearned.

Besides the ideas, with their annexed pains and pleasures, which are presented by the sense; the mind of man possesses a sort of creative power of its own; either in representing at pleasure the images of things in the order and manner in which they were received by the senses, or in combining those images in a new manner, and according to a different order. This power is called Imagination; and to this belongs whatever is called wit, fancy, invention, and the like. But it must be observed, that this power of the imagination is incapable of producing any thing absolutely new; it can only vary the

disposition of those ideas which it has received from the senses. Now the imagination is the most extensive province of pleasure and pain, as it is the region of our fears and our hopes, and of all our passions that are connected with them; and whatever is calculated to affect the imagination with these commanding ideas, by force of any original natural impression, must have the same power pretty equally over all men. For since the imagination is only the representative of the senses, it can only be pleased or displeased with the images from the same principle on which the sense is pleased or displeased with the realities; and consequently there must be just as close an agreement in the imaginations as in the senses of men. A little attention will convince us that this must of necessity be the case.

But in the imagination, besides the pain or pleasure arising from the properties of the natural object, a pleasure is perceived from the resemblance, which the imitation has to the original; the imagination, I conceive, can have no pleasure but what results from one or other of these causes. And these causes operate pretty uniformly upon all men, because they operate by principles in nature, and which are not derived from any particular habits or advantages. Mr. Locke very justly and finely observes of wit, that it is chiefly conversant in tracing resemblances; he remarks at the same time, that the business of judgment is rather in finding differences.* It may perhaps appear, on this supposition, that there is no material distinction between the wit and the judgment, as they both seem to result from different operations of the same faculty of *comparing*. But in reality, whether they are or are not dependent on the same power of the mind, they differ so very materially in many respects, that a perfect union of wit and judgment is one of the rarest things in the world. When two distinct objects are unlike to each other, it is only what we expect; things are in their common way; and therefore they make no impression on the imagination: but when two distinct objects have a resemblance, we are struck, we attend to them, and we are pleased. The mind of man has naturally a far greater alacrity and satisfaction in tracing resemblances than in searching for differences; because by making resemblances we produce *new images*, we unite, we create, we enlarge our stock; but in making

distinctions we offer no food at all to the imagination; the task itself is more severe and irksome, and what pleasure we derive from it is something of a negative and indirect nature. A piece of news is told me in the morning; this, merely as a piece of news, as a fact added to my stock, gives me some pleasure. In the evening I find there was nothing in it. What do I gain by this, but the dissatisfaction to find that I had been imposed upon? Hence it is, that men are much more naturally inclined to belief than to incredulity. And it is upon this principle, that the most ignorant and barbarous nations have frequently excelled in similitudes, comparisons, metaphors, and allegories, who have been weak and backward in distinguishing and sorting their ideas. And it is for a reason of this kind that Homer and the oriental writers, though very fond of similitudes, and though they often strike out such as are truly admirable, they seldom take care to have them exact; that is, they are taken with the general resemblance, they paint it strongly, and they take no notice of the difference which may be found between the things compared.

Now as the pleasure of resemblance is that which principally flatters the imagination, all men are nearly equal in this point, as far as their knowledge of the things represented or compared extends. The principle of this knowledge is very much accidental, as it depends upon experience and observation, and not on the strength or weakness of any natural faculty; and it is from this difference in knowledge that what we commonly, though with no great exactness, call a difference in Taste proceeds. A man to whom sculpture is new, sees a barber's block, or some ordinary piece of statuary; he is immediately struck and pleased, because he sees something like an human figure; and entirely taken up with this likeness, he does not at all attend to its defects. No person, I believe, at the first time of seeing a piece of imitation ever did. Some time after, we suppose that this novice lights upon a more artificial work of the same nature; he now begins to look with contempt on what he admired at first; not that he admired it even then for its unlikeness to a man, but for that general though inaccurate resemblance which it bore to the human figure. What he admired at different times in these so different figures, is strictly

the same; and though his knowledge is improved, his Taste is not altered. Hitherto his mistake was from a want of knowledge in art, and this arose from his inexperience; but he may be still deficient from a want of knowledge in nature. For it is possible that the man in question may stop here, and that the master-piece of a great hand may please him no more than the middling performance of a vulgar artist; and this not for want of better or higher relish, but because all men do not observe with sufficient accuracy on the human figure to enable them to judge properly of an imitation of it. And that the critical Taste does not depend upon a superior principle in men, but upon superior knowledge, may appear from several instances. The story of the ancient painter and the shoemaker is very well known.* The shoemaker set the painter right with regard to some mistakes he had made in the shoe of one of his figures, and which the painter, who had not made such accurate observations on shoes, and was content with a general resemb-lance, had never observed. But this was no impeachment to the Taste of the painter, it only shewed some want of knowledge in the art of making shoes. Let us imagine, that an anatomist had come into the painter's working room. His piece is in general well done, the figure in question in a good attitude, and the parts well adjusted to their various movements; yet the anatomist, critical in his art, may observe the swell of some muscle not quite just in the peculiar action of the figure. Here the anatomist observes what the painter had not observed, and he passes by what the shoemaker had remarked. But a want of the last critical knowledge in anatomy no more reflected on the natural good Taste of the painter, or of any common ob-server of his piece, than the want of an exact knowledge in the formation of a shoe. A fine piece of a decollated head of St. John the Baptist was shewn to a Turkish emperor; he praised many things, but he observed one defect; he observed that the skin did not shrink from the wounded part of the neck. The sultan on this occasion, though his observation was very just, discovered no more natural Taste than the painter who executed this piece, or than a thousand European connoisseurs who probably never would have made the same observation. His Turkish majesty had indeed been well acquainted with that

terrible spectacle, which the others could only have represented in their imagination.* On the subject of their dislike there is a difference between all these people, arising from the different kinds and degrees of their knowledge; but there is something in common to the painter, the shoemaker, the anatomist, and the Turkish emperor, the pleasure arising from a natural object, so far as each perceives it justly imitated; the satisfaction in seeing an agreeable figure; the sympathy proceeding from a striking and affecting incident. So far as Taste is natural, it is nearly common to all.

In poetry, and other pieces of imagination, the same parity may be observed. It is true, that one man is charmed with Don Bellianis,* and reads Virgil coldly; whilst another is transported with the Eneid, and leaves Don Bellianis to children. These two men seem to have a Taste very different from each other; but in fact they differ very little. In both these pieces, which inspire such opposite sentiments, a tale exciting admiration is told; both are full of action, both are passionate, in both are voyages, battles, triumphs, and continual changes of fortune. The admirer of Don Bellianis perhaps does not understand the refined language of the Eneid, who if it was degraded into the style of the Pilgrim's Progress,* might feel it in all its energy, on the same principle which made him an admirer of Don Bellianis.

In his favourite author he is not shocked with the continual breaches of probability, the confusion of times, the offences against manners, the trampling upon geography; for he knows nothing of geography and chronology, and he has never examined the grounds of probability. He perhaps reads of a shipwreck on the coast of Bohemia;* wholly taken up with so interesting an event, and only solicitous for the fate of his hero, he is not in the least troubled at this extravagant blunder. For why should he be shocked at a shipwreck on the coast of Bohemia, who does not know but that Bohemia may be an island in the Atlantic ocean? and after all, what reflection is this on the natural good Taste of the person here supposed?

So far then as Taste belongs to the imagination, its principle is the same in all men; there is no difference in the manner of their being affected, nor in the causes of the affection; but in

the *degree* there is a difference, which arises from two causes principally; either from a greater degree of natural sensibility, or from a closer and longer attention to the object. To illustrate this by the procedure of the senses in which the same difference is found, let us suppose a very smooth marble table to be set before two men; they both perceive it to be smooth, and they are both pleased with it, because of this quality. So far they agree. But suppose another, and after that another table, the latter still smoother than the former, to be set before them. It is now very probable that these men, who are so agreed upon what is smooth, and in the pleasure from thence, will disagree when they come to settle which table has the advantage in point of polish. Here is indeed the great difference between Tastes, when men come to compare the excess or diminution of things which are judged by degree and not by measure. Nor is it easy, when such a difference arises, to settle the point, if the excess or diminution be not glaring. If we differ in opinion about two quantities, we can have recourse to a common measure, which may decide the question with the utmost exactness; and this I take it is what gives mathematical knowledge a greater certainty than any other. But in things whose excess is not judged by greater or smaller, as smoothness and roughness, hardness and softness, darkness and light, the shades of colours, all these are very easily distinguished when the difference is any way considerable, but not when it is minute, for want of some common measures which perhaps may never come to be discovered. In these nice cases, supposing the acuteness of the sense equal, the greater attention and habit in such things will have the advantage. In the question about the tables, the marble polisher will unquestionably determine the most accurately. But notwithstanding this want of a common measure for settling many disputes relative to the senses and their representative the imagination, we find that the principles are the same in all, and that there is no disagreement until we come to examine into the preeminence or difference of things, which brings us within the province of the judgment.

So long as we are conversant with the sensible qualities of things, hardly any more than the imagination seems con-

cerned; little more also than the imagination seems concerned when the passions are represented, because by the force of natural sympathy they are felt in all men without any recourse to reasoning, and their justness recognized in every breast. Love, grief, fear, anger, joy, all these passions have in their turns affected every mind; and they do not affect it in an arbitrary or casual manner, but upon certain, natural and uniform principles. But as many of the works of imagination are not confined to the representation of sensible objects, nor to efforts upon the passions, but extend themselves to the manners, the characters, the actions, and designs of men, their relations, their virtues and vices, they come within the province of the judgment, which is improved by attention and by the habit of reasoning. All these make a very considerable part of what are considered as the objects of Taste; and Horace sends us to the schools of philosophy and the world for our instruction in them.* Whatever certainty is to be acquired in morality and the science of life; just the same degree of certainty have we in what relates to them in works of imitation. Indeed it is for the most part in our skill in manners, and in the observances of time and place, and of decency in general, which is only to be learned in those schools to which Horace recommends us, that what is called Taste by way of distinction, consists; and which is in reality no other than a more refined judgment. On the whole it appears to me, that what is called Taste, in its most general acceptation, is not a simple idea, but is partly made up of a perception of the primary pleasures of sense, of the secondary pleasures of the imagination, and of the conclusions of the reasoning faculty, concerning the various relations of these, and concerning the human passions, manners and actions. All this is requisite to form Taste, and the ground-work of all these is the same in the human mind; for as the senses are the great originals of all our ideas, and consequently of all our pleasures, if they are not uncertain and arbitrary, the whole ground-work of Taste is common to all, and therefore there is a sufficient foundation for a conclusive reasoning on these matters.

Whilst we consider Taste, merely according to its nature and species, we shall find its principles entirely uniform; but the

degree in which these principles prevail in the several indi-
viduals of mankind, is altogether as different as the principles
themselves are similar. For sensibility and judgment, which are
the qualities that compose what we commonly call a *Taste*,
vary exceedingly in various people. From a defect in the former
of these qualities, arises a want of Taste; a weakness in the
latter, constitutes a wrong or a bad one. There are some men
formed with feelings so blunt, with tempers so cold and phleg-
matic, that they can hardly be said to be awake during the
whole course of their lives. Upon such persons, the most
striking objects make but a faint and obscure impression. There
are others so continually in the agitation of gross and merely
sensual pleasures, or so occupied in the low drudgery of avarice,
or so heated in the chace of honours and distinction, that their
minds, which had been used continually to the storms of these
violent and tempestuous passions, can hardly be put in motion
by the delicate and refined play of the imagination. These men,
though from a different cause, become as stupid and insensible
as the former; but whenever either of these happen to be struck
with any natural elegance or greatness, or with these qualities
in any work of art, they are moved upon the same principle.

The cause of a wrong Taste is a defect of judgment. And this
may arise from a natural weakness of understanding (in what-
ever the strength of that faculty may consist) or, which is much
more commonly the case, it may arise from a want of proper
and well-directed exercise, which alone can make it strong and
ready. Besides that ignorance, inattention, prejudice, rashness,
levity, obstinacy, in short, all those passions, and all those vices
which pervert the judgment in other matters, prejudice it no
less in this its more refined and elegant province. These causes
produce different opinions upon every thing which is an object
of the understanding, without inducing us to suppose, that
there are no settled principles of reason. And indeed on the
whole one may observe, that there is rather less difference upon
matters of Taste among mankind, than upon most of those
which depend upon the naked reason; and that men are far
better agreed on the excellence of a description in Virgil, than
on the truth or falsehood of a theory of Aristotle.

A rectitude of judgment in the arts which may be called a

good Taste, does in a great measure depend upon sensibility; because if the mind has no bent to the pleasures of the imagination, it will never apply itself sufficiently to works of that species to acquire a competent knowledge in them. But, though a degree of sensibility is requisite to form a good judgment, yet a good judgment does not necessarily arise from a quick sensibility of pleasure; it frequently happens that a very poor judge, merely by force of a greater complexional sensibility, is more affected by a very poor piece, than the best judge by the most perfect; for as every thing new, extraordinary, grand, or passionate is well calculated to affect such a person, and that the faults do not affect him, his pleasure is more pure and unmixed; and as it is merely a pleasure of the imagination, it is much higher than any which is derived from a rectitude of the judgment; the judgment is for the greater part employed in throwing stumbling blocks in the way of the imagination, in dissipating the scenes of its enchantment, and in tying us down to the disagreeable yoke of our reason: for almost the only pleasure that men have in judging better than others, consists in a sort of conscious pride and superiority, which arises from thinking rightly; but then, this is an indirect pleasure, a pleasure which does not immediately result from the object which is under contemplation. In the morning of our days, when the senses are unworn and tender, when the whole man is awake in every part, and the gloss of novelty fresh upon all the objects that surround us, how lively at that time are our sensations, but how false and inaccurate the judgments we form of things? I despair of ever receiving the same degree of pleasure from the most excellent performances of genius which I felt at that age, from pieces which my present judgment regards as trifling and contemptible. Every trivial cause of pleasure is apt to affect the man of too sanguine a complexion: his appetite is too keen to suffer his Taste to be delicate; and he is in all respects what Ovid says of himself in love,

> *Molle meum levibus cor est violabile telis,*
> *Et semper causa est, cur ego semper amem.**

One of this character can never be a refined judge; never what the comic poet calls *elegans formarum, spectator.** The excellence

and force of a composition must always be imperfectly estimated from its effect on the minds of any, except we know the temper and character of those minds. The most powerful effects of poetry and music have been displayed, and perhaps are still displayed, where these arts are but in a very low and imperfect state. The rude hearer is affected by the principles which operate in these arts even in their rudest condition; and he is not skilful enough to perceive the defects. But as the arts advance towards their perfection, the science of criticism advances with equal pace, and the pleasure of judges is frequently interrupted by the faults which are discovered in the most finished compositions.

Before I leave this subject I cannot help taking notice of an opinion which many persons entertain, as if the Taste were a separate faculty of the mind, and distinct from the judgment and imagination; a species of instinct by which we are struck naturally, and at the first glance, without any previous reasoning with the excellencies, or the defects of a composition. So far as the imagination and the passions are concerned, I believe it true, that the reason is little consulted; but where disposition, where decorum, where congruity are concerned, in short wherever the best Taste differs from the worst, I am convinced that the understanding operates and nothing else; and its operation is in reality far from being always sudden, or when it is sudden, it is often far from being right. Men of the best Taste by consideration, come frequently to change these early and precipitate judgments which the mind from its aversion to neutrality and doubt loves to form on the spot. It is known that the Taste (whatever it is) is improved exactly as we improve our judgment, by extending our knowledge, by a steady attention to our object, and by frequent exercise. They who have not taken these methods, if their Taste decides quickly, it is always uncertainly; and their quickness is owing to their presumption and rashness, and not to any sudden irradiation that in a moment dispels all darkness from their minds. But they who have cultivated that species of knowledge which makes the object of Taste, by degrees and habitually attain not only a soundness, but a readiness of judgment, as men do by the same methods on all other occasions. At first they are

obliged to spell, but at last they read with ease and with celerity: but this celerity of its operation is no proof, that the Taste is a distinct faculty. Nobody I believe has attended the course of a discussion, which turned upon matters within the sphere of mere naked reason, but must have observed the extreme readiness with which the whole process of the argument is carried on, the grounds discovered, the objections raised and answered, and the conclusions drawn from premises, with a quickness altogether as great as the Taste can be supposed to work with; and yet where nothing but plain reason either is or can be suspected to operate. To multiply principles for every different appearance, is useless, and unphilosophical too in a high degree.

This matter might be pursued much further; but it is not the extent of the subject which must prescribe our bounds, for what subject does not branch out to infinity? it is the nature of our particular scheme, and the single point of view in which we consider it, which ought to put a stop to our researches.

A
PHILOSOPHICAL ENQUIRY
INTO THE ORIGIN
OF OUR IDEAS
OF THE SUBLIME
AND BEAUTIFUL

Part One

A

PHILOSOPHICAL ENQUIRY
INTO THE ORIGIN
OF OUR IDEAS
OF THE SUBLIME
AND BEAUTIFUL

Part One

SECTION I
NOVELTY

THE first and the simplest emotion which we discover in the human mind, is Curiosity. By curiosity, I mean whatever desire we have for, or whatever pleasure we take in novelty. We see children perpetually running from place to place to hunt out something new; they catch with great eagerness, and with very little choice, at whatever comes before them; their attention is engaged by every thing, because every thing has, in that stage of life, the charm of novelty to recommend it. But as those things which engage us merely by their novelty, cannot attach us for any length of time, curiosity is the most superficial of all the affections; it changes its object perpetually; it has an appetite which is very sharp, but very easily satisfied; and it has always an appearance of giddiness, restlessness and anxiety. Curiosity from its nature is a very active principle; it quickly runs over the greatest part of its objects, and soon exhausts the variety which is commonly to be met with in nature; the same things make frequent returns, and they return with less and less of any agreeable effect. In short, the occurrences of life, by the time we come to know it a little, would be incapable of affecting the mind with any other sensations than those of loathing and weariness, if many things were not adapted to affect the mind by means of other powers besides novelty in them, and of other passions besides curiosity in ourselves. These powers and passions shall be considered in their place. But whatever these powers are, or upon what principle soever they affect the mind, it is absolutely necessary that they should not be exerted in those things which a daily and vulgar use have brought into a stale unaffecting familiarity. Some degree of novelty must be one of the materials in every instrument which works upon the mind; and curiosity blends itself more or less with all our passions.

SECTION II
PAIN and PLEASURE

It seems then necessary towards moving the passions of people advanced in life to any considerable degree, that the objects designed for that purpose, besides their being in some measure new, should be capable of exciting pain or pleasure from other causes. Pain and pleasure are simple ideas, incapable of definition.* People are not liable to be mistaken in their feelings, but they are very frequently wrong in the names they give them, and in their reasonings about them. Many are of opinion, that pain arises necessarily from the removal of some pleasure; as they think pleasure does from the ceasing or diminution of some pain. For my part I am rather inclined to imagine, that pain and pleasure in their most simple and natural manner of affecting, are each of a positive nature, and by no means necessarily dependent on each other for their existence. The human mind is often, and I think it is for the most part, in a state neither of pain nor pleasure, which I call a state of indifference. When I am carried from this state into a state of actual pleasure, it does not appear necessary that I should pass through the medium of any sort of pain. If in such a state of indifference, or ease, or tranquillity, or call it what you please, you were to be suddenly entertained with a concert of music; or suppose some object of a fine shape, and bright lively colours to be presented before you; or imagine your smell is gratified with the fragrance of a rose; or if without any previous thirst you were to drink of some pleasant kind of wine; or to taste of some sweetmeat without being hungry; in all the several senses, of hearing, smelling, and tasting, you undoubtedly find a pleasure; yet if I enquire into the state of your mind previous to these gratifications, you will hardly tell me that they found you in any kind of pain; or having satisfied these several senses with their several pleasures, will you say that any pain has succeeded, though the pleasure is absolutely over? Suppose on the other hand, a man in the same state of indifference, to receive a violent blow, or to drink of some bitter potion, or to have his ears wounded with some harsh and grating sound; here is no removal of pleasure; and yet here is

felt, in every sense which is affected, a pain very distinguishable. It may be said perhaps, that the pain in these cases had its rise from the removal of the pleasure which the man enjoyed before, though that pleasure was of so low a degree as to be perceived only by the removal. But this seems to me a subtilty, that is not discoverable in nature. For if, previous to the pain, I do not feel any actual pleasure, I have no reason to judge that any such thing exists; since pleasure is only pleasure as it is felt. The same may be said of pain, and with equal reason. I can never persuade myself that pleasure and pain are mere relations, which can only exist as they are contrasted: but I think I can discern clearly that there are positive pains and pleasures, which do not at all depend upon each other. Nothing is more certain to my own feelings than this. There is nothing which I can distinguish in my mind with more clearness than the three states, of indifference, of pleasure, and of pain. Every one of these I can perceive without any sort of idea of its relation to any thing else. Caius is afflicted with a fit of the cholic; this man is actually in pain; stretch Caius upon the rack, he will feel a much greater pain; but does this pain of the rack arise from the removal of any pleasure? or is the fit of the cholic a pleasure or a pain just as we are pleased to consider it?

SECTION III

The difference between the removal of
PAIN and positive PLEASURE

We shall carry this proposition yet a step further. We shall venture to propose, that pain and pleasure are not only, not necessarily dependent for their existence on their mutual diminution or removal, but that, in reality, the diminution or ceasing of pleasure does not operate like positive pain; and that the removal or diminution of pain, in its effect has very little resemblance to positive pleasure.[1] The former of these propo-

[1] Mr. Locke [essay on human understanding, l. 2. c. 20. section 16.] thinks that the removal or lessening of a pain is considered and operates as a pleasure, and the loss or diminishing of pleasure as a pain. It is this opinion which we consider here.

sitions will, I believe, be much more readily allowed than the latter; because it is very evident that pleasure, when it has run its career, sets us down very nearly where it found us. Pleasure of every kind quickly satisfies; and when it is over, we relapse into indifference, or rather we fall into a soft tranquillity, which is tinged with the agreeable colour of the former sensation. I own, it is not at first view so apparent, that the removal of a great pain does not resemble positive pleasure: but let us recollect in what state we have found our minds upon escaping some imminent danger, or on being released from the severity of some cruel pain. We have on such occasions found, if I am not much mistaken, the temper of our minds in a tenor very remote from that which attends the presence of positive pleasure; we have found them in a state of much sobriety, impressed with a sense of awe, in a sort of tranquillity shadowed with horror. The fashion of the countenance and the gesture of the body on such occasions is so correspondent to this state of mind, that any person, a stranger to the cause of the appearance, would rather judge us under some consternation, than in the enjoyment of any thing like positive pleasure.

ὡς δ' ὅτ' ἂν ἄνδρ' ἄτη πυκινὴ λάβῃ, ὅς τ' ἐνὶ πάτρῃ
φῶτα κατακτείνας ἄλλων ἐξίκετο δῆμον,
ἀνδρὸς ἐς ἀφνειοῦ, θάμβος δ' ἔχει εἰσορόωντας,

Iliad. 24.*

As when a wretch, who conscious of his crime,
Pursued for murder from his native clime,
Just gains some frontier, breathless, pale, amaz'd;
All gaze, all wonder! *

This striking appearance of the man whom Homer supposes to have just escaped an imminent danger, the sort of mixt passion of terror and surprize, with which he affects the spectators, paints very strongly the manner in which we find ourselves affected upon occasions any way similar. For when we have suffered from any violent emotion, the mind naturally continues in something like the same condition, after the cause which first produced it has ceased to operate. The tossing of the sea remains after the storm; and when this remain of horror has entirely subsided, all the passion, which the accident raised,

32

subsides along with it; and the mind returns to its usual state of indifference. In short, pleasure (I mean any thing either in the inward sensation, or in the outward appearance like pleasure from a positive cause) has never, I imagine, its origin from the removal of pain or danger.

SECTION IV

Of DELIGHT and PLEASURE, as
opposed to each other

But shall we therefore say, that the removal of pain or its diminution is always simply painful? or affirm that the cessation or the lessening of pleasure is always attended itself with a pleasure? by no means. What I advance is no more than this; first, that there are pleasures and pains of a positive and independent nature; and secondly, that the feeling which results from the ceasing or diminution of pain does not bear a sufficient resemblance to positive pleasure to have it considered as of the same nature, or to entitle it to be known by the same name; and thirdly, that upon the same principle the removal or qualification of pleasure has no resemblance to positive pain. It is certain that the former feeling (the removal or moderation of pain) has something in it far from distressing, or disagreeable in its nature. This feeling, in many cases so agreeable, but in all so different from positive pleasure, has no name which I know; but that hinders not its being a very real one, and very different from all others. It is most certain, that every species of satisfaction or pleasure, how different soever in its manner of affecting, is of a positive nature in the mind of him who feels it. The affection is undoubtedly positive; but the cause may be, as in this case it certainly is, a sort of *Privation*. And it is very reasonable that we should distinguish by some term two things so distinct in nature, as a pleasure that is such simply, and without any relation, from that pleasure, which cannot exist without a relation, and that too a relation to pain. Very extraordinary it would be, if these affections, so distinguishable in their causes, so different in their

effects, should be confounded with each other, because vulgar use has ranged them under the same general title. Whenever I have occasion to speak of this species of relative pleasure, I call it *Delight*; and I shall take the best care I can, to use that word in no other sense. I am satisfied the word is not commonly used in this appropriated signification; but I thought it better to take up a word already known, and to limit its signification, than to introduce a new one which would not perhaps incorporate so well with the language. I should never have presumed the least alteration in our words, if the nature of the language, framed for the purposes of business rather than those of philosophy, and the nature of my subject that leads me but of the common track of discourse, did not in a manner necessitate me to it. I shall make use of this liberty with all possible caution. As I make use of the word *Delight* to express the sensation which accompanies the removal of pain or danger; so when I speak of positive pleasure, I shall for the most part call it simply *Pleasure*.

SECTION V

JOY and GRIEF

It must be observed, that the cessation of pleasure affects the mind three ways. If it simply ceases, after having continued a proper time, the effect is *indifference*; if it be abruptly broken off, there ensues an uneasy sense called *disappointment*; if the object be so totally lost that there is no chance of enjoying it again, a passion arises in the mind, which is called *grief*. Now there is none of these, not even grief, which is the most violent, that I think has any resemblance to positive pain. The person who grieves, suffers his passion to grow upon him; he indulges it, he loves it: but this never happens in the case of actual pain, which no man ever willingly endured for any considerable time. That grief should be willingly endured, though far from a simply pleasing sensation, is not so difficult to be understood. It is the nature of grief to keep its object perpetually in its eye, to present it in its most pleasurable views, to repeat all the circumstances that attend it, even to the last minuteness; to go

back to every particular enjoyment, to dwell upon each, and to find a thousand new perfections in all, that were not sufficiently understood before; in grief, the *pleasure* is still uppermost; and the affliction we suffer has no resemblance to absolute pain, which is always odious, and which we endeavour to shake off as soon as possible. The Odyssey of Homer, which abounds with so many natural and affecting images, has none more striking than those which Menelaus raises of the calamitous fate of his friends, and his own manner of feeling it. He owns indeed, that he often gives himself some intermission from such melancholy reflections, but he observes too, that melancholy as they are, they give him pleasure.

> ἀλλ' ἔμπης πάντας μὲν ὀδυρόμενος καὶ ἀχεύων
> πολλάκις ἐν μεγάροισι καθήμενος ἡμετέροισιν
> ἄλλοτε μέν τε γόῳ φρένα τέρπομαι, ἄλλοτε δ' αὖτε
> παύομαι· αἰψηρὸς δὲ κόρος κρυεροῖο γόοιο.*

> Still in short intervals of pleasing woe,
> Regardful of the friendly dues I owe,
> I to the glorious dead, for ever dear,
> Indulge the tribute of a grateful tear.*

Hom. Od. 4.

On the other hand, when we recover our health, when we escape an imminent danger, is it with joy that we are affected? The sense on these occasions is far from that smooth and voluptuous satisfaction which the assured prospect of pleasure bestows. The delight which arises from the modifications of pain, confesses the stock from whence it sprung, in its solid, strong, and severe nature.

SECTION VI

Of the passions which belong to SELF-PRESERVATION

Most of the ideas which are capable of making a powerful impression on the mind, whether simply of Pain or Pleasure, or of the modifications of those, may be reduced very nearly to these two heads, *self-preservation* and *society*; to the ends of

one or the other of which all our passions are calculated to answer. The passions which concern self-preservation, turn mostly on *pain* or *danger*. The ideas of *pain, sickness,* and *death,* fill the mind with strong emotions of horror; but *life* and *health,* though they put us in a capacity of being affected with pleasure, they make no such impression by the simple enjoyment. The passions therefore which are conversant about the preservation of the individual, turn chiefly on *pain* and *danger,* and they are the most powerful of all the passions.

SECTION VII

Of the SUBLIME

Whatever is fitted in any sort to excite the ideas of pain, and danger, that is to say, whatever is in any sort terrible, or is conversant about terrible objects, or operates in a manner analogous to terror, is a source of the *sublime*; that is, it is productive of the strongest emotion which the mind is capable of feeling. I say the strongest emotion, because I am satisfied the ideas of pain are much more powerful than those which enter on the part of pleasure. Without all doubt, the torments which we may be made to suffer, are much greater in their effect on the body and mind, than any pleasures which the most learned voluptuary could suggest, or than the liveliest imagination, and the most sound and exquisitely sensible body could enjoy. Nay I am in great doubt, whether any man could be found who would earn a life of the most perfect satisfaction, at the price of ending it in the torments, which justice inflicted in a few hours on the late unfortunate regicide in France.*
But as pain is stronger in its operation than pleasure, so death is in general a much more affecting idea than pain; because there are very few pains, however exquisite, which are not preferred to death; nay, what generally makes pain itself, if I may say so, more painful, is, that it is considered as an emissary of this king of terrors. When danger or pain press too nearly, they are incapable of giving any delight, and are simply terrible; but at certain distances, and with certain modifica-

tions, they may be, and they are delightful, as we every day experience. The cause of this I shall endeavour to investigate hereafter.

SECTION VIII
Of the passions which belong to
SOCIETY

The other head under which I class our passions, is that of *society*, which may be divided into two sorts. 1. The society of the *sexes*, which answers the purposes of propagation; and next, that more *general society*, which we have with men and with other animals, and which we may in some sort be said to have even with the inanimate world. The passions belonging to the preservation of the individual, turn wholly on pain and danger; those which belong to *generation*, have their origin in gratifications and *pleasures*; the pleasure most directly belonging to this purpose is of a lively character, rapturous and violent, and confessedly the highest pleasure of sense; yet the absence of this so great an enjoyment, scarce amounts to an uneasiness; and except at particular times, I do not think it affects at all. When men describe in what manner they are affected by pain and danger; they do not dwell on the pleasure of health and the comfort of security, and then lament the *loss* of these satisfactions: the whole turns upon the actual pains and horrors which they endure. But if you listen to the complaints of a forsaken lover, you observe, that he insists largely on the pleasures which he enjoyed, or hoped to enjoy, and on the perfection of the object of his desires; it is the *loss* which is always uppermost in his mind. The violent effects produced by love, which has sometimes been even wrought up to madness, is no objection to the rule which we seek to establish. When men have suffered their imaginations to be long affected with any idea, it so wholly engrosses them as to shut out by degrees almost every other, and to break down every partition of the mind which would confine it. Any idea is sufficient for the purpose, as is evident from the infinite variety of causes which give rise to madness: but this at most can only prove, that the passion of

love is capable of producing very extraordinary effects, not that its extraordinary emotions have any connection with positive pain.

SECTION IX

The final cause of the difference between the passions belonging to SELF-PRESERVATION, and those which regard the SOCIETY of the SEXES

The final cause of the difference in character between the passions which regard self-preservation, and those which are directed to the multiplication of the species, will illustrate the foregoing remarks yet further; and it is, I imagine, worthy of observation even upon its own account. As the performance of our duties of every kind depends upon life, and the performing them with vigour and efficacy depends upon health, we are very strongly affected with whatever threatens the destruction of either; but as we were not made to acquiesce in life and health, the simple enjoyment of them is not attended with any real pleasure, lest satisfied with that, we should give ourselves over to indolence and inaction. On the other hand, the generation of mankind is a great purpose, and it is requisite that men should be animated to the pursuit of it by some great incentive. It is therefore attended with a very high pleasure; but as it is by no means designed to be our constant business, it is not fit that the absence of this pleasure should be attended with any considerable pain. The difference between men and brutes in this point, seems to be remarkable. Men are at all times pretty equally disposed to the pleasures of love, because they are to be guided by reason in the time and manner of indulging them. Had any great pain arisen from the want of this satisfaction, reason, I am afraid, would find great difficulties in the performance of its office. But brutes who obey laws, in the execution of which their own reason has but little share, have their stated seasons; at such times it is not improbable that the sensation from the want is very troublesome, because the end must be then answered, or be missed in many, perhaps for ever; as the inclination returns only with its season.

SECTION X
Of BEAUTY

The passion which belongs to generation, merely as such, is
lust only; this is evident in brutes, whose passions are more un-
mixed, and which pursue their purposes more directly than
ours. The only distinction they observe with regard to their
mates, is that of sex. It is true, that they stick severally to their
own species in preference to all others. But this preference, I
imagine, does not arise from any sense of beauty which they
find in their species, as Mr. Addison supposes,* but from
a law of some other kind to which they are subject; and this
we may fairly conclude, from their apparent want of choice
amongst those objects to which the barriers of their species
have confined them. But man, who is a creature adapted
to a greater variety and intricacy of relation, connects with
the general passion, the idea of some *social* qualities, which
direct and heighten the appetite which he has in common
with all other animals; and as he is not designed like them
to live at large, it is fit that he should have something to
create a preference, and fix his choice; and this in general
should be some sensible quality; as no other can so quickly, so
powerfully, or so surely produce its effect. The object therefore
of this mixed passion which we call love, is the *beauty* of the *sex*.
Men are carried to the sex in general, as it is the sex, and by the
common law of nature; but they are attached to particulars by
personal *beauty*. I call beauty a social quality; for where women
and men, and not only they, but when other animals give us a
sense of joy and pleasure in beholding them, (and there are
many that do so) they inspire us with sentiments of tenderness
and affection towards their persons; we like to have them near
us, and we enter willingly into a kind of relation with them,
unless we should have strong reasons to the contrary. But to
what end, in many cases, this was designed, I am unable to
discover; for I see no greater reason for a connection between
man and several animals who are attired in so engaging a
manner, than between him and some others who entirely want
this attraction, or possess it in a far weaker degree. But it is

probable, that providence did not make even this distinction, but with a view to some great end, though we cannot perceive distinctly what it is, as his wisdom is not our wisdom, nor our ways his ways.

SECTION XI
SOCIETY and SOLITUDE

The second branch of the social passions, is that which administers to *society in general*. With regard to this, I observe, that society, merely as society, without any particular heightenings, gives us no positive pleasure in the enjoyment; but absolute and entire *solitude*, that is, the total and perpetual exclusion from all society, is as great a positive pain as can almost be conceived. Therefore in the balance between the pleasure of general *society*, and the pain of absolute solitude, *pain* is the predominant idea. But the pleasure of any particular social enjoyment outweighs very considerably the uneasiness caused by the want of that particular enjoyment; so that the strongest sensation, relative to the habitudes of *particular society*, are sensations of pleasure. Good company, lively conversations, and the endearments of friendship, fill the mind with great pleasure; a temporary solitude on the other hand, is itself agreeable. This may perhaps prove, that we are creatures designed for contemplation as well as action; since solitude as well as society has its pleasures; as from the former observation we may discern, that an entire life of solitude contradicts the purposes of our being, since death itself is scarcely an idea of more terror.

SECTION XII
SYMPATHY, IMITATION, and AMBITION

Under this denomination of society, the passions are of a complicated kind, and branch out into a variety of forms agreeable to that variety of ends they are to serve in the great chain of society. The three principal links in this chain are *sympathy*, *imitation*, and *ambition*.

SECTION XIII
SYMPATHY

It is by the first of these passions that we enter into the concerns of others; that we are moved as they are moved, and are never suffered to be indifferent spectators of almost any thing which men can do or suffer. For sympathy must be considered as a sort of substitution, by which we are put into the place of another man, and affected in many respects as he is affected; so that this passion may either partake of the nature of those which regard self-preservation, and turning upon pain may be a source of the sublime; or it may turn upon ideas of pleasure; and then, whatever has been said of the social affections, whether they regard society in general, or only some particular modes of it, may be applicable here. It is by this principle chiefly that poetry, painting, and other affecting arts, transfuse their passions from one breast to another, and are often capable of grafting a delight on wretchedness, misery, and death itself. It is a common observation, that objects which in the reality would shock, are in tragical, and such like representations, the source of a very high species of pleasure. This taken as a fact, has been the cause of much reasoning.* The satisfaction has been commonly attributed, first, to the comfort we receive in considering that so melancholy a story is no more than a fiction; and next, to the contemplation of our own freedom from the evils which we see represented. I am afraid it is a practice much too common in inquiries of this nature, to attribute the cause of feelings which merely arise from the mechanical structure of our bodies, or from the natural frame and constitution of our minds, to certain conclusions of the reasoning faculty on the objects presented to us; for I should imagine, that the influence of reason in producing our passions is nothing near so extensive as it is commonly believed.

SECTION XIV

The effects of SYMPATHY in the
distresses of others

To examine this point concerning the effect of tragedy in a
proper manner, we must previously consider, how we are
affected by the feelings of our fellow creatures in circumstances
of real distress. I am convinced we have a degree of delight,
and that no small one, in the real misfortunes and pains of
others; for let the affection be what it will in appearance, if it
does not make us shun such objects, if on the contrary it
induces us to approach them, if it makes us dwell upon them,
in this case I conceive we must have a delight or pleasure of
some species or other in contemplating objects of this kind. Do
we not read the authentic histories of scenes of this nature with
as much pleasure as romances or poems, where the incidents
are fictitious? The prosperity of no empire, nor the grandeur
of no king, can so agreeably affect in the reading, as the ruin
of the state of Macedon, and the distress of its unhappy prince. *
Such a catastrophe touches us in history as much as the
destruction of Troy does in fable.* Our delight in cases of this
kind, is very greatly heightened, if the sufferer be some excellent
person who sinks under an unworthy fortune. Scipio and Cato
are both virtuous characters;* but we are more deeply affected
by the violent death of the one, and the ruin of the great cause
he adhered to, than with the deserved triumphs and uninter-
rupted prosperity of the other; for terror is a passion which
always produces delight when it does not press too close, and
pity is a passion accompanied with pleasure, because it arises
from love and social affection. Whenever we are formed by
nature to any active purpose, the passion which animates us to
it, is attended with delight, or a pleasure of some kind, let the
subject matter be what it will; and as our Creator has designed
we should be united by the bond of sympathy, he has strength-
ened that bond by a proportionable delight; and there most
where our sympathy is most wanted, in the distresses of others.
If this passion was simply painful, we would shun with the
greatest care all persons and places that could excite such a

passion; as, some who are so far gone in indolence as not to endure any strong impression actually do. But the case is widely different with the greater part of mankind; there is no spectacle we so eagerly pursue, as that of some uncommon and grievous calamity; so that whether the misfortune is before our eyes, or whether they are turned back to it in history, it always touches with delight. This is not an unmixed delight, but blended with no small uneasiness. The delight we have in such things, hinders us from shunning scenes of misery; and the pain we feel, prompts us to relieve ourselves in relieving those who suffer; and all this antecedent to any reasoning, by an instinct that works us to its own purposes, without our concurrence.

SECTION XV

Of the effects of TRAGEDY

It is thus in real calamities. In imitated distresses the only difference is the pleasure resulting from the effects of imitation; for it is never so perfect, but we can perceive it is an imitation, and on that principle are somewhat pleased with it. And indeed in some cases we derive as much or more pleasure from that source than from the thing itself. But then I imagine we shall be much mistaken if we attribute any considerable part of our satisfaction in tragedy to a consideration that tragedy is a deceit, and its representations no realities. The nearer it approaches the reality, and the further it removes us from all idea of fiction, the more perfect is its power. But be its power of what kind it will, it never approaches to what it represents. Chuse a day on which to represent the most sublime and affecting tragedy we have; appoint the most favourite actors; spare no cost upon the scenes and decorations; unite the greatest efforts of poetry, painting and music; and when you have collected your audience, just at the moment when their minds are erect with expectation, let it be reported that a state criminal of high rank is on the point of being executed in the adjoining square; in a moment the emptiness of the theatre would demonstrate the comparative weakness of the imitative arts, and proclaim the triumph of the real sympathy. I believe

43

that this notion of our having a simple pain in the reality, yet a delight in the representation, arises from hence, that we do not sufficiently distinguish what we would by no means chuse to do, from what we should be eager enough to see if it was once done. We delight in seeing things, which so far from doing, our heartiest wishes would be to see redressed. This noble capital, the pride of England and of Europe, I believe no man is so strangely wicked as to desire to see destroyed by a conflagration or an earthquake, though he should be removed himself to the greatest distance from the danger. But suppose such a fatal accident to have happened, what numbers from all parts would croud to behold the ruins, and amongst them many who would have been content never to have seen London in its glory? Nor is it either in real or fictitious distresses, our immunity from them which produces our delight; in my own mind I can discover nothing like it. I apprehend that this mistake is owing to a sort of sophism, by which we are frequently imposed upon; it arises from our not distinguishing between what is indeed a necessary condition to our doing or suffering any thing in general, and what is the *cause* of some particular act. If a man kills me with a sword, it is a necessary condition to this that we should have been both of us alive before the fact; and yet it would be absurd to say, that our being both living creatures was the cause of his crime and of my death. So it is certain, that it is absolutely necessary my life should be out of any imminent hazard before I can take a delight in the sufferings of others, real or imaginary, or indeed in any thing else from any cause whatsoever. But then it is a sophism to argue from thence, that this immunity is the cause of my delight either on these or on any occasions. No one can distinguish such a cause of satisfaction in his own mind I believe; nay when we do not suffer any very acute pain, nor are exposed to any imminent danger of our lives, we can feel for others, whilst we suffer ourselves; and often then most when we are softened by affliction; we see with pity even distresses which we would accept in the place of our own.

44

SECTION XVI
IMITATION

The second passion belonging to society is imitation, or, if you will, a desire of imitating, and consequently a pleasure in it. This passion arises from much the same cause with sympathy. For as sympathy makes us take a concern in whatever men feel, so this affection prompts us to copy whatever they do; and consequently we have a pleasure in imitating, and in whatever belongs to imitation merely as it is such, without any intervention of the reasoning faculty, but solely from our natural constitution, which providence has framed in such a manner as to find either pleasure or delight according to the nature of the object, in whatever regards the purposes of our being. It is by imitation far more than by precept that we learn every thing; and what we learn thus we acquire not only more effectually, but more pleasantly. This forms our manners, our opinions, our lives. It is one of the strongest links of society; it is a species of mutual compliance which all men yield to each other, without constraint to themselves, and which is extremely flattering to all. Herein it is that painting and many other agreeable arts have laid one of the principal foundations of their power. And since by its influence on our manners and our passions it is of such great consequence, I shall here venture to lay down a rule, which may inform us with a good degree of certainty when we are to attribute the power of the arts, to imitation, or to our pleasure in the skill of the imitator merely, and when to sympathy, or some other cause in conjunction with it. When the object represented in poetry or painting is such, as we could have no desire of seeing in the reality; then I may be sure that its power in poetry or painting is owing to the power of imitation, and to no cause operating in the thing itself. So it is with most of the pieces which the painters call still life. In these a cottage, a dunghill, the meanest and most ordinary utensils of the kitchen, are capable of giving us pleasure. But when the object of the painting or poem is such as we should run to see if real, let it affect us with what odd sort of sense it will, we may rely upon it, that the power of the poem or picture is more owing to the nature of the thing

45

itself than to the mere effect of imitation, or to a consideration of the skill of the imitator however excellent. Aristotle has spoken so much and so solidly upon the force of imitation in his poetics, that it makes any further discourse upon this subject the less necessary. *

SECTION XVII
AMBITION

Although imitation is one of the great instruments used by providence in bringing our nature towards its perfection, yet if men gave themselves up to imitation entirely, and each followed the other, and so on in an eternal circle, it is easy to see that there never could be any improvement amongst them. Men must remain as brutes do, the same at the end that they are at this day, and that they were in the beginning of the world. To prevent this, God has planted in man a sense of ambition, and a satisfaction arising from the contemplation of his excelling his fellows in something deemed valuable amongst them. It is this passion that drives men to all the ways we see in use of signalizing themselves, and that tends to make whatever excites in a man the idea of this distinction so very pleasant. It has been so strong as to make very miserable men take comfort that they were supreme in misery; and certain it is, that where we cannot distinguish ourselves by something excellent, we begin to take a complacency in some singular infirmities, follies, or defects of one kind or other. It is on this principle that flattery is so prevalent; for flattery is no more than what raises in a man's mind an idea of a preference which he has not. Now whatever either on good or upon bad grounds tends to raise a man in his own opinion, produces a sort of swelling and triumph that is extremely grateful to the human mind; and this swelling is never more perceived, nor operates with more force, than when without danger we are conversant with terrible objects, the mind always claiming to itself some part of the dignity and importance of the things which it contemplates. Hence proceeds what Longinus has observed of that glorying and sense of inward greatness, that always fills the reader of

46

such passages in poets and orators as are sublime;* it is what every man must have felt in himself upon such occasions.

SECTION XVIII
The RECAPITULATION

To draw the whole of what has been said into a few distinct points. The passions which belong to self-preservation, turn on pain and danger; they are simply painful when their causes immediately affect us; they are delightful when we have an idea of pain and danger, without being actually in such circumstances; this delight I have not called pleasure, because it turns on pain, and because it is different enough from any idea of positive pleasure. Whatever excites this delight, I call *sublime*. The passions belonging to self-preservation are the strongest of all the passions.

The second head to which the passions are referred with relation to their final cause, is society. There are two sorts of societies. The first is, the society of sex. The passion belonging to this is called love, and it contains a mixture of lust; its object is the beauty of women. The other is the great society with man and all other animals. The passion subservient to this is called likewise love, but it has no mixture of lust, and its object is beauty; which is a name I shall apply to all such qualities in things as induce in us a sense of affection and tenderness, or some other passion the most nearly resembling these. The passion of love has its rise in positive pleasure; it is, like all things which grow out of pleasure, capable of being mixed with a mode of uneasiness, that is, when an idea of its object is excited in the mind with an idea at the same time of having irretrievably lost it. This mixed sense of pleasure I have not called *pain*, because it turns upon actual pleasure, and because it is both in its cause and in most of its effects of a nature altogether different.

Next to the general passion we have for society, to a choice in which we are directed by the pleasure we have in the object, the particular passion under this head called sympathy has the greatest extent. The nature of this passion is to put us in the place of another in whatever circumstance he is in, and to

affect us in a like manner; so that this passion may, as the occasion requires, turn either on pain or pleasure; but with the modifications mentioned in some cases in section 11. As to imitation and preference nothing more need be said.

SECTION XIX
The CONCLUSION

I believed that an attempt to range and methodize some of our most leading passions, would be a good preparative to such an enquiry as we are going to make in the ensuing discourse. The passions I have mentioned are almost the only ones which it can be necessary to consider in our present design; though the variety of the passions is great, and worthy in every branch of that variety of an attentive investigation. The more accurately we search into the human mind, the stronger traces we every where find of his wisdom who made it. If a discourse on the use of the parts of the body may be considered as an hymn to the Creator; the use of the passions, which are the organs of the mind, cannot be barren of praise to him, nor unproductive to ourselves of that noble and uncommon union of science and admiration, which a contemplation of the works of infinite wisdom alone can afford to a rational mind; whilst referring to him whatever we find of right, or good, or fair in ourselves, discovering his strength and wisdom even in our own weakness and imperfection, honouring them where we discover them clearly, and adoring their profundity where we are lost in our search, we may be inquisitive without impertinence, and elevated without pride; we may be admitted, if I may dare to say so, into the counsels of the Almighty by a consideration of his works. The elevation of the mind ought to be the principal end of all our studies, which if they do not in some measure effect, they are of very little service to us. But besides this great purpose, a consideration of the rationale of our passions seems to me very necessary for all who would affect them upon solid and sure principles. It is not enough to know them in general; to affect them after a delicate manner, or to judge properly of any work designed to affect them, we should know the exact boundaries of their several jurisdictions; we should pursue them

through all their variety of operations, and pierce into the inmost, and what might appear inaccessible parts of our nature,

Quod latet arcanâ non enarrabile fibrâ. *

Without all this it is possible for a man after a confused manner sometimes to satisfy his own mind of the truth of his work; but he can never have a certain determinate rule to go by, nor can he ever make his propositions sufficiently clear to others. Poets, and orators, and painters, and those who cultivate other branches of the liberal arts, have without this critical knowledge succeeded well in their several provinces, and will succeed; as among artificers there are many machines made and even invented without any exact knowledge of the principles they are governed by. It is, I own, not uncommon to be wrong in theory and right in practice; and we are happy that it is so. Men often act right from their feelings, who afterwards reason but ill on them from principle; but as it is impossible to avoid an attempt at such reasoning, and equally impossible to prevent its having some influence on our practice, surely it is worth taking some pains to have it just, and founded on the basis of sure experience. We might expect that the artists themselves would have been our surest guides; but the artists have been too much occupied in the practice; the philosophers have done little, and what they have done, was mostly with a view to their own schemes and systems; and as for those called critics, they have generally sought the rule of the arts in the wrong place; they sought it among poems, pictures, engravings, statues and buildings. But art can never give the rules that make an art. This is, I believe, the reason why artists in general, and poets principally, have been confined in so narrow a circle; they have been rather imitators of one another than of nature; and this with so faithful an uniformity, and to so remote an antiquity, that it is hard to say who gave the first model. Critics follow them, and therefore can do little as guides. I can judge but poorly of any thing whilst I measure it by no other standard than itself. The true standard of the arts is in every man's power; and an easy observation of the most common, sometimes of the meanest things in nature, will give the truest

lights, where the greatest sagacity and industry that slights such observation, must leave us in the dark, or what is worse, amuse and mislead us by false lights. In an enquiry, it is almost every thing to be once in a right road. I am satisfied I have done but little by these observations considered in themselves; and I never should have taken the pains to digest them, much less should I have ever ventured to publish them, if I was not convinced that nothing tends more to the corruption of science than to suffer it to stagnate. These waters must be troubled before they can exert their virtues. A man who works beyond the surface of things, though he may be wrong himself, yet he clears the way for others, and may chance to make even his errors subservient to the cause of truth. In the following parts I shall enquire what things they are that cause in us the affections of the sublime and beautiful, as in this I have considered the affections themselves. I only desire one favour; that no part of this discourse may be judged of by itself and independently of the rest; for I am sensible I have not disposed my materials to abide the test of a captious controversy, but of a sober and even forgiving examination; that they are not armed at all points for battle; but dressed to visit those who are willing to give a peaceful entrance to truth.

The end of the First Part.

A
PHILOSOPHICAL ENQUIRY
INTO THE ORIGIN
OF OUR IDEAS
OF THE SUBLIME
AND BEAUTIFUL

Part Two

A
PHILOSOPHICAL ENQUIRY
INTO THE ORIGIN
OF OUR IDEAS
OF THE SUBLIME
AND BEAUTIFUL

Part Two

SECTION I

Of the passion caused by the SUBLIME

THE passion caused by the great and sublime in *nature*, when those causes operate most powerfully, is Astonishment; and astonishment is that state of the soul, in which all its motions are suspended, with some degree of horror.[1] In this case the mind is so entirely filled with its object, that it cannot entertain any other, nor by consequence reason on that object which employs it. Hence arises the great power of the sublime, that far from being produced by them, it anticipates our reasonings, and hurries us on by an irresistible force. Astonishment, as I have said, is the effect of the sublime in its highest degree; the inferior effects are admiration, reverence and respect.

SECTION II

TERROR

No passion so effectually robs the mind of all its powers of acting and reasoning as fear. [2]For fear being an apprehension of pain or death, it operates in a manner that resembles actual pain. Whatever therefore is terrible, with regard to sight, is sublime too, whether this cause of terror, be endued with greatness of dimensions or not; for it is impossible to look on any thing as trifling, or contemptible, that may be dangerous. There are many animals, who though far from being large, are yet capable of raising ideas of the sublime, because they are considered as objects of terror. As serpents and poisonous animals of almost all kinds. And to things of great dimensions, if we annex an adventitious idea of terror, they become without comparison greater. A level plain of a vast extent on land, is certainly no mean idea; the prospect of such a plain may be as extensive as a prospect of the ocean; but can it ever fill the mind with any thing so great as the ocean itself? This is owing

[1] Part 1, sections 3, 4, 7 [2] Part 4, sections 3, 4, 5, 6.

to several causes, but it is owing to none more than this, that the ocean is an object of no small terror. Indeed terror is in all cases whatsoever, either more openly or latently the ruling principle of the sublime. Several languages bear a strong testimony to the affinity of these ideas. They frequently use the same word, to signify indifferently the modes of astonishment or admiration and those of terror. Θάμβος is in greek, either fear or wonder; δεινός is terrible or respectable; αἰδέω, to reverence or to fear. *Vereor* in latin, is what αἰδέω is in greek. The Romans used the verb *stupeo*, a term which strongly marks the state of an astonished mind, to express the effect either of simple fear, or of astonishment; the word *attonitus*, (thunderstruck) is equally expressive of the alliance of these ideas; and do not the french *etonnement*, and the english *astonishment* and *amazement*, point out as clearly the kindred emotions which attend fear and wonder? They who have a more general knowledge of languages, could produce, I make no doubt, many other and equally striking examples.

SECTION III

OBSCURITY

To make any thing very terrible, obscurity[1] seems in general to be necessary. When we know the full extent of any danger, when we can accustom our eyes to it, a great deal of the apprehension vanishes. Every one will be sensible of this, who considers how greatly night adds to our dread, in all cases of danger, and how much the notions of ghosts and goblins, of which none can form clear ideas, affect minds, which give credit to the popular tales concerning such sorts of beings. Those despotic governments, which are founded on the passions of men, and principally upon the passion of fear, keep their chief as much as may be from the public eye. The policy has been the same in many cases of religion. Almost all the heathen temples were dark. Even in the barbarous temples of the

[1] Part 4, sections 14, 15, 16.

Americans at this day, they keep their idol in a dark part of the hut, which is consecrated to his worship. For this purpose too the druids performed all their ceremonies in the bosom of the darkest woods, and in the shade of the oldest and most spreading oaks. No person seems better to have understood the secret of heightening, or of setting terrible things, if I may use the expression, in their strongest light by the force of a judicious obscurity, than Milton. His description of Death in the second book is admirably studied; it is astonishing with what a gloomy pomp, with what a significant and expressive uncertainty of strokes and colouring he has finished the portrait of the king of terrors.

> *The other shape,*
> *If shape it might be called that shape had none*
> *Distinguishable, in member, joint, or limb;*
> *Or substance might be called that shadow seemed,*
> *For each seemed either; black he stood as night;*
> *Fierce as ten furies; terrible as hell;*
> *And shook a deadly dart. What seemed his head*
> *The likeness of a kingly crown had on.* *

In this description all is dark, uncertain, confused, terrible, and sublime to the last degree.

SECTION IV

Of the difference between CLEARNESS and OBSCURITY with regard to the passions

It is one thing to make an idea clear, and another to make it *affecting* to the imagination. If I make a drawing of a palace, or a temple, or a landscape, I present a very clear idea of those objects; but then (allowing for the effect of imitation which is something) my picture can at most affect only as the palace, temple, or landscape would have affected in the reality. On the other hand, the most lively and spirited verbal description I can give, raises a very obscure and imperfect *idea* of such objects; but then it is in my power to raise a stronger *emotion* by the description than I could do by the best painting. This

experience constantly evinces. The proper manner of conveying the *affections* of the mind from one to another, is by words; there is a great insufficiency in all other methods of communication; 'and so far is a clearness of imagery from being absolutely necessary to an influence upon the passions, that they may be considerably operated upon without presenting any image at all, by certain sounds adapted to that purpose; of which we have a sufficient proof in the acknowledged and powerful effects of instrumental music. In reality a great clearness helps but little towards affecting the passions, as it is in some sort an enemy to all enthusiasms whatsoever.

SECTION [IV]

The same subject continued

There are two verses in Horace's art of poetry that seem to contradict this opinion, for which reason I shall take a little more pains in clearing it up. The verses are,

> *Segnius inritant animos demissa per aurem*
> *Quam quæ sunt oculis subjecta fidelibus.**

On this the abbe du Bos founds a criticism,* wherein he gives painting the preference to poetry in the article of moving the passions; principally on account of the greater *clearness* of the ideas it represents. I believe this excellent judge was led into this mistake (if it be a mistake) by his system, to which he found it more conformable than I imagine it will be found to experience. I know several who admire and love painting, and yet who regard the objects of their admiration in that art, with coolness enough, in comparison of that warmth with which they are animated by affecting pieces of poetry or rhetoric. Among the common sort of people, I never could perceive that painting had much influence on their passions. It is true that the best sorts of painting, as well as the best sorts of poetry, are not much understood in that sphere. But it is most certain, that their passions are very strongly roused by a fanatic preacher, or by the ballads of Chevy-chase,* or the children in the wood, and by other little popular poems and tales that are current

in that rank of life. I do not know of any paintings, bad or good, that produce the same effect. So that poetry with all its obscurity, has a more general as well as a more powerful dominion over the passions than the other art. And I think there are reasons in nature why the obscure idea, when properly conveyed, should be more affecting than the clear. It is our ignorance of things that causes all our admiration, and chiefly excites our passions. Knowledge and acquaintance make the most striking causes affect but little. It is thus with the vulgar, and all men are as the vulgar in what they do not understand. The ideas of eternity, and infinity, are among the most affecting we have, and yet perhaps there is nothing of which we really understand so little, as of infinity and eternity. We do not any where meet a more sublime description than this justly celebrated one of Milton, wherein he gives the portrait of Satan with a dignity so suitable to the subject.

> He above the rest
> In shape and gesture proudly eminent
> Stood like a tower; his form had yet not lost
> All her original brightness, nor appeared
> Less than archangel ruin'd, and th' excess
> Of glory obscured: as when the sun new ris'n
> Looks through the horizontal misty air
> Shorn of his beams; or from behind the moon
> In dim eclipse disastrous twilight sheds
> On half the nations; and with fear of change
> Perplexes monarchs.*

Here is a very noble picture; and in what does this poetical picture consist? in images of a tower, an archangel, the sun rising through mists, or in an eclipse, the ruin of monarchs, and the revolutions of kingdoms. The mind is hurried out of itself, by a croud of great and confused images; which affect because they are crouded and confused. For separate them, and you lose much of the greatness, and join them, and you infallibly lose the clearness. The images raised by poetry are always of this obscure kind; though in general the effects of poetry, are by no means to be attributed to the images it raises; which point we shall examine more at large hereafter.[1] But painting,

[1] Part 5.

when we have allowed for the pleasure of imitation, can only affect simply by the images it presents; and even in painting a judicious obscurity in some things contributes to the effect of the picture; because the images in painting are exactly similar to those in nature; and in nature dark, confused, uncertain images have a greater power on the fancy to form the grander passions than those have which are more clear and determinate. But where and when this observation may be applied to practice, and how far it shall be extended, will be better deduced from the nature of the subject, and from the occasion, than from any rules that can be given.

I am sensible that this idea has met with opposition, and is likely still to be rejected by several.* But let it be considered that hardly any thing can strike the mind with its greatness, which does not make some sort of approach towards infinity; which nothing can do whilst we are able to perceive its bounds; but to see an object distinctly, and to perceive its bounds, is one and the same thing. A clear idea is therefore another name for a little idea. There is a passage in the book of Job amazingly sublime, and this sublimity is principally due to the terrible uncertainty of the thing described. *In thoughts from the visions of the night, when deep sleep falleth upon men, fear came upon me and trembling, which made all my bones to shake. Then a spirit passed before my face. The hair of my flesh stood up. It stood still, but I could not discern the form thereof; an image was before mine eyes; there was silence; and I heard a voice,—Shall mortal man be more just than God?* We are first prepared with the utmost solemnity for the vision; we are first terrified, before we are let even into the obscure cause of our emotion; but when this grand cause of terror makes its appearance, what is it? is it not, wrapt up in the shades of its own incomprehensible darkness, more aweful, more striking, more terrible, than the liveliest description, than the clearest painting could possibly represent it? When painters have attempted to give us clear representations of these very fanciful and terrible ideas, they have I think almost always failed; insomuch that I have been at a loss, in all the pictures I have seen of hell, whether the painter did not intend something ludicrous. Several painters have handled a subject of this kind, with a view of assembling as many horrid phantoms as their

imagination could suggest; but all the designs I have chanced
to meet of the temptations of St. Anthony,* were rather a sort
of odd wild grotesques, than any thing capable of producing a
serious passion. In all these subjects poetry is very happy. Its
apparitions, its chimeras, its harpies, its allegorical figures, are
grand and affecting; and though Virgil's Fame,* and Homer's
Discord,* are obscure, they are magnificent figures. These
figures in painting would be clear enough, but I fear they
might become ridiculous.

SECTION V
POWER

Besides these things which *directly* suggest the idea of danger,
and those which produce a similar effect from a mechanical
cause, I know of nothing sublime which is not some modification
of power. And this branch rises as naturally as the other two
branches, from terror, the common stock of every thing that is
sublime. The idea of power at first view, seems of the class of
these indifferent ones, which may equally belong to pain or to
pleasure. But in reality, the affection arising from the idea of
vast power, is extremely remote from that neutral character.
For first, we must remember,[1] that the idea of pain, in its
highest degree, is much stronger than the highest degree of
pleasure; and that it preserves the same superiority through all
the subordinate gradations. From hence it is, that where the
chances for equal degrees of suffering or enjoyment are in any
sort equal, the idea of the suffering must always be prevalent.
And indeed the ideas of pain, and above all of death, are so
very affecting, that whilst we remain in the presence of what-
ever is supposed to have the power of inflicting either, it is
impossible to be perfectly free from terror. Again, we know by
experience, that for the enjoyment of pleasure, no great efforts
of power are at all necessary; nay we know, that such efforts

[1] Part 1, section 7.

would go a great way towards destroying our satisfaction: for pleasure must be stolen, and not forced upon us; pleasure follows the will; and therefore we are generally affected with it by many things of a force greatly inferior to our own. But pain is always inflicted by a power in some way superior, because we never submit to pain willingly. So that strength, violence, pain and terror, are ideas that rush in upon the mind together. Look at a man, or any other animal of prodigious strength, and what is your idea before reflection? Is it that this strength will be subservient to you, to your ease, to your pleasure, to your interest in any sense? No; the emotion you feel is, lest this enormous strength should be employed to the purposes of [1] rapine and destruction. That power derives all its sublimity from the terror with which it is generally accompanied, will appear evidently from its effect in the very few cases, in which it may be possible to strip a considerable degree of strength of its ability to hurt. When you do this, you spoil it of every thing sublime, and it immediately becomes contemptible. An ox is a creature of vast strength; but he is an innocent creature, extremely serviceable, and not at all dangerous; for which reason the idea of an ox is by no means grand. A bull is strong too; but his strength is of another kind; often very destructive, seldom (at least amongst us) of any use in our business; the idea of a bull is therefore great, and it has frequently a place in sublime descriptions, and elevating comparisons. Let us look at another strong animal in the two distinct lights in which we may consider him. The horse in the light of an useful beast, fit for the plough, the road, the draft, in every social useful light the horse has nothing of the sublime; but is it thus that we are affected with him, *whose neck is cloathed with thunder, the glory of whose nostrils is terrible, who swalloweth the ground with fierceness and rage, neither believeth that it is the sound of the trumpet?*[*] In this description the useful character of the horse entirely disappears, and the terrible and sublime blaze out together. We have continually about us animals of a strength that is considerable, but not pernicious. Amongst these we never look for the sublime: it comes upon us in the gloomy forest, and in the

howling wilderness, in the form of the lion, the tiger, the panther, or rhinoceros. Whenever strength is only useful, and employed for our benefit or our pleasure, then it is never sublime; for nothing can act agreeably to us, that does not act in conformity to our will; but to act agreeably to our will, it must be subject to us; and therefore can never be the cause of a grand and commanding conception. The description of the wild ass, in Job, is worked up into no small sublimity, merely by insisting on his freedom, and his setting mankind at defiance; otherwise the description of such an animal could have had nothing noble in it. *Who hath loosed* (says he) *the bands of the wild ass? whose house I have made the wilderness, and the barren land his dwellings. He scorneth the multitude of the city, neither regardeth he the voice of the driver. The range of the mountains is his pasture.* The magnificent description of the unicorn and of leviathan in the same book, is full of the same heightening circumstances. *Will the unicorn be willing to serve thee? canst thou bind the unicorn with his band in the furrow? wilt thou trust him because his strength is great?——Canst thou draw out leviathan with an hook? will he make a covenant with thee? wilt thou take him for a servant for ever? shall not one be cast down even at the sight of him?** In short, wheresoever we find strength, and in what light soever we look upon power, we shall all along observe the sublime the concomitant of terror, and contempt the attendant on a strength that is subservient and innoxious. The race of dogs in many of their kinds, have generally a competent degree of strength and swiftness; and they exert these, and other valuable qualities which they possess, greatly to our convenience and pleasure. Dogs are indeed the most social, affectionate, and amiable animals of the whole brute creation; but love approaches much nearer to contempt than is commonly imagined; and accordingly, though we caress dogs, we borrow from them an appellation of the most despicable kind, when we employ terms of reproach; and this appellation is the common mark of the last vileness and contempt in every language. Wolves have not more strength than several species of dogs; but on account of their unmanageable fierceness, the idea of a wolf is not despicable; it is not excluded from grand descriptions and similitudes. Thus we are affected by strength, which is *natural*

power. The power which arises from institution in kings and commanders, has the same connection with terror. Sovereigns are frequently addressed with the title of *dread majesty*. And it may be observed, that young persons little acquainted with the world, and who have not been used to approach men in power, are commonly struck with an awe which takes away the free use of their faculties. *When I prepared my seat in the street* (says Job) *the young men saw me, and hid themselves.** Indeed so natural is this timidity with regard to power, and so strongly does it inhere in our constitution, that very few are able to conquer it, but by mixing much in the business of the great world, or by using no small violence to their natural dispositions. I know some people are of opinion, that no awe, no degree of terror, accompanies the idea of power, and have hazarded to affirm, that we can contemplate the idea of God himself without any such emotion.* I purposely avoided when I first considered this subject, to introduce the idea of that great and tremendous being, as an example in an argument so light as this; though it frequently occurred to me, not as an objection to, but as a strong confirmation of my notions in this matter. I hope, in what I am going to say, I shall avoid presumption, where it is almost impossible for any mortal to speak with strict propriety. I say then, that whilst we consider the Godhead merely as he is an object of the understanding, which forms a complex idea of power, wisdom, justice, goodness, all stretched to a degree far exceeding the bounds of our comprehension, whilst we consider the divinity in this refined and abstracted light, the imagination and passions are little or nothing affected. But because we are bound by the condition of our nature to ascend to these pure and intellectual ideas, through the medium of sensible images, and to judge of these divine qualities by their evident acts and exertions, it becomes extremely hard to disentangle our idea of the cause from the effect by which we are led to know it. Thus when we contemplate the Deity, his attributes and their operation coming united on the mind, form a sort of sensible image, and as such are capable of affecting the imagination. Now, though in a just idea of the Deity, perhaps none of his attributes are predominant, yet to our imagination, his power is by far the most striking. Some

reflection, some comparing is necessary to satisfy us of his wisdom, his justice, and his goodness; to be struck with his power, it is only necessary that we should open our eyes. But whilst we contemplate so vast an object, under the arm, as it were, of almighty power, and invested upon every side with omnipresence, we shrink into the minuteness of our own nature, and are, in a manner, annihilated before him. And though a consideration of his other attributes may relieve in some measure our apprehensions; yet no conviction of the justice with which it is exercised, nor the mercy with which it is tempered, can wholly remove the terror that naturally arises from a force which nothing can withstand. If we rejoice, we rejoice with trembling; and even whilst we are receiving benefits, we cannot but shudder at a power which can confer benefits of such mighty importance. When the prophet David contemplated the wonders of wisdom and power, which are displayed in the œconomy of man, he seems to be struck with a sort of divine horror, and cries out, *fearfully and wonderfully am I made!** An heathen poet has a sentiment of a similar nature; Horace looks upon it as the last effort of philosophical fortitude, to behold without terror and amazement, this immense and glorious fabric of the universe.

> *Hunc solem, et stellas, et decedentia certis*
> *Tempora momentis, sunt qui formidine nulla*
> *Imbuti spectent.**

Lucretius is a poet not to be suspected of giving way to superstitious terrors; yet when he supposes the whole mechanism of nature laid open by the master of his philosophy, his transport on this magnificent view which he has represented in the colours of such bold and lively poetry, is overcast with a shade of secret dread and horror.

> *His tibi me rebus quædam Divina voluptas*
> *Percipit, adque horror, quod sic Natura tua vi*
> *Tam manifesta patet ex omni parte retecta.**

But the scripture alone can supply ideas answerable to the majesty of this subject. In the scripture, wherever God is represented as appearing or speaking, every thing terrible in

nature is called up to heighten the awe and solemnity of the divine presence. The psalms, and the prophetical books, are crouded with instances of this kind. *The earth shook* (says the psalmist) *the heavens also dropped at the presence of the Lord.** And what is remarkable, the painting preserves the same character, not only when he is supposed descending to take vengeance upon the wicked, but even when he exerts the like plenitude of power in acts of beneficence to mankind. *Tremble, thou earth! at the presence of the Lord; at the presence of the God of Jacob; which turned the rock into standing water, the flint into a fountain of waters!* * It were endless to enumerate all the passages both in the sacred and profane writers, which establish the general sentiment of mankind, concerning the inseparable union of a sacred and reverential awe, with our ideas of the divinity. Hence the common maxim, *primos in orbe deos fecit timor.** This maxim may be, as I believe it is, false with regard to the origin of religion. The maker of the maxim saw how inseparable these ideas were, without considering that the notion of some great power must be always precedent to our dread of it. But this dread must necessarily follow the idea of such a power, when it is once excited in the mind. It is on this principle that true religion has, and must have, so large a mixture of salutary fear; and that false religions have generally nothing else but fear to support them. Before the christian religion had, as it were, humanized the idea of the divinity, and brought it somewhat nearer to us, there was very little said of the love of God. The followers of Plato have something of it, and only something. The other writers of pagan antiquity, whether poets or philosophers, nothing at all. And they who consider with what infinite attention, by what a disregard of every perishable object, through what long habits of piety and contemplation it is, any man is able to attain an entire love and devotion to the Deity, will easily perceive, that it is not the first, the most natural, and the most striking effect which proceeds from that idea. Thus we have traced power through its several gradations unto the highest of all, where our imagination is finally lost; and we find terror quite throughout the progress, its inseparable companion, and growing along with it, as far as we can possibly trace them. Now as power is un-

doubtedly a capital source of the sublime, this will point out evidently from whence its energy is derived, and to what class of ideas we ought to unite it.

SECTION VI

PRIVATION

All *general* privations are great, because they are all terrible; *Vacuity, Darkness, Solitude* and *Silence*. With what a fire of imagination, yet with what severity of judgment, has Virgil amassed all these circumstances where he knows that all the images of a tremendous dignity ought to be united, at the mouth of hell! where before he unlocks the secrets of the great deep, he seems to be seized with a religious horror, and to retire astonished at the boldness of his own design.

> *Dii quibus imperium est animarum, umbræq; silentes!*
> *Et Chaos, et Phlegethon! loca nocte silentia late?*
> *Sit mihi fas audita loqui! sit numine vestro*
> *Pandere res alta terra et caligine mersas!*
> *Ibant obscuri, sola sub nocte, per umbram,*
> *Perque domos Ditis vacuas, et inania regna.**

> *Ye subterraneous gods! whose aweful sway*
> *The gliding ghosts, and silent shades obey;*
> *O Chaos hoar! and Phlegethon profound!*
> *Whose solemn empire stretches wide around;*
> *Give me, ye great tremendous·powers, to tell*
> *Of scenes and wonders in the depth of hell;*
> *Give me your mighty secrets to display*
> *From those black realms of darkness to the day.*

<div align="right">PITT.*</div>

> Obscure *they went through dreary* shades *that led*
> *Along the* waste *dominions of the* dead.

<div align="right">DRYDEN.*</div>

SECTION VII
VASTNESS

Greatness [1] of dimension, is a powerful cause of the sublime. This is too evident, and the observation too common, to need any illustration; it is not so common, to consider in what ways greatness of dimension, vastness of extent, or quantity, has the most striking effect. For certainly, there are ways, and modes, wherein the same quantity of extension shall produce greater effects than it is found to do in others. Extension is either in length, height, or depth. Of these the length strikes least; an hundred yards of even ground will never work such an effect as a tower an hundred yards high, or a rock or mountain of that altitude. I am apt to imagine likewise, that height is less grand than depth; and that we are more struck at looking down from a precipice, than at looking up at an object of equal height, but of that I am not very positive. A perpendicular has more force in forming the sublime, than an inclined plane; and the effects of a rugged and broken surface seem stronger than where it is smooth and polished. It would carry us out of our way to enter in this place into the cause of these appearances; but certain it is they afford a large and fruitful field of speculation. However, it may not be amiss to add to these remarks upon magnitude; that, as the great extreme of dimension is sublime, so the last extreme of littleness is in some measure sublime likewise; when we attend to the infinite divisibility of matter, when we pursue animal life into these excessively small, and yet organized beings, that escape the nicest inquisition of the sense, when we push our discoveries yet downward, and consider those creatures so many degrees yet smaller, and the still diminishing scale of existence, in tracing which the imagination is lost as well as the sense, we become amazed and confounded at the wonders of minuteness; nor can we distinguish in its effect this extreme of littleness from the vast itself. For division must be infinite as well as addition; because the idea of a perfect unity can no more be

[1] Part 4, section 9.

arrived at, than that of a compleat whole to which nothing may be added.

SECTION VIII

INFINITY

Another source of the sublime, is *infinity*; if it does not rather belong to the last. Infinity has a tendency to fill the mind with that sort of delightful horror, which is the most genuine effect, and truest test of the sublime. There are scarce any things which can become the objects of our senses that are really, and in their own nature infinite. But the eye not being able to perceive the bounds of many things, they seem to be infinite, and they produce the same effects as if they were really so. We are deceived in the like manner, if the parts of some large object are so continued to any indefinite number, that the imagination meets no check which may hinder its extending them at pleasure.

Whenever we repeat any idea frequently, the mind by a sort of mechanism repeats it long after the first cause has ceased to operate. [1] After whirling about; when we sit down, the objects about us still seem to whirl. After a long succession of noises, as the fall of waters, or the beating of forge hammers, the hammers beat and the water roars in the imagination long after the first sounds have ceased to affect it; and they die away at last by gradations which are scarcely perceptible. If you hold up a strait pole, with your eye to one end, it will seem extended to a length almost incredible. [2] Place a number of uniform and equidistant marks on this pole, they will cause the same deception, and seem multiplied without end. The senses strongly affected in some one manner, cannot quickly change their tenor, or adapt themselves to other things; but they continue in their old channel until the strength of the first mover decays. This is the reason of an appearance very frequent in madmen; that they remain whole days and nights, sometimes whole

[1] Part 4, section 12.
[2] Part 4, section 14. This should presumably read:"Part 4, section 13."

years, in the constant repetition of some remark, some complaint, or song; which having struck powerfully on their disordered imagination, in the beginning of their phrensy, every repetition reinforces it with new strength; and the hurry of their spirits, unrestrained by the curb of reason, continues it to the end of their lives.

SECTION IX
SUCCESSION and UNIFORMITY

Succession and *uniformity* of parts, are what constitute the artificial infinite. 1. *Succession*; which is requisite that the parts may be continued so long, and in such a direction, as by their frequent impulses on the sense to impress the imagination with an idea of their progress beyond their actual limits. 2. *Uniformity*; because if the figures of the parts should be changed, the imagination at every change finds a check; you are presented at every alteration with the termination of one idea, and the beginning of another; by which means it becomes impossible to continue that uninterrupted progression, which alone can stamp on bounded objects the character of infinity.[1] It is in this kind of artificial infinity, I believe, we ought to look for the cause why a rotund has such a noble effect. For in a rotund, whether it be a building or a plantation, you can no where fix a boundary; turn which way you will, the same object still seems to continue, and the imagination has no rest. But the parts must be uniform as well as circularly disposed, to give this figure its full force; because any difference, whether it be in the disposition, or in the figure, or even in the colour of the parts, is highly prejudicial to the idea of infinity, which every change must check and interrupt, at every alteration commencing a new series. On the same principles of succession and uniformity, the grand appearance of the ancient heathen

[1] Mr. Addison, in the Spectators concerning the pleasures of the imagination, thinks it is, because in the rotund at one glance you see half the building. This I do not imagine to be the real cause.

temples, which were generally oblong forms, with a range of uniform pillars on every side, will be easily accounted for. From the same cause also may be derived the grand effect of the isles in many of our own old cathedrals. The form of a cross used in some churches seems to me not so eligible, as the parallelogram of the ancients; at least I imagine it is not so proper for the outside. For, supposing the arms of the cross every way equal, if you stand in a direction parallel to any of the side walls, or colonnades, instead of a deception that makes the building more extended than it is, you are cut off from a considerable part (two thirds) of its *actual* length; and to prevent all possibility of progression, the arms of the cross taking a new direction, make a right angle with the beam, and thereby wholly turn the imagination from the repetition of the former idea. Or suppose the spectator placed where he may take a direct view of such a building; what will be the consequence? the necessary consequence will be, that a good part of the basis of each angle, formed by the intersection of the arms of the cross, must be inevitably lost; the whole must of course assume a broken unconnected figure; the lights must be unequal, here strong, and there weak; without that noble gradation, which the perspective always effects on parts disposed uninterruptedly in a right line. Some or all of these objections, will lie against every figure of a cross, in whatever view you take it. I exemplified them in the Greek cross in which these faults appear the most strongly; but they appear in some degree in all sorts of crosses. Indeed there is nothing more prejudicial to the grandeur of buildings, than to abound in angles; a fault obvious in many; and owing to an inordinate thirst for variety, which, whenever it prevails, is sure to leave very little true taste.

SECTION X

Magnitude in BUILDING

To the sublime in building, greatness of dimension seems requisite; for on a few parts, and those small, the imagination cannot rise to any idea of infinity. No greatness in the manner

can effectually compensate for the want of proper dimensions. There is no danger of drawing men into extravagant designs by this rule; it carries its own caution along with it. Because too great a length in buildings destroys the purpose of greatness which it was intended to promote; the perspective will lessen it in height as it gains in length; and will bring it at last to a point; turning the whole figure into a sort of triangle, the poorest in its effect of almost any figure, that can be presented to the eye. I have ever observed, that colonnades and avenues of trees of a moderate length, were without comparison far grander, than when they were suffered to run to immense distances. A true artist should put a generous deceit on the spectators, and effect the noblest designs by easy methods. Designs that are vast only by their dimensions, are always the sign of a common and low imagination. No work of art can be great, but as it deceives; to be otherwise is the prerogative of nature only. A good eye will fix the medium betwixt an excessive length, or height, (for the same objection lies against both), and a short or broken quantity; and perhaps it might be ascertained to a tolerable degree of exactness, if it was my purpose to descend far into the particulars of any art.

SECTION XI

INFINITY in pleasing OBJECTS

Infinity, though of another kind, causes much of our pleasure in agreeable, as well as of our delight in sublime images. The spring is the pleasantest of the seasons; and the young of most animals, though far from being compleatly fashioned, afford a more agreeable sensation than the full grown; because the imagination is entertained with the promise of something more, and does not acquiesce in the present object of the sense. In unfinished sketches of drawing, I have often seen something which pleased me beyond the best finishing; and this I believe proceeds from the cause I have just now assigned.

SECTION XII

DIFFICULTY

[1] Another source of greatness is *Difficulty*. When any work seems to have required immense force and labour to effect it, the idea is grand. Stonehenge, neither for disposition nor ornament, has any thing admirable; but those huge rude masses of stone, set on end, and piled each on other, turn the mind on the immense force necessary for such a work. Nay the rudeness of the work increases this cause of grandeur, as it excludes the idea of art, and contrivance; for dexterity produces another sort of effect which is different enough from this.

SECTION XIII

MAGNIFICENCE

Magnificence is likewise a source of the sublime. A great profusion of things which are splendid or valuable in themselves, is *magnificent*. The starry heaven, though it occurs so very frequently to our view, never fails to excite an idea of grandeur. This cannot be owing to any thing in the stars themselves, separately considered. The number is certainly the cause. The apparent disorder augments the grandeur, for the appearance of care is highly contrary to our ideas of magnificence. Besides, the stars lye in such apparent confusion, as makes it impossible on ordinary occasions to reckon them. This gives them the advantage of a sort of infinity. In works of art, this kind of grandeur, which consists in multitude, is to be very cautiously admitted; because, a profusion of excellent things is not to be attained, or with too much difficulty; and, because in many cases this splendid confusion would destroy all use, which should be attended to in most of the works of art with the greatest care; besides it is to be considered, that unless you can produce an appearance of infinity by your disorder, you

[1] Part 4, sections 4, 5, 6.

will have disorder only without magnificence. There are, how-
ever, a sort of fireworks, and some other things, that in this way
succeed well, and are truly grand. There are also many
descriptions in the poets and orators which owe their sublimity
to a richness and profusion of images, in which the mind is so
dazzled as to make it impossible to attend to that exact co-
herence and agreement of the allusions, which we should
require on every other occasion. I do not now remember a
more striking example of this, than the description which is
given of the king's army in the play of Henry the fourth;

> *All furnished, all in arms,*
> *All plumed like ostriches that with the wind*
> *Baited like eagles having lately bathed:*
> *As full of spirit as the month of May,*
> *And gorgeous as the sun in Midsummer,*
> *Wanton as youthful goats, wild as young bulls.*
> *I saw young Harry with his beaver on*
> *Rise from the ground like feathered Mercury;*
> *And vaulted with such ease into his seat*
> *As if an angel dropped down from the clouds*
> *To turn and wind a fiery Pegasus.* *

In that excellent book so remarkable for the vivacity of its
descriptions, as well as the solidity and penetration of its
sentences, the Wisdom of the son of Sirach, there is a noble
panegyric on the high priest Simon the son of Onias; and it is
a very fine example of the point before us.

*How was he honoured in the midst of the people, in his coming out of
the sanctuary! He was as the morning star in the midst of a cloud, and
as the moon at the full: as the sun shining upon the temple of the Most
High, and as the rainbow giving light in the bright clouds: and as the
flower of roses in the spring of the year; as lillies by the rivers of waters,
and as the frankincense tree in summer; as fire and incense in the
censer; and as a vessel of gold set with precious stones; as a fair olive
tree budding forth fruit, and as a cypress which groweth up to the clouds.
When he put on the robe of honour, and was clothed with the perfection
of glory, when he went up to the holy altar, he made the garment of
holiness honourable. He himself stood by the hearth of the altar com-*

*passed with his brethren round about, as a young cedar in Libanus, and
as palm trees compassed they him about. So were all the sons of Aaron
in their glory, and the oblations of the Lord in their hands, &c.**

SECTION XIV
LIGHT

Having considered extension, so far as it is capable of raising
ideas of greatness; *colour* comes next under consideration. All
colours depend on *light*. Light therefore ought previously to be
examined, and with it, its opposite, darkness. With regard to
light; to make it a cause capable of producing the sublime, it
must be attended with some circumstances, besides its bare
faculty of shewing other objects. Mere light is too common a
thing to make a strong impression on the mind, and without
a strong impression nothing can be sublime. But such a light
as that of the sun, immediately exerted on the eye, as it over-
powers the sense, is a very great idea. Light of an inferior
strength to this, if it moves with great celerity, has the same
power; for lightning is certainly productive of grandeur, which
it owes chiefly to the extreme velocity of its motion. A quick
transition from light to darkness, or from darkness to light, has
yet a greater effect. But darkness is more productive of sublime
ideas than light. Our great poet was convinced of this; and
indeed so full was he of this idea, so entirely possessed with the
power of a well managed darkness, that, in describing the
appearance of the Deity, amidst that profusion of magnificent
images, which the grandeur of his subject provokes him to
pour out upon every side, he is far from forgetting the obscurity
which surrounds the most incomprehensible of all beings, but

> ——*With the majesty of* darkness *round
> Circles his throne.**

And what is no less remarkable, our author had the secret
of preserving this idea, even when he seemed to depart the
farthest from it, when he describes the light and glory which

flows from the divine presence; a light which by its very excess is converted into a species of darkness,

Dark *with excessive* light *thy skirts appear.*[*]

Here is an idea not only poetical in an high degree, but strictly and philosophically just. Extreme light, by overcoming the organs of sight, obliterates all objects, so as in its effect exactly to resemble darkness. After looking for some time at the sun, two black spots, the impression which it leaves, seem to dance before our eyes. Thus are two ideas as opposite as can be imagined reconciled in the extremes of both; and both in spite of their opposite nature brought to concur in producing the sublime. And this is not the only instance wherein the opposite extremes operate equally in favour of the sublime, which in all things abhors mediocrity.

SECTION XV

Light in BUILDING

As the management of light is a matter of importance in architecture, it is worth enquiring, how far this remark is applicable to building. I think then, that all edifices calculated to produce an idea of the sublime, ought rather to be dark and gloomy, and this for two reasons; the first is, that darkness itself on other occasions is known by experience to have a greater effect on the passions than light. The second is, that to make an object very striking, we should make it as different as possible from the objects with which we have been immediately conversant; when therefore you enter a building, you cannot pass into a greater light than you had in the open air; to go into one some few degrees less luminous, can make only a trifling change; but to make the transition thoroughly striking, you ought to pass from the greatest light, to as much darkness as is consistent with the uses of architecture. At night the contrary rule will hold, but for the very same reason; and the more highly a room is then illuminated, the grander will the passion be.

SECTION XVI

COLOUR considered as productive of
the SUBLIME

Among colours, such as are soft, or cheerful, (except perhaps a strong red which is cheerful) are unfit to produce grand images. An immense mountain covered with a shining green turf, is nothing in this respect, to one dark and gloomy; the cloudy sky is more grand than the blue; and night more sublime and solemn than day. Therefore in historical painting, a gay or gaudy drapery, can never have a happy effect: and in buildings, when the highest degree of the sublime is intended, the materials and ornaments ought neither to be white, nor green, nor yellow, nor blue, nor of a pale red, nor violet, nor spotted, but of sad and fuscous*colours, as black, or brown, or deep purple, and the like. Much of gilding, mosaics, painting or statues, contribute but little to the sublime. This rule need not be put in practice, except where an uniform degree of the most striking sublimity is to be produced, and that in every particular; for it ought to be observed, that this melancholy kind of greatness, though it be certainly the highest, ought not to be studied in all sorts of edifices, where yet grandeur must be studied; in such cases the sublimity must be drawn from the other sources; with a strict caution however against any thing light and riant;* as nothing so effectually deadens the whole taste of the sublime.

SECTION XVII

SOUND and LOUDNESS

The eye is not the only organ of sensation, by which a sublime passion may be produced. Sounds have a great power in these as in most other passions. I do not mean words, because words do not affect simply by their sounds, but by means altogether different. Excessive loudness alone is sufficient to overpower the soul, to suspend its action, and to fill it with terror. The noise of vast cataracts, raging storms, thunder, or artillery, awakes a great and aweful sensation in the mind, though we can observe no nicety or artifice in those sorts of music. The shouting of

multitudes has a similar effect; and by the sole strength of
the sound, so amazes and confounds the imagination, that in
this staggering, and hurry of the mind, the best established
tempers can scarcely forbear being borne down, and joining in
the common cry, and common resolution of the croud.

SECTION XVIII
SUDDENNESS

A sudden beginning, or sudden cessation of sound of any con-
siderable force, has the same power. The attention is roused by
this; and the faculties driven forward, as it were, on their guard.
Whatever either in sights or sounds makes the transition from
one extreme to the other easy, causes no terror, and conse-
quently can be no cause of greatness. In every thing sudden
and unexpected, we are apt to start; that is, we have a percep-
tion of danger, and our nature rouses us to guard against it. It
may be observed, that a single sound of some strength, though
but of short duration, if repeated after intervals, has a grand
effect. Few things are more aweful than the striking of a great
clock, when the silence of the night prevents the attention from
being too much dissipated. The same may be said of a single
stroke on a drum, repeated with pauses; and of the successive
firing of cannon at a distance; all the effects mentioned in this
section have causes very nearly alike.

SECTION XIX
INTERMITTING

A low, tremulous, intermitting sound, though it seems in some
respects opposite to that just mentioned, is productive of the
sublime. It is worth while to examine this a little. The fact
itself must be determined by every man's own experience, and
reflection. I have already observed, that[1] night increases our
terror more perhaps than any thing else; it is our nature, that,
when we do not know what may happen to us, to fear the worst
that can happen us; and hence it is, that uncertainty is so

[1] Section 3.

terrible, that we often seek to be rid of it, at the hazard of a certain mischief. Now some low, confused, uncertain sounds, leave us in the same fearful anxiety concerning their causes, that no light, or an uncertain light does concerning the objects that surround us.

> *Quale per incertam lunam sub luce maligna*
> *Est iter in silvis.——*[*]
> *——A faint shadow of uncertain light,*
> *Like as a lamp, whose life doth fade away;*
> *Or as the moon cloathed with cloudy night*
> *Doth shew to him who walks in fear and great affright.*
> SPENSER.[*]

But a light now appearing, and now leaving us, and so off and on, is even more terrible than total darkness; and a sort of uncertain sounds are, when the necessary dispositions concur, more alarming than a total silence.

SECTION XX
The cries of ANIMALS

Such sounds as imitate the natural inarticulate voices of men, or any animals in pain or danger, are capable of conveying great ideas; unless it be the well known voice of some creature, on which we are used to look with contempt. The angry tones of wild beasts are equally capable of causing a great and aweful sensation.

> *Hinc exaudiri gemitus, iræque leonum*
> *Vincla recusantum, et sera sub nocte rudentum;*
> *Setigerique sues, atque in presepibus ursi*
> *Sævire; et formæ magnorum ululare luporum.*[*]

It might seem that these modulations of sound carry some connection with the nature of the things they represent, and are not merely arbitrary; because the natural cries of all animals, even of those animals with whom we have not been acquainted, never fail to make themselves sufficiently understood; this cannot be said of language. The modifications of sound, which may be productive of the sublime, are almost

infinite. Those I have mentioned, are only a few instances to shew, on what principle they are all built.

SECTION XXI

SMELL and TASTE. BITTERS and STENCHES

Smells, and *Tastes*, have some share too, in ideas of greatness; but it is a small one, weak in its nature, and confined in its operations. I shall only observe, that no smells or tastes can produce a grand sensation, except excessive bitters, and intolerable stenches. It is true, that these affections of the smell and taste, when they are in their full force, and lean directly upon the sensory, are simply painful, and accompanied with no sort of delight; but when they are moderated, as in a description or narrative, they become sources of the sublime as genuine as any other, and upon the very same principle of a moderated pain. "A cup of bitterness;" to drain the bitter "cup of fortune;" the bitter apples of "Sodom." These are all ideas suitable to a sublime description. Nor is this passage of Virgil without sublimity, where the stench of the vapour in Albunea conspires so happily with the sacred horror and gloominess of that prophetic forest.

> *At rex sollicitus monstrorum oraculi fauni*
> *Fatidici genitoris adit, lucosque sub alta*
> *Consulit Albunea, nemorum quæ maxima sacro*
> *Fonte sonat; sævamque exhalat opaca Mephitim.**

In the sixth book, and in a very sublime description, the poisonous exhalation of Acheron is not forgot, nor does it at all disagree with the other images amongst which it is introduced.

> *Spelunca alta fuit, vastoque immanis hiatu*
> *Scrupea, tuta lacu nigro, nemorumque tenebris*
> *Quam super haud ullæ poterant impune volantes*
> *Tendere iter pennis, talis sese halitus atris*
> *Faucibus effundens supera ad convexa ferebat.**

I have added these examples, because some friends, for whose judgment I have great deference, were of opinion, that if the

sentiment stood nakedly by itself, it would be subject at first view to burlesque and ridicule; but this I imagine would principally arise from considering the bitterness and stench in company with mean and contemptible ideas, with which it must be owned they are often united; such an union degrades the sublime in all other instances as well as in those. But it is one of the tests by which the sublimity of an image is to be tried, not whether it becomes mean when associated with mean ideas; but whether, when united with images of an allowed grandeur, the whole composition is supported with dignity. Things which are terrible are always great; but when things possess disagreeable qualities, or such as have indeed some degree of danger, but of a danger easily overcome, they are merely *odious*, as toads and spiders.

SECTION XXII

FEELING. PAIN

Of *Feeling* little more can be said, than that the idea of bodily pain, in all the modes and degrees of labour, pain, anguish, torment, is productive of the sublime; and nothing else in this sense can produce it. I need not give here any fresh instances, as those given in the former sections abundantly illustrate a remark, that in reality wants only an attention to nature, to be made by every body.

Having thus run through the causes of the sublime with reference to all the senses, my first observation, (section 7.) will be found very nearly true; that the sublime is an idea belonging to self-preservation. That it is therefore one of the most affecting we have. That its strongest emotion is an emotion of distress, and that no[1] pleasure from a positive cause belongs to it. Numberless examples besides those mentioned, might be brought in support of these truths, and many perhaps useful consequences drawn from them.————

> *Sed fugit interea, fugit irrevocabile tempus,*
> *Singula dum capti circumvectamur amore.**

[1] Vide section 6, part 1.

SECTION XIII

FEELING-PAIN

A
PHILOSOPHICAL ENQUIRY
INTO THE ORIGIN
OF OUR IDEAS
OF THE SUBLIME
AND BEAUTIFUL

Part Three

SECTION I

Of BEAUTY

IT is my design to consider beauty as distinguished from the sublime; and in the course of the enquiry, to examine how far it is consistent with it. But previous to this, we must take a short review of the opinions already entertained of this quality; which I think are hardly to be reduced to any fixed principles; because men are used to talk of beauty in a figurative manner, that is to say, in a manner extremely uncertain, and indeterminate. By beauty I mean, that quality or those qualities in bodies by which they cause love, or some passion similar to it. I confine this definition to the merely sensible qualities of things, for the sake of preserving the utmost simplicity in a subject which must always distract us, whenever we take in those various causes of sympathy which attach us to any persons or things from secondary considerations, and not from the direct force which they have merely on being viewed. I likewise distinguish love, by which I mean that satisfaction which arises to the mind upon contemplating any thing beautiful, of whatsoever nature it may be, from desire or lust; which is an energy of the mind, that hurries us on to the possession of certain objects, that do not affect us as they are beautiful, but by means altogether different. We shall have a strong desire for a woman of no remarkable beauty; whilst the greatest beauty in men, or in other animals, though it causes love, yet excites nothing at all of desire. Which shews that beauty, and the passion caused by beauty, which I call love, is different from desire, though desire may sometimes operate along with it; but it is to this latter that we must attribute those violent and tempestuous passions, and the consequent emotions of the body which attend what is called love in some of its ordinary acceptations, and not to the effects of beauty merely as it is such.

SECTION II

Proportion not the cause of BEAUTY in VEGETABLES

Beauty hath usually been said to consist in certain proportions of parts. On considering the matter, I have great reason to doubt, whether beauty be at all an idea belonging to proportion. Proportion relates almost wholly to convenience, as every idea of order seems to do; and it must therefore be considered as a creature of the understanding, rather than a primary cause acting on the senses and imagination. It is not by the force of long attention and enquiry that we find any object to be beautiful; beauty demands no assistance from our reasoning; even the will is unconcerned; the appearance of beauty as effectually causes some degree of love in us, as the application of ice or fire produces the ideas of heat or cold. To gain something like a satisfactory conclusion in this point, it were well to examine, what proportion is; since several who make use of that word, do not always seem to understand very clearly the force of the term, nor to have very distinct ideas concerning the thing itself. Proportion is the measure of relative quantity. Since all quantity is divisible, it is evident that every distinct part into which any quantity is divided, must bear some relation to the other parts or to the whole. These relations give an origin to the idea of proportion. They are discovered by mensuration, and they are the objects of mathematical enquiry. But whether any part of any determinate quantity be a fourth, or a fifth, or a sixth, or a moiety of the whole; or whether it be of equal length with any other part, or double its length, or but one half, is a matter merely indifferent to the mind; it stands neuter in the question: and it is from this absolute indifference and tranquillity of the mind, that mathematical speculations derive some of their most considerable advantages; because there is nothing to interest the imagination; because the judgment sits free and unbiassed to examine the point. All proportions, every arrangement of quantity is alike to the understanding, because the same truths result to it from all; from greater, from lesser; from equality and inequality. But

surely beauty is no idea belonging to mensuration; nor has it any thing to do with calculation and geometry. If it had, we might then point out some certain measures which we could demonstrate to be beautiful, either as simply considered, or as related to others; and we could call in those natural objects, for whose beauty we have no voucher but the sense, to this happy standard, and confirm the voice of our passions by the determination of our reason. But since we have not this help, let us see whether proportion can in any sense be considered as the cause of beauty, as hath been so generally, and by some so confidently affirmed. If proportion be one of the constituents of beauty, it must derive that power either from some natural properties inherent in certain measures, which operate mechanically; from the operation of custom; or from the fitness which some measures have to answer some particular ends of conveniency. Our business therefore is to enquire, whether the parts of those objects which are found beautiful in the vegetable or animal kingdoms, are constantly so formed according to such certain measures, as may serve to satisfy us that their beauty results from those measures, on the principle of a natural mechanical cause; or from custom; or in fine, from their fitness for any determinate purposes. I intend to examine this point under each of these heads in their order. But before I proceed further, I hope it will not be thought amiss, if I lay down the rules which governed me in this enquiry, and which have misled me in it if I have gone astray. 1. If two bodies produce the same or a similar effect on the mind, and on examination they are found to agree in some of their properties, and to differ in others; the common effect is to be attributed to the properties in which they agree, and not to those in which they differ. 2. Not to account for the effect of a natural object from the effect of an artificial object. 3. Not to account for the effect of any natural object from a conclusion of our reason concerning its uses, if a natural cause may be assigned. 4. Not to admit any determinate quantity, or any relation of quantity, as the cause of a certain effect, if the effect is produced by different or opposite measures and relations; or if these measures and relations may exist, and yet the effect may not be produced. These are the rules which I have chiefly followed, whilst I

examined into the power of proportion considered as a natural cause; and these, if he thinks them just, I request the reader to carry with him throughout the following discussion; whilst we enquire in the first place, in what things we find this quality of beauty; next, to see whether in these, we can find any assignable proportions, in such a manner as ought to convince us, that our idea of beauty results from them. We shall consider this pleasing power, as it appears in vegetables, in the inferior animals, and in man. Turning our eyes to the vegetable creation, we find nothing there so beautiful as flowers; but flowers are almost of every sort of shape, and of every sort of disposition; they are turned and fashioned into an infinite variety of forms; and from these forms, botanists have given them their names, which are almost as various. What proportion do we discover between the stalks and the leaves of flowers, or between the leaves and the pistils? How does the slender stalk of the rose agree with the bulky head under which it bends? but the rose is a beautiful flower; and can we undertake to say that it does not owe a great deal of its beauty even to that disproportion? the rose is a large flower, yet it grows upon a small shrub; the flower of the apple is very small, and it grows upon a large tree; yet the rose and the apple blossom are both beautiful, and the plants that bear them are most engagingly attired notwithstanding this disproportion. What by general consent is allowed to be a more beautiful object than an orange tree, flourishing at once with its leaves, its blossoms, and its fruit? but it is in vain that we search here for any proportion between the height, the breadth, or any thing else concerning the dimensions of the whole, or concerning the relation of the particular parts to each other. I grant that we may observe in many flowers, something of a regular figure, and of a methodical disposition of the leaves. The rose has such a figure and such a disposition of its petals; but in an oblique view, when this figure is in a good measure lost, and the order of the leaves confounded, it yet retains its beauty; the rose is even more beautiful before it is full blown; in the bud; before this exact figure is formed; and this is not the only instance wherein method and exactness, the soul of proportion, are found rather prejudicial than serviceable to the cause of beauty.

SECTION III

Proportion not the cause of BEAUTY
in ANIMALS

That proportion has but a small share in the formation of beauty, is full as evident among animals. Here the greatest variety of shapes, and dispositions of parts are well fitted, to excite this idea. The swan, confessedly a beautiful bird, has a neck longer than the rest of his body, and but a very short tail; is this a beautiful proportion? we must allow that it is. But then what shall we say to the peacock, who has comparatively but a short neck, with a tail longer than the neck and the rest of the body taken together? How many birds are there that vary infinitely from each of these standards, and from every other which you can fix, with proportions different, and often directly opposite to each other! and yet many of these birds are extremely beautiful; when upon considering them we find nothing in any one part that might determine us, *a priori*,* to say what the others ought to be, nor indeed to guess any thing about them, but what experience might shew to be full of disappointment and mistake. And with regard to the colours either of birds or flowers, for there is something similar in the colouring of both, whether they are considered in their extension or gradation, there is nothing of proportion to be observed. Some are of but one single colour; others have all the colours of the rainbow; some are of the primary colours, others are of the mixt; in short, an attentive observer may soon conclude, that there is as little of proportion in the colouring as in the shapes of these objects. Turn next to beasts; examine the head of a beautiful horse; find what proportion that bears to his body, and to his limbs, and what relation these have to each other; and when you have settled these proportions as a standard of beauty, then take a dog or cat, or any other animal, and examine how far the same proportions between their heads and their necks, between those and the body, and so on, are found to hold; I think we may safely say, that they differ in every species, yet that there are individuals found in a great many species so differing, that have a very striking beauty. Now if

it be allowed that very different, and even contrary forms and dispositions are consistent with beauty, it amounts I believe to a concession, that no certain measures operating from a natural principle, are necessary to produce it, at least so far as the brute species is concerned.

SECTION IV

Proportion not the cause of BEAUTY in the human species

There are some parts of the human body, that are observed to hold certain proportions to each other; but before it can be proved, that the efficient cause of beauty lies in these, it must be shewn, that wherever these are found exact, the person to whom they belong is beautiful. I mean in the effect produced on the view, either of any member distinctly considered, or of the whole body together. It must be likewise shewn, that these parts stand in such a relation to each other, that the comparison between them may be easily made, and that the affection of the mind may naturally result from it. For my part, I have at several times very carefully examined many of those proportions, and found them hold very nearly, or altogether alike in many subjects, which were not only very different from one another, but where one has been very beautiful, and the other very remote from beauty. With regard to the parts which are found so proportioned, they are often so remote from each other, in situation, nature, and office, that I cannot see how they admit of any comparison, nor consequently how any effect owing to proportion can result from them. The neck, say they, in beautiful bodies should measure with the calf of the leg; it should likewise be twice the circumference of the wrist. And an infinity of observations of this kind are to be found in the writings, and conversations of many. But what relation has the calf of the leg to the neck; or either of these parts to the wrist? These proportions are certainly to be found in handsome bodies. They are as certainly in ugly ones, as any who will take the pains to try, may find. Nay, I do not know but they may be least perfect in some of the most beautiful. You may

assign any proportions you please to every part of the human body; and I undertake, that a painter shall religiously observe them all, and notwithstanding produce if he pleases, a very ugly figure. The same painter shall considerably deviate from these proportions, and produce a very beautiful one. And indeed it may be observed in the masterpieces of the ancient and modern statuary, that several of them differ very widely from the proportions of others, in parts very conspicuous, and of great consideration; and that they differ no less from the proportions we find in living men, of forms extremely striking and agreeable. And after all, how are the partizans of proportional beauty agreed amongst themselves about the proportions of the human body? some hold it to be seven heads; some make it eight; whilst others extend it even to ten; a vast difference in such a small number of divisions! Others take other methods of estimating the proportions, and all with equal success. But are these proportions exactly the same in all handsome men? or are they at all the proportions found in beautiful women? nobody will say that they are; yet both sexes are undoubtedly capable of beauty, and the female of the greatest; which advantage I believe will hardly be attributed to the superior exactness of proportion in the fair sex.* Let us rest a moment on this point; and consider how much difference there is between the measures that prevail in many similar parts of the body, in the two sexes of this single species only. If you assign any determinate proportions to the limbs of a man, and if you limit human beauty to these proportions, when you find a woman who differs in the make and measures of almost every part, you must conclude her not to be beautiful in spite of the suggestions of your imagination; or in obedience to your imagination you must renounce your rules; you must lay by the scale and compass, and look out for some other cause of beauty. For if beauty be attached to certain measures which operate from a *principle in nature*, why should similar parts with different measures of proportion be found to have beauty, and this too in the very same species? But to open our view a little, it is worth observing, that almost all animals have parts of very much the same nature, and destined nearly to the same purposes; an head, neck, body, feet, eyes, ears, nose and mouth;

89

yet Providence to provide in the best manner for their several wants, and to display the riches of his wisdom and goodness in his creation, has worked out of these few and similar organs, and members, a diversity hardly short of infinite in their disposition, measures, and relation. But, as we have before observed, amidst this infinite diversity, one particular is common to many species; several of the individuals which compose them, are capable of affecting us with a sense of loveliness; and whilst they agree in producing this effect, they differ extremely in the relative measures of those parts which have produced it. These considerations were sufficient to induce me to reject the notion of any particular proportions that operated by nature to produce a pleasing effect; but those who will agree with me with regard to a particular proportion, are strongly pre-possessed in favour of one more indefinite. They imagine, that although beauty in general is annexed to no certain measures common to the several kinds of pleasing plants and animals; yet that there is a certain proportion in each species absolutely essential to the beauty of that particular kind. If we consider the animal world in general, we find beauty confined to no certain measures; but as some peculiar measure and relation of parts, is what distinguishes each peculiar class of animals, it must of necessity be, that the beautiful in each kind will be found in the measures and proportions of that kind; for otherwise it would deviate from its proper species, and become in some sort monstrous: however, no species is so strictly confined to any certain proportions, that there is not a considerable variation amongst the individuals; and as it has been shewn of the human, so it may be shewn of the brute kinds, that beauty is found indifferently in all the proportions which each kind can admit, without quitting its common form; and it is this idea of a common form that makes the proportion of parts at all regarded, and not the operation of any natural cause; indeed a little consideration will make it appear that it is not measure, but manner, that creates all the beauty which belongs to shape. What lights do we borrow from these boasted proportions, when we study ornamental design? It seems amazing to me, that artists, if they were as well convinced as they pretend to be, that proportion is a principal cause of

beauty, have not by them at all times accurate measurements of all sorts of beautiful animals to help them to proper proportions when they would contrive any thing elegant, especially as they frequently assert, that it is from an observation of the beautiful in nature they direct their practice. I know that it has been said long since, and echoed backward and forward from one writer to another a thousand times, that the proportions of building have been taken from those of the human body.* To make this forced analogy complete, they represent a man with his arms raised and extended at full length, and then describe a sort of square, as it is formed by passing lines along the extremities of this strange figure. But it appears very clearly to me, that the human figure never supplied the architect with any of his ideas. For in the first place, men are very rarely seen in this strained posture; it is not natural to them; neither is it at all becoming. Secondly, the view of the human figure so disposed, does not naturally suggest the idea of a square, but rather of a cross; as that large space between the arms and the ground, must be filled with something before it can make any body think of a square. Thirdly, several buildings are by no means of the form of that particular square, which are notwithstanding planned by the best architects, and produce an effect altogether as good, and perhaps a better. And certainly nothing could be more unaccountably whimsical, than for an architect to model his performance by the human figure, since no two things can have less resemblance or analogy, than a man, and an house or temple; do we need to observe, that their purposes are entirely different? What I am apt to suspect is this: that these analogies were devised to give a credit to the works of art, by shewing a conformity between them and the noblest works in nature, not that the latter served at all to supply hints for the perfection of the former. And I am the more fully convinced, that the patrons of proportion have transferred their artificial ideas to nature, and not borrowed from thence the proportions they use in works of art; because in any discussion of this subject, they always quit as soon as possible the open field of natural beauties, the animal and vegetable kingdoms, and fortify themselves within the artificial lines and angles of architecture. For there is in mankind an

unfortunate propensity to make themselves, their views, and their works, the measure of excellence in every thing whatsoever. Therefore having observed, that their dwellings were most commodious and firm when they were thrown into regular figures, with parts answerable to each other; they transferred these ideas to their gardens; they turned their trees into pillars, pyramids, and obelisks; they formed their hedges into so many green walls, and fashioned the walks into squares, triangles, and other mathematical figures, with exactness and symmetry; and they thought if they were not imitating, they were at least improving nature, and teaching her to know her business. But nature has at last escaped from their discipline and their fetters; and our gardens, if nothing else, declare, we begin to feel that mathematical ideas are not the true measures of beauty. And surely they are full as little so in the animal, as the vegetable world. For it is not extraordinary, that in these fine descriptive pieces, these innumerable odes and elegies, which are in the mouths of all the world, and many of which have been the entertainment of ages, that in these pieces which describe love with such a passionate energy, and represent its object in such an infinite variety of lights, not one word is said of proportion, if it be what some insist it is, the principal component of beauty; whilst at the same time, several other qualities are very frequently and warmly mentioned? But if proportion has not this power, it may appear odd how men came originally to be so prepossessed in its favour. It arose, I imagine, from the fondness I have just mentioned, which men bear so remarkably to their own works and notions; it arose from false reasonings on the effects of the customary figure of animals; it arose from the Platonic theory of fitness and aptitude.* For which reason in the next section, I shall consider the effects of custom in the figure of animals; and afterwards the idea of fitness; since if proportion does not operate by a natural power attending some measures, it must be either by custom, or the idea of utility; there is no other way.

SECTION V

Proportion further considered

If I am not mistaken, a great deal of the prejudice in favour of proportion has arisen, not so much from the observation of any certain measures found in beautiful bodies, as from a wrong idea of the relation which deformity bears to beauty, to which it has been considered as the opposite; on this principle it was concluded, that where the causes of deformity were removed, beauty must naturally and necessarily be introduced. This I believe is a mistake. For *deformity* is opposed, not to beauty, but to the *compleat, common form*. If one of the legs of a man be found shorter than the other, the man is deformed; because there is something wanting to complete the whole idea we form of a man; and this has the same effect in natural faults, as maiming and mutilation produce from accidents. So if the back be humped, the man is deformed; because his back has an unusual figure, and what carries with it the idea of some disease or misfortune; so if a man's neck be considerably longer or shorter than usual, we say he is deformed in that part, because men are not commonly made in that manner. But surely every hour's experience may convince us, that a man may have his legs of an equal length, and resembling each other in all respects, and his neck of a just size, and his back quite strait, without having at the same time the least perceivable beauty. Indeed beauty is so far from belonging to the idea of custom, that in reality what affects us in that manner is extremely rare and uncommon. The beautiful strikes us as much by its novelty as the deformed itself. It is thus in those species of animals with which we are acquainted; and if one of a new species were presented, we should by no means wait until custom had settled an idea of proportion before we decided concerning its beauty or ugliness. Which shews that the general idea of beauty, can be no more owing to customary than to natural proportion. Deformity arises from the want of the common proportions; but the necessary result of their existence in any object is not beauty. If we suppose proportion in natural things to be relative to custom and use, the nature of use and

custom will shew, that beauty, which is a *positive* and powerful quality, cannot result from it. We are so wonderfully formed, that whilst we are creatures vehemently desirous of novelty, we are as strongly attached to habit and custom. But it is the nature of things which hold us by custom to affect us very little whilst we are in possession of them, but strongly when they are absent. I remember to have frequented a certain place, every day for a long time together; and I may truly say, that so far from finding pleasure in it, I was affected with a sort of weariness and disgust; I came, I went, I returned without pleasure; yet if by any means I passed by the usual time of my going thither, I was remarkably uneasy, and was not quiet till I had got into my old track. They who use snuff take it almost without being sensible that they take it, and the acute sense of smell is deadened, so as to feel hardly any thing from so sharp a stimulus; yet deprive the snuff-taker of his box, and he is the most uneasy mortal in the world. Indeed so far are use and habit from being causes of pleasure, merely as such; that the effect of constant use is to make all things of whatever kind entirely unaffecting. For as use at last takes off the painful effect of many things, it reduces the pleasurable effect of others in the same manner, and brings both to a sort of mediocrity and indifference. Very justly is use called a second nature; and our natural and common state is one of absolute indifference, equally prepared for pain or pleasure. But when we are thrown out of this state, or deprived of any thing requisite to maintain us in it; when this chance does not happen by pleasure from some mechanical cause, we are always hurt. It is so with the second nature, custom, in all things which relate to it. Thus the want of the usual proportions in men and other animals is sure to disgust, though their presence is by no means any cause of real pleasure. It is true, that the proportions laid down as causes of beauty in the human body are frequently found in beautiful ones, because they are generally found in all man-kind; but if it can be shewn too that they are found without beauty, and that beauty frequently exists without them, and that this beauty, where it exists, always can be assigned to other less equivocal causes, it will naturally lead us to conclude, that proportion and beauty are not ideas of the same nature.

The true opposite to beauty is not disproportion or deformity, but *ugliness*; and as it proceeds from causes opposite to those of positive beauty, we cannot consider it until we come to treat of that. Between beauty and ugliness there is a sort of mediocrity, in which the assigned proportions are most commonly found, but this has no effect upon the passions.

SECTION VI

FITNESS not the cause of BEAUTY

It is said that the idea of utility, or of a part's being well adapted to answer its end, is the cause of beauty, or indeed beauty itself. If it were not for this opinion, it had been impossible for the doctrine of proportion to have held its ground very long; the world would be soon weary of hearing of measures which related to nothing, either of a natural principle, or of a fitness to answer some end; the idea which mankind most commonly conceive of proportion, is the suitableness of means to certain ends, and where this is not the question, very seldom trouble themselves about the effect of different measures of things. Therefore it was necessary for this theory to insist, that not only artificial, but natural objects took their beauty from the fitness of the parts for their several purposes. But in framing this theory, I am apprehensive that experience was not sufficiently consulted. For on that principle, the wedge-like snout of a swine, with its tough cartilage at the end, the little sunk eyes, and the whole make of the head, so well adapted to its offices of digging, and rooting, would be extremely beautiful. The great bag hanging to the bill of a pelican, a thing highly useful to this animal, would be likewise as beautiful in our eyes. The hedgehog, so well secured against all assaults by his prickly hide, and the porcupine with his missile quills, would be then considered as creatures of no small elegance. There are few animals, whose parts are better contrived than those of a monkey; he has the hands of a man, joined to the springy limbs of a beast; he is admirably calculated for running, leaping, grappling, and climbing: and yet there are few animals which seem to have less beauty in the

eyes of all mankind. I need say little on the trunk of the elephant, of such various usefulness, and which is so far from contributing to his beauty. How well fitted is the wolf for running and leaping? how admirably is the lion armed for battle? But will any one therefore call the elephant, the wolf, and the lion, beautiful animals? I believe nobody will think the form of a man's legs so well adapted to running, as those of an horse, a dog, a deer, and several other creatures; at least they have not that appearance: yet I believe a well-fashioned human leg will be allowed far to exceed all these in beauty. If the fitness of parts was what constituted the loveliness of their form, the actual employment of them would undoubtedly much augment it; but this, though it is sometimes so upon another principle, is far from being always the case. A bird on the wing is not so beautiful as when it is perched; nay, there are several of the domestic fowls which are seldom seen to fly, and which are nothing the less beautiful on that account; yet birds are so extremely different in their form from the beast and human kinds, that you cannot on the principle of fitness allow them any thing agreeable, but in consideration of their parts being designed for quite other purposes. I never in my life chanced to see a peacock fly; and yet before, very long before I considered any aptitude in his form for the aerial life, I was struck with the extreme beauty which raises that bird above many of the best flying fowls in the world; though for any thing I saw, his way of living was much like that of the swine, which fed in the farm-yard along with him. The same may be said of cocks, hens, and the like; they are of the flying kind in figure; in their manner of moving not very different from men and beasts. To leave these foreign examples; if beauty in our own species was annexed to use, men would be much more lovely than women; and strength and agility would be considered as the only beauties. But to call strength by the name of beauty, to have but one denomination for the qualities of a Venus and Hercules,* so totally different in almost all respects, is surely a strange confusion of ideas, or abuse of words. The cause of this confusion, I imagine, proceeds from our frequently perceiving the parts of the human and other animal bodies to be at once very beautiful, and very well adapted to their purposes; and we are deceived by a

sophism, which makes us take that for a cause which is only a concomitant; this is the sophism of the fly; who imagined he raised a great dust, because he stood upon the chariot that really raised it.* The stomach, the lungs, the liver, as well as other parts, are incomparably well adapted to their purposes; yet they are far from having any beauty. Again, many things are very beautiful, in which it is impossible to discern any idea of use. And I appeal to the first and most natural feelings of mankind, whether on beholding a beautiful eye, or a well-fashioned mouth, or a well-turned leg, any ideas of their being well fitted for seeing, eating, or running, ever present themselves. What idea of use is it that flowers excite, the most beautiful part of the vegetable world? It is true, that the infinitely wise and good Creator has, of his bounty, frequently joined beauty to those things which he has made useful to us; but this does not prove that an idea of use and beauty are the same thing, or that they are any way dependent on each other.

SECTION VII
The real effects of FITNESS

When I excluded proportion and fitness from any share in beauty, I did not by any means intend to say that they were of no value, or that they ought to be disregarded in works of art. Works of art are the proper sphere of their power; and here it is that they have their full effect. Whenever the wisdom of our Creator intended that we should be affected with any thing, he did not confide the execution of his design to the languid and precarious operation of our reason; but he endued it with powers and properties that prevent the understanding, and even the will, which seizing upon the senses and imagination, captivate the soul before the understanding is ready either to join with them or to oppose them. It is by a long deduction and much study that we discover the adorable wisdom of God in his works: when we discover it, the effect is very different, not only in the manner of acquiring it, but in its own nature, from that which strikes us without any preparation from the sublime or the beautiful. How different is the satisfaction of an

anatomist, who discovers the use of the muscles and of the skin, the excellent contrivance of the one for the various movements of the body, and the wonderful texture of the other, at once a general covering, and at once a general outlet as well as inlet; how different is this from the affection which possesses an ordinary man at the sight of a delicate smooth skin, and all the other parts of beauty which require no investigation to be perceived? In the former case, whilst we look up to the Maker with admiration and praise, the object which causes it may be odious and distasteful; the latter very often so touches us by its power on the imagination, that we examine but little into the artifice of its contrivance; and we have need of a strong effort of our reason to disentangle our minds from the allurements of the object to a consideration of that wisdom which invented so powerful a machine. The effect of proportion and fitness, at least so far as they proceed from a mere consideration of the work itself, produce approbation, the acquiescence of the understanding, but not love, nor any passion of that species. When we examine the structure of a watch, when we come to know thoroughly the use of every part of it, satisfied as we are with the fitness of the whole, we are far enough from perceiving any thing like beauty in the watch-work itself; but let us look on the case, the labour of some curious artist in engraving, with little or no idea of use, we shall have a much livelier idea of beauty than we ever could have had from the watch itself, though the master-piece of Graham.* In beauty, as I said, the effect is previous to any knowledge of the use; but to judge of proportion, we must know the end for which any work is designed. According to the end the proportion varies. Thus there is one proportion of a tower, another of an house; one proportion of a gallery, another of an hall, another of a chamber. To judge of the proportions of these, you must be first acquainted with the purposes for which they were designed. Good sense and experience acting together, find out what is fit to be done in every work of art. We are rational creatures, and in all our works we ought to regard their end and purpose; the gratification of any passion, how innocent soever, ought only to be of secondary consideration. Herein is placed the real power of fitness and proportion; they operate on the under-

standing considering them, which *approves* the work and acquiesces in it. The passions, and the imagination which principally raises them, have here very little to do. When a room appears in its original nakedness, bare walls and a plain ceiling; let its proportion be ever so excellent, it pleases very little; a cold approbation is the utmost we can reach; a much worse proportioned room, with elegant mouldings and fine festoons, glasses, and other merely ornamental furniture, will make the imagination revolt against the reason; it will please much more than the naked proportion of the first room which the understanding has so much approved, as admirably fitted for its purposes. What I have here said and before concerning proportion, is by no means to persuade people absurdly to neglect the idea of use in the works of art. It is only to shew that these excellent things, beauty and proportion, are not the same; not that they should either of them be disregarded.

SECTION VIII

The RECAPITULATION

On the whole; if such parts in human bodies as are found proportioned, were likewise constantly found beautiful, as they certainly are not; or if they were so situated, as that a pleasure might flow from the comparison, which they seldom are; or if any assignable proportions were found, either in plants or animals, which were always attended with beauty, which never was the case; or if, where parts were well adapted to their purposes, they were constantly beautiful, and when no use appeared, there was no beauty, which is contrary to all experience; we might conclude, that beauty consisted in proportion or utility. But since, in all respects, the case is quite otherwise; we may be satisfied, that beauty does not depend on these, let it owe its origin to what else it will.

SECTION IX
Perfection not the cause of BEAUTY

There is another notion current, pretty closely allied to the former; that *Perfection* is the constituent cause of beauty. This opinion has been made to extend much further than to sensible objects. But in these, so far is perfection, considered as such, from being the cause of beauty; that this quality, where it is highest in the female sex, almost always carries with it an idea of weakness and imperfection. Women are very sensible of this; for which reason, they learn to lisp, to totter in their walk, to counterfeit weakness, and even sickness. In all this, they are guided by nature. Beauty in distress is much the most affecting beauty. Blushing has little less power; and modesty in general, which is a tacit allowance of imperfection, is itself considered as an amiable quality, and certainly heightens every other that is so. I know, it is in every body's mouth, that we ought to love perfection. This is to me a sufficient proof, that it is not the proper object of love. Who ever said, we *ought* to love a fine woman, or even any of these beautiful animals, which please us? Here to be affected, there is no need of the concurrence of our will.

SECTION X
How far the idea of BEAUTY may be applied to the qualities of the MIND

Nor is this remark in general less applicable to the qualities of the mind. Those virtues which cause admiration, and are of the sublimer kind, produce terror rather than love. Such as fortitude, justice, wisdom, and the like. Never was any man amiable by force of these qualities. Those which engage our hearts, which impress us with a sense of loveliness, are the softer virtues; easiness of temper, compassion, kindness and liberality; though certainly those latter are of less immediate and momentous concern to society, and of less dignity. But it is for that reason that they are so amiable. The great virtues turn principally on dangers, punishments, and troubles, and are exercised

rather in preventing the worst mischiefs, than in dispensing favours; and are therefore not lovely, though highly venerable. The subordinate turn on reliefs, gratifications, and indulgences; and are therefore more lovely, though inferior in dignity. Those persons who creep into the hearts of most people, who are chosen as the companions of their softer hours, and their reliefs from care and anxiety, are never persons of shining qualities, nor strong virtues. It is rather the soft green of the soul on which we rest our eyes, that are fatigued with beholding more glaring objects. It is worth observing, how we feel ourselves affected in reading the characters of Cæsar, and Cato, as they are so finely drawn and contrasted in Sallust. In one, the *ignoscendo, largiundo*; in the other, *nil largiundo*. In one, the *miseris perfugium*; in the other, *malis perniciem*.* In the latter we have much to admire, much to reverence, and perhaps something to fear; we respect him, but we respect him at a distance. The former makes us familiar with him; we love him, and he leads us whither he pleases. To draw things closer to our first and most natural feelings, I will add a remark made upon reading this section by an ingenious friend. The authority of a father, so useful to our well-being, and so justly venerable upon all accounts, hinders us from having that entire love for him that we have for our mothers, where the parental authority is almost melted down into the mother's fondness and indulgence. But we generally have a great love for our grandfathers, in whom this authority is removed a degree from us, and where the weakness of age mellows it into something of a feminine partiality.

SECTION XI

How far the idea of BEAUTY may be applied to VIRTUE

From what has been said in the foregoing section, we may easily see, how far the application of beauty to virtue may be made with propriety. The general application of this quality to virtue, has a strong tendency to confound our ideas of things; and it has given rise to an infinite deal of whimsical theory; as the affixing the name of beauty to proportion, congruity and

perfection, as well as to qualities of things yet more remote from our natural ideas of it, and from one another, has tended to confound our ideas of beauty, and left us no standard or rule to judge by, that was not even more uncertain and fallacious than our own fancies. This loose and inaccurate manner of speaking, has therefore misled us both in the theory of taste and of morals; and induced us to remove the science of our duties from their proper basis, (our reason, our relations, and our necessities,) to rest it upon foundations altogether visionary and unsubstantial.

SECTION XII
The real cause of BEAUTY

Having endeavoured to shew what beauty is not, it remains that we should examine, at least with equal attention, in what it really consists. Beauty is a thing much too affecting not to depend upon some positive qualities. And, since it is no creature of our reason, since it strikes us without any reference to use, and even where no use at all can be discerned, since the order and method of nature is generally very different from our measures and proportions, we must conclude that beauty is, for the greater part, some quality in bodies, acting mechanically upon the human mind by the intervention of the senses. We ought therefore to consider attentively in what manner those sensible qualities are disposed, in such things as by experience we find beautiful, or which excite in us the passion of love, or some correspondent affection.

SECTION XIII
Beautiful objects small

The most obvious point that presents itself to us in examining any object, is its extent or quantity. And what degree of extent prevails in bodies, that are held beautiful, may be gathered from the usual manner of expression concerning it. I am told that in most languages, the objects of love are spoken of under diminutive epithets. It is so in all the languages of which I have any knowledge. In Greek the ιον,* and other diminutive

terms, are almost always the terms of affection and tenderness. These diminutives were commonly added by the Greeks to the names of persons with whom they conversed on terms of friendship and familiarity. Though the Romans were a people of less quick and delicate feelings, yet they naturally slid into the lessening termination upon the same occasions. Anciently in the English language the diminishing *ling* was added to the names of persons and things that were the objects of love. Some we retain still, as darling, (or little dear) and a few others. But to this day in ordinary conversation, it is usual to add the endearing name of *little* to every thing we love; the French and Italians make use of these affectionate diminutives even more than we. In the animal creation, out of our own species, it is the small we are inclined to be fond of; little birds, and some of the smaller kinds of beasts. A great beautiful thing, is a manner of expression scarcely ever used; but that of a great ugly thing, is very common. There is a wide difference between admiration and love. The sublime, which is the cause of the former, always dwells on great objects, and terrible; the latter on small ones, and pleasing; we submit to what we admire, but we love what submits to us; in one case we are forced, in the other we are flattered into compliance. In short, the ideas of the sublime and the beautiful stand on foundations so different, that it is hard, I had almost said impossible, to think of reconciling them in the same subject, without considerably lessening the effect of the one or the other upon the passions. So that attending to their quantity, beautiful objects are comparatively small.

SECTION XIV

SMOOTHNESS

The next property constantly observable in such objects is[1] *Smoothness*. A quality so essential to beauty, that I do not now recollect any thing beautiful that is not smooth. In trees and flowers, smooth leaves are beautiful; smooth slopes of earth in

[1] Part 4, section 21.

gardens; smooth streams in the landscape; smooth coats of birds and beasts in animal beauties; in fine women, smooth skins; and in several sorts of ornamental furniture, smooth and polished surfaces. A very considerable part of the effect of beauty is owing to this quality; indeed the most considerable. For take any beautiful object, and give it a broken and rugged surface, and however well formed it may be in other respects, it pleases no longer. Whereas let it want ever so many of the other constituents, if it wants not this, it becomes more pleasing than almost all the others without it. This seems to me so evident, that I am a good deal surprised, that none who have handled the subject have made any mention of the quality of smoothness in the enumeration of those that go to the forming of beauty. For indeed any ruggedness, any sudden projection, any sharp angle, is in the highest degree contrary to that idea.

SECTION XV
Gradual VARIATION

But as perfectly beautiful bodies are not composed of angular parts, so their parts never continue long in the same right line. [1] They vary their direction every moment, and they change under the eye by a deviation continually carrying on, but for whose beginning or end you will find it difficult to ascertain a point. The view of a beautiful bird will illustrate this observation. Here we see the head increasing insensibly to the middle, from whence it lessens gradually until it mixes with the neck; the neck loses itself in a larger swell, which continues to the middle of the body, when the whole decreases again to the tail; the tail takes a new direction; but it soon varies its new course; it blends again with the other parts; and the line is perpetually changing, above, below, upon every side. In this description I have before me the idea of a dove; it agrees very well with most of the conditions of beauty. It is smooth and downy; its parts are (to use that expression) melted into one another; you are presented with no sudden protuberance through the whole, and yet the whole is continually changing.

[1] Part 5, section 23. This should read : " Part 4, section 23 ".

Observe that part of a beautiful woman where she is perhaps the most beautiful, about the neck and breasts; the smoothness; the softness; the easy and insensible swell; the variety of the surface, which is never for the smallest space the same; the deceitful maze, through which the unsteady eye slides giddily, without knowing where to fix, or whither it is carried. Is not this a demonstration of that change of surface continual and yet hardly perceptible at any point which forms one of the great constituents of beauty? It gives me no small pleasure to find that I can strengthen my theory in this point, by the opinion of the very ingenious Mr. Hogarth;* whose idea of the line of beauty I take in general to be extremely just. But the idea of variation, without attending so accurately to the *manner* of the variation, has led him to consider angular figures as beautiful; these figures, it is true, vary greatly; yet they vary in a sudden and broken manner; and I do not find any natural object which is angular, and at the same time beautiful. Indeed few natural objects are entirely angular. But I think those which approach the most nearly to it, are the ugliest. I must add too, that, so far as I could observe of nature, though the varied line is that alone in which complete beauty is found, yet there is no particular line which is always found in the most completely beautiful; and which is therefore beautiful in preference to all other lines. At least I never could observe it.

SECTION XVI

DELICACY

An air of robustness and strength is very prejudicial to beauty. An appearance of *delicacy*, and even of fragility, is almost essential to it. Whoever examines the vegetable or animal creation, will find this observation to be founded in nature. It is not the oak, the ash, or the elm, or any of the robust trees of the forest, which we consider as beautiful; they are awful and majestic; they inspire a sort of reverence. It is the delicate myrtle, it is the orange, it is the almond, it is the jessamine, it is the vine, which we look on as vegetable beauties. It is the flowery species, so remarkable for its weakness and momentary

THE SUBLIME AND BEAUTIFUL

duration, that gives us the liveliest idea of beauty, and elegance. Among animals; the greyhound is more beautiful than the mastiff; and the delicacy of a gennet, a barb,* or an Arabian horse, is much more amiable than the strength and stability of some horses of war or carriage. I need here say little of the fair sex, where I believe the point will be easily allowed me. The beauty of women is considerably owing to their weakness, or delicacy, and is even enhanced by their timidity, a quality of mind analogous to it. I would not here be understood to say, that weakness betraying very bad health has any share in beauty; but the ill effect of this is not because it is weakness, but because the ill state of health which produces such weakness alters the other conditions of beauty; the parts in such a case collapse; the bright colour, the *lumen purpureum juventæ**is gone; and the fine variation is lost in wrinkles, sudden breaks, and right lines.

SECTION XVII

Beauty in COLOUR

As to the colours usually found in beautiful bodies; it may be somewhat difficult to ascertain them, because in the several parts of nature, there is an infinite variety. However, even in this variety, we may mark out something on which to settle. First, the colours of beautiful bodies must not be dusky or muddy, but clean and fair. Secondly, they must not be of the strongest kind. Those which seem most appropriated to beauty, are the milder of every sort; light greens; soft blues; weak whites; pink reds; and violets. Thirdly, if the colours be strong and vivid, they are always diversified, and the object is never of one strong colour; there are almost always such a number of them (as in variegated flowers) that the strength and glare of each is considerably abated. In a fine complexion, there is not only some variety in the colouring, but the colours, neither the red nor the white are strong and glaring. Besides, they are mixed in such a manner, and with such gradations, that it is impossible to fix the bounds. On the same principle it is, that the dubious colour in the necks and tails of peacocks, and about the heads of drakes, is so very agreeable. In reality, the beauty

both of shape and colouring are as nearly related, as we can well suppose it possible for things of such different natures to be.

SECTION XVIII
RECAPITULATION

On the whole, the qualities of beauty, as they are merely sensible qualities, are the following. First, to be comparatively small. Secondly, to be smooth. Thirdly, to have a variety in the direction of the parts; but fourthly, to have those parts not angular, but melted as it were into each other. Fifthly, to be of a delicate frame, without any remarkable appearance of strength. Sixthly, to have its colours clear and bright; but not very strong and glaring. Seventhly, or if it should have any glaring colour, to have it diversified with others. These are, I believe, the properties on which beauty depends; properties that operate by nature, and are less liable to be altered by caprice, or confounded by a diversity of tastes, than any others.

SECTION XIX
The PHYSIOGNOMY

The *Physiognomy* has a considerable share in beauty, especially in that of our own species. The manners give a certain determination to the countenance, which being observed to correspond pretty regularly with them, is capable of joining the effect of certain agreeable qualities of the mind to those of the body. So that to form a finished human beauty, and to give it its full influence, the face must be expressive of such gentle and amiable qualities, as correspond with the softness, smoothness, and delicacy of the outward form.

SECTION XX
The EYE

I have hitherto purposely omitted to speak of the *Eye*, which has so great a share in the beauty of the animal creation, as it did not fall so easily under the foregoing heads, though in fact it is reducible to the same principles. I think then, that the beauty of the eye consists, first, in its *clearness*; what *coloured* eye shall please most, depends a good deal on particular fancies; but none are pleased with an eye, whose water (to use that term) is dull and muddy.[1] We are pleased with the eye in this view, on the principle upon which we like diamonds, clear water, glass, and such like transparent substances. Secondly, the motion of the eye contributes to its beauty, by continually shifting its direction; but a slow and languid motion is more beautiful than a brisk one; the latter is enlivening; the former lovely. Thirdly, with regard to the union of the eye with the neighbouring parts, it is to hold the same rule that is given of other beautiful ones; it is not to make a strong deviation from the line of the neighbouring parts; nor to verge into any exact geometrical figure. Besides all this, the eye affects, as it is expressive of some qualities of the mind, and its principal power generally arises from this; so that what we have just said of the physiognomy is applicable here.

SECTION XXI
UGLINESS

It may perhaps appear like a sort of repetition of what we have before said, to insist here upon the nature of *Ugliness*. As I imagine it to be in all respects the opposite to those qualities which we have laid down for the constituents of beauty. But though ugliness be the opposite to beauty, it is not the opposite to proportion and fitness. For it is possible that a thing may be very ugly with any proportions, and with a perfect fitness to

[1] Part 4, section 25.

any uses. Ugliness I imagine likewise to be consistent enough with an idea of the sublime. But I would by no means insinuate that ugliness of itself is a sublime idea, unless united with such qualities as excite a strong terror.

SECTION XXII

GRACE

Gracefulness is an idea not very different from beauty; it consists in much the same things. Gracefulness is an idea belonging to *posture* and *motion*. In both these, to be graceful, it is requisite that there be no appearance of difficulty; there is required a small inflexion of the body; and a composure of the parts, in such a manner, as not to incumber each other, nor to appear divided by sharp and sudden angles. In this ease, this round-ness, this delicacy of attitude and motion, it is that all the magic of grace consists, and what is called its *je ne sais quoi*;* as will be obvious to any observer who considers attentively the Venus de Medicis, the Antinous, or any statue generally allowed to be graceful in an high degree.

SECTION XXIII

ELEGANCE and SPECIOUSNESS

When any body is composed of parts smooth and polished, without pressing upon each other, without shewing any rugged-ness or confusion, and at the same time affecting some *regular shape*, I call it *elegant*. It is closely allied to the beautiful, differing from it only in this *regularity*; which however, as it makes a very material difference, in the affection produced, may very well constitute another species. Under this head I rank those delicate and regular works of art, that imitate no determinate object in nature, as elegant buildings, and pieces of furniture. When any object partakes of the above mentioned qualities, or of those of beautiful bodies, and is withal of great dimensions; it is full as remote from the idea of mere beauty. I call it *fine* or *specious*.

SECTION XXIV
The beautiful in FEELING

The foregoing description of beauty, so far as is taken in by the eye, may be greatly illustrated by describing the nature of objects, which produce a similar effect through the touch. This I call the beautiful in *Feeling*. It corresponds wonderfully with what causes the same species of pleasure to the sight. There is a chain in all our sensations; they are all but different sorts of feeling, calculated to be affected by various sorts of objects, but all to be affected after the same manner. All bodies that are pleasant to the touch, are so by the slightness of the resistance they make. Resistance is either to motion along the surface, or to the pressure of the parts on one another; if the former be slight, we call the body, smooth; if the latter, soft. The chief pleasure we receive by feeling, is in the one or the other of these qualities; and if there be a combination of both, our pleasure is greatly increased. This is so plain, that it is rather more fit to illustrate other things, than to be illustrated itself by any example. The next source of pleasure in this sense, as in every other, is the continually presenting somewhat new; and we find that bodies which continually vary their surface, are much the most pleasant, or beautiful, to the feeling, as any one that pleases may experience. The third property in such objects is, that though the surface continually varies its direction, it never varies it suddenly. The application of any thing sudden, even though the impression itself have little or nothing of violence, is disagreeable. The quick application of a finger a little warmer or colder than usual, without notice, makes us start; a slight tap on the shoulder, not expected, has the same effect. Hence it is that angular bodies, bodies that suddenly vary the direction of the outline, afford so little pleasure to the feeling. Every such change is a sort of climbing or falling in miniature; so that squares, triangles, and other angular figures, are neither beautiful to the sight nor feeling. Whoever compares his state of mind, on feeling soft, smooth, variated, unangular bodies, with that in which he finds himself, on the view of a beautiful object, will perceive a very

striking analogy in the effects of both; and which may go a good way towards discovering their common cause. Feeling and sight in this respect, differ in but a few points. The touch takes in the pleasure of softness, which is not primarily an object of sight; the sight on the other hand comprehends colour, which can hardly be made perceptible to the touch; the touch again has the advantage in a new idea of pleasure resulting from a moderate degree of warmth; but the eye triumphs in the infinite extent and multiplicity of its objects. But there is such a similitude in the pleasures of these senses, that I am apt to fancy, if it were possible that one might discern colour by feeling, (as it is said some blind men have done) that the same colours, and the same disposition of colouring, which are found beautiful to the sight, would be found likewise most grateful to the touch. But setting aside conjectures, let us pass to the other sense; of hearing.

SECTION XXV
The beautiful in SOUNDS

In this sense we find an equal aptitude to be affected in a soft and delicate manner; and how far sweet or beautiful sounds agree with our descriptions of beauty in other senses, the experience of every one must decide. Milton has described this species of music in one of his juvenile poems.[1] I need not say that Milton was perfectly well versed in that art; and that no man had a finer ear, with a happier manner of expressing the affections of one sense by metaphors taken from another. The description is as follows.

> ——*And ever against eating cares,*
> *Lap me in* soft *Lydian airs;*
> *In notes with many a* winding *bout*
> *Of* linked sweetness long drawn *out;*
> *With wanton heed, and giddy cunning,*
> *The* melting *voice through* mazes *running;*
> Untwisting *all the chains that tye*
> *The hidden soul of harmony.**

[1] Il allegro.

III

Let us parallel this with the softness, the winding surface, the unbroken continuance, the easy gradation of the beautiful in other things; and all the diversities of the several senses, with all their several affections, will rather help to throw lights from one another to finish one clear, consistent idea of the whole, than to obscure it by their intricacy and variety.

To the above mentioned description I shall add one or two remarks. The first is; that the beautiful in music will not bear that loudness and strength of sounds, which may be used to raise other passions; nor notes, which are shrill, or harsh, or deep; it agrees best with such as are clear, even, smooth, and weak. The second is; that great variety, and quick transitions from one measure or tone to another, are contrary to the genius of the beautiful in music. Such[1] transitions often excite mirth, or other sudden and tumultuous passions; but not that sinking, that melting, that languor, which is the character- istical effect of the beautiful, as it regards every sense. The passion excited by beauty is in fact nearer to a species of melancholy, than to jollity and mirth. I do not here mean to confine music to any one species of notes, or tones, neither is it an art in which I can say I have any great skill. My sole design in this remark is, to settle a consistent idea of beauty. The infinite variety of the affections of the soul will suggest to a good head, and skilful ear, a variety of such sounds, as are fitted to raise them. It can be no prejudice to this, to clear and distinguish some few particulars, that belong to the same class, and are consistent with each other, from the immense croud of different, and someumes contradictory ideas, that rank vulgarly under the standard of beauty. And of these it is my intention to mark such only of the leading points as shew the conformity of the sense of hearing, with all the other senses in the article of their pleasures.

[1] I ne'er am merry, when I hear sweet music.

SHAKESPEARE. *

112

SECTION XXVI
TASTE and SMELL

This general agreement of the senses is yet more evident on minutely considering those of taste and smell. We metaphorically apply the idea of sweetness to sights, and sounds; but as the qualities of bodies by which they are fitted to excite either pleasure or pain in these senses, are not so obvious as they are in the others, we shall refer an explanation of their analogy, which is a very close one, to that part, wherein we come to consider the common efficient cause of beauty as it regards all the senses. I do not think any thing better fitted to establish a clear and settled idea of visual beauty, than this way of examining the similar pleasures of other senses; for one part is sometimes clear in one of these senses, that is more obscure in another; and where there is a clear concurrence of all, we may with more certainty speak of any one of them. By this means, they bear witness to each other; nature is, as it were, scrutinized; and we report nothing of her, but what we receive from her own information.

SECTION XXVII
The Sublime and Beautiful compared

On closing this general view of beauty, it naturally occurs, that we should compare it with the sublime; and in this comparison there appears a remarkable contrast. For sublime objects are vast in their dimensions, beautiful ones comparatively small; beauty should be smooth, and polished; the great, rugged and negligent; beauty should shun the right line, yet deviate from it insensibly; the great in many cases loves the right line, and when it deviates, it often makes a strong deviation; beauty should not be obscure; the great ought to be dark and gloomy; beauty should be light and delicate; the great ought to be solid, and even massive. They are indeed ideas of a very different nature, one being founded on pain, the other on pleasure; and however they may vary afterwards from the direct nature of

their causes, yet these causes keep up an eternal distinction between them, a distinction never to be forgotten by any whose business it is to affect the passions. In the infinite variety of natural combinations we must expect to find the qualities of things the most remote imaginable from each other united in the same object. We must expect also to find combinations of the same kind in the works of art. But when we consider the power of an object upon our passions, we must know that when any thing is intended to affect the mind by the force of some predominant property, the affection produced is like to be the more uniform and perfect, if all the other properties or qualities of the object be of the same nature, and tending to the same design as the principal;

> *If black, and white blend, soften, and unite,*
> *A thousand ways, are there no black and white?*[*]

If the qualities of the sublime and beautiful are sometimes found united, does this prove, that they are the same, does it prove, that they are any way allied, does it prove even that they are not opposite and contradictory? Black and white may soften, may blend, but they are not therefore the same. Nor when they are so softened and blended with each other, or with different colours, is the power of black as black, or of white as white, so strong as when each stands uniform and distinguished.

The end of the Third Part.

A
PHILOSOPHICAL ENQUIRY
INTO THE ORIGIN
OF OUR IDEAS
OF THE SUBLIME
AND BEAUTIFUL

Part Four

SECTION I

Of the efficient cause of the SUBLIME and BEAUTIFUL

WHEN I say, I intend to enquire into the efficient cause of sublimity and beauty, I would not be understood to say, that I can come to the ultimate cause. I do not pretend that I shall ever be able to explain, why certain affections of the body produce such a distinct emotion of mind, and no other; or why the body is at all affected by the mind, or the mind by the body. A little thought will shew this to be impossible. But I conceive, if we can discover what affections of the mind produce certain emotions of the body; and what distinct feelings and qualities of body shall produce certain determinate passions in the mind, and no others, I fancy a great deal will be done; something not unuseful towards a distinct knowledge of our passions, so far at least as we have them at present under our consideration. This is all, I believe, we can do. If we could advance a step farther, difficulties would still remain, as we should be still equally distant from the first cause. When Newton*first discovered the property of attraction, and settled its laws, he found it served very well to explain several of the most remarkable phænomena in nature; but yet with reference to the general system of things, he could consider attraction but as an effect, whose cause at that time he did not attempt to trace. But when he afterwards began to account for it by a subtle elastic æther, this great man (if in so great a man it be not impious to discover any thing like a blemish) seemed to have quitted his usual cautious manner of philosophising; since, perhaps, allowing all that has been advanced on this subject to be sufficiently proved, I think it leaves us with as many difficulties as it found us. That great chain of causes, which linking one to another even to the throne of God himself, can never be unravelled by any industry of ours. When we go but one step beyond the immediately sensible qualities of things, we go out of our depth. All we do after, is but a faint

struggle, that shews we are in an element which does not belong to us. So that when I speak of cause, and efficient cause, I only mean, certain affections of the mind, that cause certain changes in the body; or certain powers and properties in bodies, that work a change in the mind. As if I were to explain the motion of a body falling to the ground, I would say it was caused by gravity, and I would endeavour to shew after what manner this power operated, without attempting to shew why it operated in this manner; or if I were to explain the effects of bodies striking one another by the common laws of percussion, I should not endeavour to explain how motion itself is communicated.

SECTION II
ASSOCIATION

It is no small bar in the way of our enquiry into the cause of our passions, that the occasion of many of them are given, and that their governing motions are communicated at a time when we have not capacity to reflect on them; at a time of which all sort of memory is worn out of our minds. For besides such things as affect us in various manners according to their natural powers, there are associations made at that early season, which we find it very hard afterwards to distinguish from natural effects. Not to mention the unaccountable antipathies which we find in many persons, we all find it impossible to remember when a steep became more terrible than a plain; or fire or water more dreadful than a clod of earth; though all these are very probably either conclusions from experience, or arising from the premonitions of others; and some of them impressed, in all likelihood, pretty late. But as it must be allowed that many things affect us after a certain manner, not by any natural powers they have for that purpose, but by association; so it would be absurd on the other hand, to say that all things affect us by association only; since some things must have been originally and naturally agreeable or disagreeable, from which the others derive their associated powers; and it would be, I fancy, to little purpose to look for the cause of

our passions in association, until we fail of it in the natural properties of things.

SECTION III

Cause of PAIN and FEAR

I have before observed,[1] that whatever is qualified to cause terror, is a foundation capable of the sublime; to which I add, that not only these, but many things from which we cannot probably apprehend any danger have a similar effect, because they operate in a similar manner. I observed too, that[2] whatever produces pleasure, positive and original pleasure, is fit to have beauty engrafted on it. Therefore, to clear up the nature of these qualities, it may be necessary to explain the nature of pain and pleasure on which they depend. A man who suffers under violent bodily pain; (I suppose the most violent, because the effect may be the more obvious.) I say a man in great pain has his teeth set, his eye-brows are violently contracted, his forehead is wrinkled, his eyes are dragged inwards, and rolled with great vehemence, his hair stands on end, the voice is forced out in short shrieks and groans, and the whole fabric totters. Fear or terror, which is an apprehension of pain or death, exhibits exactly the same effects, approaching in violence to those just mentioned in proportion to the nearness of the cause, and the weakness of the subject. This is not only so in the human species, but I have more than once observed in dogs, under an apprehension of punishment, that they have writhed their bodies, and yelped, and howled, as if they had actually felt the blows. From hence I conclude that pain, and fear, act upon the same parts of the body, and in the same manner, though somewhat differing in degree. That pain and fear consist in an unnatural tension of the nerves; that this is sometimes accompanied with an unnatural strength, which sometimes suddenly changes into an extraordinary weakness; that these effects often come on alternately, and are sometimes mixed with each other. This is the

[1] Part 1, section 8. This should presumably read: "Part 1, section 7."
[2] Part 1, section 10.

nature of all convulsive agitations, especially in weaker subjects, which are the most liable to the severest impressions of pain and fear. The only difference between pain and terror, is, that things which cause pain operate on the mind, by the intervention of the body; whereas things that cause terror generally affect the bodily organs by the operation of the mind suggesting the danger; but both agreeing, either primarily, or secondarily, in producing a tension, contraction, or violent emotion of the nerves[1], they agree likewise in every thing else. For it appears very clearly to me, from this, as well as from many other examples, that when the body is disposed, by any means whatsoever, to such emotions as it would acquire by the means of a certain passion; it will of itself excite something very like that passion in the mind.

SECTION IV
Continued

To this purpose Mr. Spon, in his Recherches d'Antiquité, gives us a curious story of the celebrated physiognomist Campanella;* this man, it seems, had not only made very accurate observations on human faces, but was very expert in mimicking such, as were any way remarkable. When he had a mind to penetrate into the inclinations of those he had to deal with, he composed his face, his gesture, and his whole body, as nearly as he could into the exact similitude of the person he intended to examine; and then carefully observed what turn of mind he seemed to acquire by this change. So that, says my author, he was able to enter into the dispositions and thoughts of people, as effectually as if he had been changed into the very men. I have often observed, that on mimicking the looks and gestures, of angry, or placid, or frighted, or daring men, I have involuntarily found my mind turned to that passion whose

[1] I do not here enter into the question debated among physiologists, whether pain be the effect of a contraction, or a tension of the nerves. Either will serve my purpose; for by tension, I mean no more than a violent pulling of the fibres, which compose any muscle or membrane, in whatever way this is done.

appearance I endeavoured to imitate; nay, I am convinced it is hard to avoid it; though one strove to separate the passion from its correspondent gestures. Our minds and bodies are so closely and intimately connected, that one is incapable of pain or pleasure without the other. Campanella, of whom we have been speaking, could so abstract his attention from any sufferings of his body, that he was able to endure the rack itself without much pain; and in lesser pains, every body must have observed, that when we can employ our attention on any thing else, the pain has been for a time suspended; on the other hand, if by any means the body is indisposed to perform such gestures, or to be stimulated into such emotions as any passion usually produces in it, that passion itself never can arise, though its cause should be never so strongly in action; though it should be merely mental, and immediately affecting none of the senses. As an opiate, or spirituous liquors shall suspend the operation of grief, or fear, or anger, in spite of all our efforts to the contrary; and this by inducing in the body a disposition contrary to that which it receives from these passions.

SECTION V

How the Sublime is produced

Having considered terror as producing an unnatural tension and certain violent emotions of the nerves; it easily follows, from what we have just said, that whatever is fitted to produce such a tension, must be productive of a passion similar to terror[1], and consequently must be a source of the sublime, though it should have no idea of danger connected with it. So that little remains towards shewing the cause of the sublime, but to shew that the instances we have given of it in the second part, relate to such things, as are fitted by nature to produce this sort of tension, either by the primary operation of the mind or the body. With regard to such things as affect by the associated idea of danger, there can be no doubt but that they produce terror, and act by some modification of that passion;

[1] Part 2, section 2.

and that terror, when sufficiently violent, raises the emotions of the body just mentioned, can as little be doubted. But if the sublime is built on terror, or some passion like it, which has pain for its object; it is previously proper to enquire how any species of delight can be derived from a cause so apparently contrary to it. I say, *delight*, because, as I have often remarked, it is very evidently different in its cause, and in its own nature, from actual and positive pleasure.

SECTION VI

How pain can be a cause of delight

Providence has so ordered it, that a state of rest and inaction, however it may flatter our indolence, should be productive of many inconveniencies; that it should generate such disorders, as may force us to have recourse to some labour, as a thing absolutely requisite to make us pass our lives with tolerable satisfaction; for the nature of rest is to suffer all the parts of our bodies to fall into a relaxation, that not only disables the members from performing their functions, but takes away the vigorous tone of fibre which is requisite for carrying on the natural and necessary secretions. At the same time, that in this languid inactive state, the nerves are more liable to the most horrid convulsions, than when they are sufficiently braced and strengthened. Melancholy, dejection, despair, and often self-murder, is the consequence of the gloomy view we take of things in this relaxed state of body. The best remedy for all these evils is exercise or *labour*; and labour is a surmounting of *difficulties*, an exertion of the contracting power of the muscles; and as such resembles pain, which consists in tension or contraction, in every thing but degree. Labour is not only requisite to preserve the coarser organs in a state fit for their functions, but it is equally necessary to these finer and more delicate organs, on which, and by which, the imagination, and perhaps the other mental powers act. Since it is probable, that not only the inferior parts of the soul, as the passions are called, but the understanding itself makes use of some fine corporeal

instruments in its operation; though what they are, and where they are, may be somewhat hard to settle: but that it does make use of such, appears from hence; that a long exercise of the mental powers induces a remarkable lassitude of the whole body; and on the other hand, that great bodily labour, or pain, weakens, and sometimes actually destroys the mental faculties. Now, as a due exercise is essential to the coarse muscular parts of the constitution, and that without this rousing they would become languid, and diseased, the very same rule holds with regard to those finer parts we have mentioned; to have them in proper order, they must be shaken and worked to a proper degree.

SECTION VII

EXERCISE necessary for the finer organs

As common labour, which is a mode of pain, is the exercise of the grosser, a mode of terror is the exercise of the finer parts of the system; and if a certain mode of pain be of such a nature as to act upon the eye or the ear, as they are the most delicate organs, the affection approaches more nearly to that which has a mental cause. In all these cases, if the pain and terror are so modified as not to be actually noxious; if the pain is not carried to violence, and the terror is not conversant about the present destruction of the person, as these emotions clear the parts, whether fine, or gross, of a dangerous and troublesome incumbrance, they are capable of producing delight; not pleasure, but a sort of delightful horror, a sort of tranquillity tinged with terror; which as it belongs to self-preservation is one of the strongest of all the passions. Its object is the sublime [1]. Its highest degree I call *astonishment*; the subordinate degrees are awe, reverence, and respect, which by the very etymology of the words shew from what source they are derived, and how they stand distinguished from positive pleasure.

[1] Part 2, section 2.

SECTION VIII

Why things not dangerous produce a passion like TERROR

[1]A mode of terror, or of pain, is always the cause of the sublime. For terror, or associated danger, the foregoing explication is, I believe, sufficient. It will require something more trouble to shew, that such examples, as I have given of the sublime in the second part, are capable of producing a mode of pain, and of being thus allied to terror, and to be accounted for on the same principles. And first of such objects as are great in their dimensions. I speak of visual objects.

SECTION IX

Why visual objects of great dimensions are Sublime

Vision is performed by having a picture formed by the rays of light which are reflected from the object, painted in one piece, instantaneously, on the retina, or last nervous part of the eye. Or, according to others, there is but one point of any object painted on the eye in such a manner as to be perceived at once; but by moving the eye, we gather up with great celerity, the several parts of the object, so as to form one uniform piece. If the former opinion be allowed, it will be considered, that[2] though all the light reflected from a large body should strike the eye in one instant; yet we must suppose that the body itself is formed of a vast number of distinct points, every one of which, or the ray from every one, makes an impression on the retina. So that, though the image of one point should cause but a small tension of this membrane, another, and another, and another stroke, must in their progress cause a very great one, until it arrives at last to the highest degree; and the whole capacity of the eye, vibrating in all its parts must approach near to the nature of what causes pain, and consequently must

[1] Part 1, section 7. Part 2, section 2.

[2] Part 2, section 7.

produce an idea of the sublime. Again, if we take it, that one point only of an object is distinguishable at once; the matter will amount nearly to the same thing, or rather it will make the origin of the sublime from greatness of dimension yet clearer. For if but one point is observed at once, the eye must traverse the vast space of such bodies with great quickness, and consequently the fine nerves and muscles destined to the motion of that part must be very much strained; and their great sensibility must make them highly affected by this straining. Besides, it signifies just nothing to the effect produced, whether a body has its parts connected and makes its impression at once; or making but one impression of a point at a time, it causes a succession of the same, or others, so quickly, as to make them seem united; as is evident from the common effect of whirling about a lighted torch or piece of wood; which if done with celerity, seems a circle of fire.

SECTION X

UNITY why requisite to vastness

It may be objected to this theory, that the eye generally receives an equal number of rays at all times, and that therefore a great object cannot affect it by the number of rays, more than that variety of objects which the eye must always discern whilst it remains open. But to this I answer, that admitting an equal number of rays, or an equal quantity of luminous particles to strike the eye at all times, yet if these rays frequently vary their nature, now to blue, now to red, and so on, or their manner of termination as to a number of petty squares, triangles, or the like, at every change, whether of colour or shape, the organ has a sort of relaxation or rest; but this relaxation and labour so often interrupted, is by no means productive of ease; neither has it the effect of vigorous and uniform labour. Whoever has remarked the different effects of some strong exercise, and some little piddling action, will understand why a teazing fretful employment, which at once wearies and weakens the body, should have nothing great; these sorts of impulses which are rather teazing than painful, by continually and suddenly altering their tenor and direction, prevent that full tension,

that species of uniform labour which is allied to strong pain, and causes the sublime. The sum total of things of various kinds, though it should equal the number of the uniform parts composing some *one* entire object, is not equal in its effect upon the organs of our bodies. Besides the one already assigned, there is another very strong reason for the difference. The mind in reality hardly ever can attend diligently to more than one thing at a time; if this thing be little, the effect is little, and a number of other little objects cannot engage the attention; the mind is bounded by the bounds of the object; and what is not attended to, and what does not exist, are much the same in the effect; but the eye or the mind (for in this case there is no difference) in great uniform objects does not readily arrive at their bounds; it has no rest, whilst it contemplates them; the image is much the same every where. So that every thing great by its quantity must necessarily be, one, simple and entire.

SECTION XI

The artificial INFINITE

We have observed, that a species of greatness arises from the artificial infinite; and that this infinite consists in an uniform succession of great parts: we observed too, that the same uniform succession had a like power in sounds. But because the effects of many things are clearer in one of the senses than in another, and that all the senses bear an analogy to, and illustrate one another; I shall begin with this power in sounds, as the cause of the sublimity from succession is rather more obvious in the sense of hearing. And I shall here once for all observe, that an investigation of the natural and mechanical causes of our passions, besides the curiosity of the subject, gives, if they are discovered, a double strength and lustre to any rules we deliver on such matters. When the ear receives any simple sound, it is struck by a single pulse of the air, which makes the ear-drum and the other membranous parts vibrate according to the nature and species of the stroke. If the stroke be strong, the organ of hearing suffers a considerable degree of tension. If the stroke be repeated pretty soon after, the repeti-

tion causes an expectation of another stroke. And it must be observed, that expectation itself causes a tension. This is apparent in many animals, who, when they prepare for hearing any sound, rouse themselves, and prick up their ears; so that here the effect of the sounds is considerably augmented by a new auxiliary, the expectation. But though after a number of strokes, we expect still more, not being able to ascertain the exact time of their arrival, when they arrive, they produce a sort of surprise, which increases this tension yet further. For, I have observed, that when at any time I have waited very earnestly for some sound, that returned at intervals, (as the successive firing of cannon) though I fully expected the return of the sound, when it came, it always made me start a little; the ear-drum suffered a convulsion, and the whole body consented with it. The tension of the part thus increasing at every blow, by the united forces of the stroke itself, the expectation, and the surprise, it is worked up to such a pitch as to be capable of the sublime; it is brought just to the verge of pain. Even when the cause has ceased; the organs of hearing being often successively struck in a similar manner, continue to vibrate in that manner for some time longer; this is an additional help to the greatness of the effect.

SECTION XII
The vibrations must be similar

But if the vibration be not similar at every impression, it can never be carried beyond the number of actual impressions; for move any body, as a pendulum, in one way, and it will continue to oscillate in an arch of the same circle, until the known causes make it rest; but if after first putting it in motion in one direction, you push it into another, it can never reassume the first direction; because it can never move itself, and consequently it can have but the effect of that last motion; whereas, if in the same direction you act upon it several times, it will describe a greater arch, and move a longer time.

SECTION XIII

The effects of SUCCESSION in visual objects explained

If we can comprehend clearly how things operate upon one of our senses; there can be very little difficulty in conceiving in what manner they affect the rest. To say a great deal therefore upon the corresponding affections of every sense, would tend rather to fatigue us by an useless repetition, than to throw any new light upon the subject, by that ample and diffuse manner of treating it; but as in this discourse we chiefly attach ourselves to the sublime, as it affects the eye, we shall consider particularly why a successive disposition of uniform parts in the same right line should be sublime,[1] and upon what principle this disposition is enabled to make a comparatively small quantity of matter produce a grander effect, than a much larger quantity disposed in another manner. To avoid the perplexity of general notions; let us set before our eyes a colonnade of uniform pillars planted in a right line; let us take our stand, in such a manner, that the eye may shoot along this colonnade, for it has its best effect in this view. In our present situation it is plain, that the rays from the first round pillar will cause in the eye a vibration of that species; an image of the pillar itself. The pillar immediately succeeding increases it; that which follows renews and enforces the impression; each in its order as it succeeds, repeats impulse after impulse, and stroke after stroke, until the eye long exercised in one particular way cannot lose that object immediately; and being violently roused by this continued agitation, it presents the mind with a grand or sublime conception. But instead of viewing a rank of uniform pillars; let us suppose, that they succeed each other, a round and a square one alternately. In this case the vibration caused by the first round pillar perishes as soon as it is formed; and one of quite another sort (the square) directly occupies its place; which however it resigns as quickly to the round one; and thus the eye proceeds, alternately, taking up one image and laying

[1] Part 2, section 10.

down another, as long as the building continues. From whence it is obvious, that at the last pillar, the impression is as far from continuing as it was at the very first; because in fact, the sensory can receive no distinct impression but from the last; and it can never of itself resume a dissimilar impression: besides, every variation of the object is a rest and relaxation to the organs of sight; and these reliefs prevent that powerful emotion so necessary to produce the sublime. To produce therefore a perfect grandeur in such things as we have been mentioning, there should be a perfect simplicity, an absolute uniformity in disposition, shape and colouring. Upon this principle of succession and uniformity it may be asked, why a long bare wall should not be a more sublime object than a colonnade; since the succession is no way interrupted; since the eye meets no check; since nothing more uniform can be conceived? A long bare wall is certainly not so grand an object as a colonnade of the same length and height. It is not altogether difficult to account for this difference. When we look at a naked wall, from the evenness of the object, the eye runs along its whole space, and arrives quickly at its termination; the eye meets nothing which may interrupt its progress; but then it meets nothing which may detain it a proper time to produce a very great and lasting effect. The view of a bare wall, if it be of a great height and length, is undoubtedly grand: but this is only *one* idea, and not a *repetition* of *similar* ideas; it is therefore great, not so much upon the principle of *infinity*, as upon that of *vastness*. But we are not so powerfully affected with any one impulse, unless it be one of a prodigious force indeed, as we are with a succession of similar impulses; because the nerves of the sensory do not (if I may use the expression) acquire a habit of repeating the same feeling in such a manner as to continue it longer than its cause is in action; besides, all the effects which I have attributed to expectation and surprise in section 11. can have no place in a bare wall.

SECTION XIV

Locke's opinion concerning darkness, considered

It is Mr. Locke's opinion, that darkness is not naturally an idea of terror; and that, though an excessive light is painful to the sense, that the greatest excess of darkness is no ways troublesome.* He observes indeed in another place, that a nurse or an old woman having once associated the ideas of ghosts and goblins with that of darkness; night ever after becomes painful and horrible to the imagination.* The authority of this great man is doubtless as great, as that of any man can be, and it seems to stand in the way of our general principle.[1] We have considered darkness as a cause of the sublime; and we have all along considered the sublime as depending on some modification of pain or terror; so that, if darkness be no way painful or terrible to any, who have not had their minds early tainted with superstitions, it can be no source of the sublime to them. But with all deference to such an authority; it seems to me, that an association of a more general nature, an association which takes in all mankind may make darkness terrible; for in utter darkness, it is impossible to know in what degree of safety we stand; we are ignorant of the objects that surround us; we may every moment strike against some dangerous obstruction; we may fall down a precipice the first step we take; and if an enemy approach, we know not in what quarter to defend ourselves; in such a case strength is no sure protection; wisdom can only act by guess; the boldest are staggered, and he who would pray for nothing else towards his defence, is forced to pray for light.

> Ζεῦ πάτερ, ἀλλὰ σὺ ῥῦσαι ὑπ᾽ ἠέρος υἷας Ἀχαιῶν,
> ποίησον δ᾽ αἴθρην, δὸς δ᾽ ὀφθαλμοῖσιν ἰδέσθαι·
> ἐν δὲ φάει καὶ ὄλεσσον.*

As to the association of ghosts and goblins; surely it is more natural to think, that darkness being originally an idea of terror, was chosen as a fit scene for such terrible representations, than that such representations have made darkness terrible.

[1] Part 2, section 3.

The mind of man very easily slides into an error of the former sort; but it is very hard to imagine, that the effect of an idea so universally terrible in all times, and in all countries, as darkness, could possibly have been owing to a set of idle stories, or to any cause of a nature so trivial, and of an operation so precarious.

SECTION XV

DARKNESS terrible in its own nature

Perhaps it may appear on enquiry, that blackness and darkness are in some degree painful by their natural operation, independent of any associations whatsoever. I must observe, that the ideas of darkness and blackness are much the same; and they differ only in this, that blackness is a more confined idea. Mr. Cheselden*has given us a very curious story of a boy, who had been born blind, and continued so until he was thirteen or fourteen years old; he was then couched for a cataract, by which operation he received his sight. Among many remarkable particulars that attended his first perceptions, and judgments on visual objects, Cheselden tells us, that the first time the boy saw a black object, it gave him great uneasiness; and that some time after, upon accidentally seeing a negro woman, he was struck with great horror at the sight. The horror, in this case, can scarcely be supposed to arise from any association. The boy appears by the account to have been particularly observing, and sensible for one of his age: and therefore, it is probable, if the great uneasiness he felt at the first sight of black had arisen from its connexion with any other disagreeable ideas, he would have observed and mentioned it. For an idea, disagreeable only by association, has the cause of its ill effect on the passions evident enough at the first impression; in ordinary cases, it is indeed frequently lost; but this is, because the original association was made very early, and the consequent impression repeated often. In our instance, there was no time for such an habit; and there is no reason to think, that the ill effects of black on his imagination were more owing to its connexion

with any disagreeable ideas, than that the good effects of more
cheerful colours were derived from their connexion with
pleasing ones. They had both probably their effects from their
natural operation.

SECTION XVI

Why DARKNESS is terrible

It may be worth while to examine, how darkness can operate
in such a manner as to cause pain. It is observable, that still
as we recede from the light, nature has so contrived it, that the
pupil is enlarged by the retiring of the iris, in proportion to our
recess. Now instead of declining from it but a little, suppose
that we withdraw entirely from the light; it is reasonable to
think, that the contraction of the radial fibres of the iris is
proportionably greater; and that this part may by great
darkness come to be so contracted, as to strain the nerves that
compose it beyond their natural tone; and by this means to
produce a painful sensation. Such a tension it seems there
certainly is, whilst we are involved in darkness; for in such a
state whilst the eye remains open, there is a continual nisus*to
receive light; this is manifest from the flashes, and luminous
appearances which often seem in these circumstances to play
before it; and which can be nothing but the effect of spasms,
produced by its own efforts in pursuit of its object; several
other strong impulses will produce the idea of light in the eye,
besides the substance of light itself, as we experience on many
occasions. Some who allow darkness to be a cause of the
sublime, would infer from the dilatation of the pupil, that a
relaxation may be productive of the sublime as well as a
convulsion; but they do not, I believe, consider, that although
the circular ring of the iris be in some sense a sphincter, which
may possibly be dilated by a simple relaxation, yet in one
respect it differs from most of the other sphincters of the body,
that it is furnished with antagonist muscles, which are the radial
fibres of the iris; no sooner does the circular muscle begin to
relax, than these fibres wanting their counterpoise, are forcibly
drawn back, and open the pupil to a considerable wideness.

But though we were not apprized of this, I believe any one will find if he opens his eyes and makes an effort to see in a dark place, that a very perceivable pain ensues. And I have heard some ladies remark, that after having worked a long time upon a ground of black, their eyes were so pained and weakened they could hardly see. It may perhaps be objected to this theory of the mechanical effect of darkness , that the ill effects of darkness or blackness seem rather mental than corporeal; and I own it is true, that they do so; and so do all those that depend on the affections of the finer parts of our system. The ill effects of bad weather appear often no otherwise, than in a melancholy and dejection of spirits, though without doubt, in this case, the bodily organs suffer first, and the mind through these organs.

SECTION XVII

The effects of BLACKNESS

Blackness is but a *partial darkness*; and therefore it derives some of its powers from being mixed and surrounded with coloured bodies. In its own nature, it cannot be considered as a colour. Black bodies, reflecting none, or but a few rays, with regard to sight, are but as so many vacant spaces dispersed among the objects we view. When the eye lights on one of these vacuities, after having been kept in some degree of tension by the play of the adjacent colours upon it, it suddenly falls into a relaxation; out of which it as suddenly recovers by a convulsive spring. To illustrate this; let us consider, that when we intend to sit on a chair, and find it much lower than was expected, the shock is very violent; much more violent than could be thought from so slight a fall as the difference between one chair and another can possibly make. If, after descending a flight of stairs, we attempt inadvertently to take another step in the manner of the former ones, the shock is extremely rude and disagreeable; and by no art, can we cause such a shock by the same means, when we expect and prepare for it. When I say, that this is owing to having the change made contrary to expectation; I do not mean solely, when the *mind* expects. I mean likewise, that when any organ of sense is for some time

affected in some one manner, if it be suddenly affected other-wise there ensues a convulsive motion; such a convulsion as is caused when any thing happens against the expectance of the mind. And though it may appear strange that such a change as produces a relaxation, should immediately produce a sudden convulsion; it is yet most certainly so, and so in all the senses. Every one knows that sleep is a relaxation; and that silence, where nothing keeps the organs of hearing in action, is in general fittest to bring on this relaxation; yet when a sort of murmuring sounds dispose a man to sleep, let these sounds cease suddenly, and the person immediately awakes; that is, the parts are braced up suddenly, and he awakes. This I have often experienced myself, and I have heard the same from observing persons. In like manner, if a person in broad day light were falling asleep, to introduce a sudden darkness would prevent his sleep for that time, though silence and darkness in themselves, and not suddenly introduced, are very favourable to it. This I knew only by conjecture on the analogy of the senses when I first digested these observations; but I have since experienced it. And I have often experienced, and so have a thousand others; that on the first inclining towards sleep, we have been suddenly awakened with a most violent start; and that this start was generally preceded by a sort of dream of our falling down a precipice: whence does this strange motion arise; but from the too sudden relaxation of the body, which by some mechanism in nature restores itself by as quick and vigorous an exertion of the contracting power of the muscles? the dream itself is caused by this relaxation; and it is of too uniform a nature to be attributed to any other cause. The parts relax too suddenly, which is in the nature of falling; and this accident of the body induces this image in the mind. When we are in a confirmed state of health and vigour, as all changes are then less sudden, and less on the extreme, we can seldom complain of this disagreeable sensation.

SECTION XVIII
The effects of BLACKNESS moderated

Though the effects of black be painful originally, we must not think they always continue so. Custom reconciles us to every thing. After we have been used to the sight of black objects, the terror abates, and the smoothness and glossiness or some agreeable accident of bodies so coloured, softens in some measure the horror and sternness of their original nature; yet the nature of the original impression still continues. Black will always have something melancholy in it, because the sensory will always find the change to it from other colours too violent; or if it occupy the whole compass of the sight, it will then be darkness; and what was said of darkness, will be applicable here. I do not purpose to go into all that might be said to illustrate this theory of the effects of light and darkness; neither will I examine all the different effects produced by the various modifications and mixtures of these two causes. If the foregoing observations have any foundation in nature, I conceive them very sufficient to account for all the phænomena that can arise from all the combinations of black with other colours. To enter into every particular, or to answer every objection, would be an endless labour. We have only followed the most leading roads, and we shall observe the same conduct in our enquiry into the cause of beauty.

SECTION XIX
The physical cause of LOVE

When we have before us such objects as excite love and complacency, the body is affected, so far as I could observe, much in the following manner. The head reclines something on one side; the eyelids are more closed than usual, and the eyes roll gently with an inclination to the object, the mouth is a little opened, and the breath drawn slowly, with now and then a low sigh: the whole body is composed, and the hands fall idly to the sides. All this is accompanied with an inward sense of melting and languor. These appearances are always propor-

tioned to the degree of beauty in the object, and of sensibility in the observer. And this gradation from the highest pitch of beauty and sensibility, even to the lowest of mediocrity and indifference, and their correspondent effects, ought to be kept in view, else this description will seem exaggerated, which it certainly is not. But from this description it is almost impossible not to conclude, that beauty acts by relaxing the solids of the whole system. There are all the appearances of such a relaxation; and a relaxation somewhat below the natural tone seems to me to be the cause of all positive pleasure. Who is a stranger to that manner of expression so common in all times and in all countries, of being softened, relaxed, enervated, dissolved, melted away by pleasure?* The universal voice of mankind, faithful to their feelings, concurs in affirming this uniform and general effect; and although some odd and particular instance may perhaps be found, wherein there appears a considerable degree of positive pleasure, without all the characters of relaxation, we must not therefore reject the conclusion we had drawn from a concurrence of many experiments, but we must still retain it, subjoining the exceptions which may occur according to the judicious rule laid down by Sir Isaac Newton in the third book of his Optics.* Our position will, I conceive, appear confirmed beyond any reasonable doubt, if we can shew that such things as we have already observed to be the genuine constituents of beauty, have each of them separately taken a natural tendency to relax the fibres. And if it must be allowed us, that the appearance of the human body, when all these constituents are united together before the sensory, further favours this opinion, we may venture, I believe, to conclude, that the passion called love is produced by this relaxation. By the same method of reasoning, which we have used in the enquiry into the causes of the sublime, we may likewise conclude, that as a beautiful object presented to the sense, by causing a relaxation in the body, produces the passion of love in the mind; so if by any means the passion should first have its origin in the mind, a relaxation of the outward organs will as certainly ensue in a degree proportioned to the cause.

SECTION XX
Why SMOOTHNESS is beautiful

It is to explain the true cause of visual beauty, that I call in the assistance of the other senses. If it appears that *smoothness* is a principal cause of pleasure to the touch, taste, smell, and hearing, it will be easily admitted a constituent of visual beauty; especially as we have before shewn, that this quality is found almost without exception in all bodies that are by general consent held beautiful. There can be no doubt that bodies which are rough and angular, rouse and vellicate* the organs of feeling, causing a sense of pain, which consists in the violent tension or contraction of the muscular fibres. On the contrary, the application of smooth bodies relax; gentle stroking with a smooth hand allays violent pains and cramps, and relaxes the suffering parts from their unnatural tension; and it has therefore very often no mean effect in removing swellings and obstructions. The sense of feeling is highly gratified with smooth bodies. A bed smoothly laid, and soft, that is, where the resistance is every way inconsiderable, is a great luxury, disposing to an universal relaxation, and inducing beyond any thing else, that species of it called sleep.

SECTION XXI
SWEETNESS, its nature

Nor is it only in the touch, that smooth bodies cause positive pleasure by relaxation. In the smell and taste, we find all things agreeable to them, and which are commonly called sweet, to be of a smooth nature, and that they all evidently tend to relax their respective sensories. Let us first consider the taste. Since it is most easy to enquire into the property of liquids, and since all things seem to want a fluid vehicle to make them tasted at all, I intend rather to consider the liquid than the solid parts of our food. The vehicles of all tastes are *water* and *oil*. And what determines the taste is some salt, which affects

variously according to its nature, or its manner of being combined with other things. Water and oil simply considered are capable of giving some pleasure to the taste. Water, when simple, is insipid, inodorous, colourless, and smooth; it is found when *not cold* to be a great resolver of spasms, and lubricator of the fibres; this power it probably owes to its smoothness. For as fluidity depends, according to the most general opinion, on the roundness, smoothness, and weak cohesion of the component parts of any body; and as water acts merely as a simple fluid; it follows, that the cause of its fluidity is likewise the cause of its relaxing quality; namely, the smoothness and slippery texture of its parts. The other fluid vehicle of tastes is *oil*. This too, when simple, is insipid, inodorous, colourless, and smooth to the touch and taste. It is smoother than water, and in many cases yet more relaxing. Oil is in some degree pleasant to the eye, the touch and the taste, insipid as it is. Water is not so grateful, which I do not know on what principle to account for, other than that water is not so soft and smooth. Suppose that to this oil or water were added a certain quantity of a specific salt, which had a power of putting the nervous papillæ*of the tongue into a gentle vibratory motion; as suppose sugar dissolved in it. The smoothness of the oil, and the vibratory power of the salt, cause the sense we call sweetness. In all sweet bodies, sugar, or a substance very little different from sugar, is constantly found; every species of salt examined by the microscope has its own distinct, regular, invariable form. That of nitre is a pointed oblong; that of sea salt an exact cube; that of sugar a perfect globe. If you have tried how smooth globular bodies, as the marbles with which boys amuse themselves, have affected the touch when they are rolled backward and forward and over one another, you will easily conceive how sweetness, which consists in a salt of such nature, affects the taste; for a single globe, (though somewhat pleasant to the feeling) yet by the regularity of its form, and the somewhat too sudden deviation of its parts from a right line, it is nothing near so pleasant to the touch as several globes, where the hand gently rises to one and falls to another; and this pleasure is greatly increased if the globes are in motion, and sliding over one another; for this soft variety prevents that

weariness, which the uniform disposition of the several globes would otherwise produce. Thus in sweet liquors, the parts of the fluid vehicle though most probably round, are yet so minute as to conceal the figure of their component parts from the nicest inquisition of the microscope; and consequently being so excessively minute, they have a sort of flat simplicity to the taste, resembling the effects of plain smooth bodies to the touch; for if a body be composed of round parts excessively small, and packed pretty closely together, the surface will be both to the sight and touch as if it were nearly plain and smooth. It is clear from their unveiling their figure to the microscope, that the particles of sugar are considerably larger than those of water or oil, and consequently that their effects from their roundness will be more distinct and palpable to the nervous papillæ of that nice organ the tongue: they will induce that sense called sweetness, which in a weak manner we discover in oil, and in a yet weaker in water; for insipid as they are, water and oil are in some degree sweet; and it may be observed, that insipid things of all kinds approach more nearly to the nature of sweetness than to that of any other taste.

SECTION XXII

SWEETNESS relaxing

In the other senses we have remarked, that smooth things are relaxing. Now it ought to appear that sweet things, which are the smooth of taste, are relaxing too. It is remarkable, that in some languages soft and sweet have but one name. *Doux* in French signifies soft as well as sweet. The Latin *Dulcis*, and the Italian *Dolce*, have in many cases the same double signification. That sweet things are generally relaxing is evident; because all such, especially those which are most oily, taken frequently or in a large quantity, very much enfeeble the tone of the stomach. Sweet smells, which bear a great affinity to sweet tastes, relax very remarkably. The smell of flowers disposes people to drowsiness; and this relaxing effect is further apparent from the prejudice which people of weak nerves

receive from their use. It were worth while to examine, whether tastes of this kind, sweet ones, tastes that are caused by smooth oils and a relaxing salt are not the originally pleasant tastes. For many which use has rendered such, were not at all agreeable at first. The way to examine this is, to try what nature has originally provided for us, which she has undoubtedly made originally pleasant: and to analyse this provision. *Milk* is the first support of our childhood. The component parts of this are water, oil, and a sort of a very sweet salt called the sugar of milk. All these when blended have a great *smoothness* to the taste, and a relaxing quality to the skin. The next thing children covet is *fruit*, and of fruits, those principally which are sweet; and every one knows that the sweetness of fruit is caused by a subtle oil and such a salt as that mentioned in the last section. Afterwards, custom, habit, the desire of novelty, and a thousand other causes, confound, adulterate, and change our palates, so that we can no longer reason with any satisfaction about them. Before we quit this article we must observe; that as smooth things are, as such, agreeable to the taste, and are found of a relaxing quality; so on the other hand, things which are found by experience to be of a strengthening quality, and fit to brace the fibres, are almost universally rough and pungent to the taste, and in many cases rough even to the touch. We often apply the quality of sweetness, metaphorically, to visual objects. For the better carrying on this remarkable analogy of the senses, we may here call sweetness the beautiful of the taste.

SECTION XXIII

VARIATION, why beautiful

Another principal property of beautiful objects is, that the line of their parts is continually varying its direction; but it varies it by a very insensible deviation, it never varies it so quickly as to surprise, or by the sharpness of its angle to cause any twitching or convulsion of the optic nerve. Nothing long continued in the same manner, nothing very suddenly varied can be beautiful; because both are opposite to that agreeable relaxation, which is the characteristic effect of beauty. It is thus in all the senses. A motion in a right line, is that manner of

moving next to a very gentle descent, in which we meet the
least resistance; yet it is not that manner of moving, which
next to a descent, wearies us the least. Rest certainly tends to
relax; yet there is a species of motion which relaxes more than
rest; a gentle oscillatory motion, a rising and falling. Rocking
sets children to sleep better than absolute rest; there is indeed
scarce any thing at that age, which gives more pleasure than to
be gently lifted up and down; the manner of playing which
their nurses use with children, and the weighing and swinging
used afterwards by themselves as a favourite amusement,
evince this very sufficiently. Most people must have observed
the sort of sense they have had, on being swiftly drawn in an
easy coach, on a smooth turf, with gradual ascents and
declivities. This will give a better idea of the beautiful, and
point out its probable cause better than almost any thing else.
On the contrary; when one is hurried over a rough, rocky,
broken road, the pain felt by these sudden inequalities shews
why similar sights, feelings and sounds, are so contrary to
beauty; and with regard to the feeling, it is exactly the same
in its effect, or very nearly the same, whether, for instance, I
move my hand along the surface of a body of a certain shape, or
whether such a body is moved along my hand. But to bring
this analogy of the senses home to the eye; if a body presented
to that sense has such a waving surface that the rays of light
reflected from it are in a continual insensible deviation from the
strongest to the weakest, (which is always the case in a surface
gradually unequal,) it must be exactly similar in its effect on
the eye and touch; upon the one of which it operates directly,
on the other indirectly. And this body will be beautiful if the
lines which compose its surface are not continued, even so
varied, in a manner that may weary or dissipate the attention.
The variation itself must be continually varied.

SECTION XXIV

Concerning SMALLNESS

To avoid a sameness which may arise from the too frequent
repetition of the same reasonings, and of illustrations of the

same nature, I will not enter very minutely into every particular that regards beauty, as it is founded on the disposition of its quantity, or its quantity itself. In speaking of the magnitude of bodies there is great uncertainty, because the ideas of great and small, are terms almost entirely relative to the species of the objects, which are infinite. It is true, that having once fixed the species of any object, and the dimensions common in the individuals of that species, we may observe some that exceed, and some that fall short of the ordinary standard: these which greatly exceed, are by that excess, provided the species itself be not very small, rather great and terrible than beautiful; but as in the animal world, and in a good measure in the vegetable world likewise, the qualities that constitute beauty may possibly be united to things of greater dimensions; when they are so united they constitute a species something different both from the sublime and beautiful, which I have before called *Fine*; but this kind I imagine has not such a power on the passions, either as vast bodies have which are endued with the correspondent qualities of the sublime; or as the qualities of beauty have when united in a small object. The affection produced by large bodies adorned with the spoils of beauty, is a tension continually relieved; which approaches to the nature of mediocrity. But if I were to say how I find myself affected upon such occasions, I should say, that the sublime suffers less by being united to some of the qualities of beauty, than beauty does by being joined to greatness of quantity, or any other properties of the sublime. There is something so over-ruling in whatever inspires us with awe, in all things which belong ever so remotely to terror, that nothing else can stand in their presence. There lie the qualities of beauty either dead and unoperative; or at most exerted to mollify the rigour and sternness of the terror, which is the natural concomitant of greatness. Besides the extraordinary great in every species, the opposite to this, the dwarfish and diminutive ought to be considered. Littleness, merely as such, has nothing contrary to the idea of beauty. The humming bird both in shape and colouring yields to none of the winged species, of which it is the least; and perhaps his beauty is enhanced by his smallness. But there are animals, which when they are extremely small are rarely

(if ever) beautiful. There is a dwarfish size of men and women, which is almost constantly so gross and massive in comparison of their height, that they present us with a very disagreeable image. But should a man be found not above two or three feet high, supposing such a person to have all the parts of his body of a delicacy suitable to such a size, and otherwise endued with the common qualities of other beautiful bodies, I am pretty well convinced that a person of such a stature might be considered as beautiful; might be the object of love; might give us very pleasing ideas on viewing him. The only thing which could possibly interpose to check our pleasure is, that such creatures, however formed, are unusual, and are often therefore considered as something monstrous. The large and gigantic, though very compatible with the sublime, is contrary to the beautiful. It is impossible to suppose a giant the object of love. When we let our imaginations loose in romance, the ideas we naturally annex to that size are those of tyranny, cruelty, injustice, and every thing horrid and abominable. We paint the giant ravaging the country, plundering the innocent traveller, and afterwards gorged with his half-living flesh: such are Polyphemus, Cacus,* and others, who make so great a figure in romances and heroic poems. The event we attend to with the greatest satisfaction is their defeat and death. I do not remember in all that multitude of deaths with which the Iliad is filled, that the fall of any man remarkable for his great stature and strength touches us with pity; nor does it appear that the author, so well read in human nature, ever intended it should. It is Simoisius* in the soft bloom of youth, torn from his parents, who tremble for a courage so ill suited to his strength; it is another hurried by war from the new embraces of his bride, young, and fair, and a novice to the field, who melts us by his untimely fate.* Achilles, in spite of the many qualities of beauty which Homer has bestowed on his outward form, and the many great virtues with which he has adorned his mind, can never make us love him. It may be observed, that Homer has given the Trojans, whose fate he has designed to excite our compassion, infinitely more of the amiable social virtues than he has distributed among his Greeks. With regard to the Trojans, the passion he chuses to raise is pity; pity is a passion founded on love; and

these *lesser*, and if I may say, domestic virtues, are certainly the most amiable. But he has made the Greeks far their superiors in the politic and military virtues. The councils of Priam are weak; the arms of Hector comparatively feeble; his courage far below that of Achilles. Yet we love Priam more than Agamemnon, and Hector more than his conqueror Achilles.* Admiration is the passion which Homer would excite in favour of the Greeks, and he has done it by bestowing on them the virtues which have but little to do with love. This short digression is perhaps not wholly beside our purpose, where our business is to shew, that objects of great dimensions are incompatible with beauty, the more incompatible as they are greater; whereas the small, if ever they fail of beauty, this failure is not to be attributed to their size.

SECTION XXV
Of COLOUR

With regard to colour, the disquisition is almost infinite; but I conceive the principles laid down in the beginning of this part are sufficient to account for the effects of them all, as well as for the agreeable effects of transparent bodies, whether fluid or solid. Suppose I look at a bottle of muddy liquor, of a blue or red colour: the blue or red rays cannot pass clearly to the eye, but are suddenly and unequally stopped by the intervention of little opaque bodies, which without preparation change the idea, and change it too into one disagreeable in its own nature, conformable to the principles laid down in section 24. But when the ray passes without such opposition through the glass or liquor, when the glass or liquor are quite transparent, the light is something softened in the passage, which makes it more agreeable even as light; and the liquor reflecting all the rays of its proper colour *evenly*, it has such an effect on the eye, as smooth opaque bodies have on the eye and touch. So that the pleasure here is compounded of the softness of the transmitted, and the evenness of the reflected light. This pleasure may be heightened by the common principles in other things, if the shape of the glass which holds the transparent liquor be so judiciously varied, as to present the colour gradually and

interchangeably weakened and strengthened with all that variety which judgment in affairs of this nature shall suggest. On a review of all that has been said of the effects, as well as the causes of both; it will appear, that the sublime and beautiful are built on principles very different, and that their affections are as different: the great has terror for its basis; which, when it is modified, causes that emotion in the mind, which I have called astonishment; the beautiful is founded on mere positive pleasure, and excites in the soul that feeling, which is called love. Their causes have made the subject of this fourth part.

The end of the Fourth Part.

The end of the Fourth Part.

A
PHILOSOPHICAL ENQUIRY
INTO THE ORIGIN
OF OUR IDEAS
OF THE SUBLIME
AND BEAUTIFUL

Part Five

SECTION I

Of WORDS

NATURAL objects affect us, by the laws of that connexion, which Providence has established between certain motions and configurations of bodies, and certain consequent feelings in our minds. Painting affects in the same manner, but with the superadded pleasure of imitation. Architecture affects by the laws of nature, and the law of reason; from which latter result the rules of proportion, which make a work to be praised or censured, in the whole or in some part, when the end for which it was designed is or is not properly answered. But as to words; they seem to me to affect us in a manner very different from that in which we are affected by natural objects, or by painting or architecture; yet words have as considerable a share in exciting ideas of beauty and of the sublime as any of those, and sometimes a much greater than any of them; therefore an enquiry into the manner by which they excite such emotions is far from being unnecessary in a discourse of this kind.

SECTION II

The common effect of POETRY, not by raising ideas of things

The common notion of the power of poetry and eloquence, as well as that of words in ordinary conversation, is; that they affect the mind by raising in it ideas of those things for which custom has appointed them to stand. To examine the truth of this notion, it may be requisite to observe that words may be divided into three sorts. The first are such as represent many simple ideas *united by nature* to form some one determinate composition, as man, horse, tree, castle, &c. These I call *aggregate words*. The second, are they that stand for one simple idea of such compositions and no more; as red, blue, round, square, and the like. These I call *simple abstract* words. The

third, are those, which are formed by an union, an *arbitrary* union of both the others, and of the various relations between them, in greater or lesser degrees of complexity; as virtue, honour, persuasion, magistrate, and the like. These I call *compounded abstract* words. Words, I am sensible, are capable of being classed into more curious distinctions; but these seem to be natural, and enough for our purpose; and they are disposed in that order in which they are commonly taught, and in which the mind gets the ideas they are substituted for. I shall begin with the third sort of words; compound abstracts, such as virtue, honour, persuasion, docility. Of these I am convinced, that whatever power they may have on the passions, they do not derive it from any representation raised in the mind of the things for which they stand. As compositions, they are not real essences, and hardly cause, I think, any real ideas. No body, I believe, immediately on hearing the sounds, virtue, liberty, or honour, conceives any precise notion of the particular modes of action and thinking, together with the mixt and simple ideas, and the several relations of them for which these words are substituted; neither has he any general idea, compounded of them; for if he had, then some of those particular ones, though indistinct perhaps, and confused, might come soon to be perceived. But this, I take it, is hardly ever the case. For put yourself upon analysing one of these words, and you must reduce it from one set of general words to another, and then into the simple abstracts and aggregates, in a much longer series than may be at first imagined, before any real idea emerges to light; before you come to discover any thing like the first principles of such compositions; and when you have made such a discovery of the original ideas, the effect of the composition is utterly lost. A train of thinking of this sort, is much too long to be pursued in the ordinary ways of conversation, nor is it at all necessary that it should. Such words are in reality but mere sounds; but they are sounds, which being used on particular occasions, wherein we receive some good, or suffer some evil, or see others affected with good or evil; or which we hear applied to other interesting things or events; and being applied in such a variety of cases that we know readily by habit to what things they belong, they produce in

the mind, whenever they are afterwards mentioned, effects similar to those of their occasions. The sounds being often used without reference to any particular occasion, and carrying still their first impressions, they at last utterly lose their connection with the particular occasions that gave rise to them; yet the sound without any annexed notion continues to operate as before.

SECTION III

General words before IDEAS

Mr Locke[*] has somewhere observed with his usual sagacity, that most general words, those belonging to virtue and vice, good and evil, especially, are taught before the particular modes of action to which they belong are presented to the mind; and with them, the love of the one, and the abhorrence of the other; for the minds of children are so ductile,[*] that a nurse, or any person about a child, by seeming pleased or displeased with any thing, or even any word, may give the disposition of the child a similar turn. When afterwards, the several occurrences in life come to be applied to these words; and that which is pleasant often appears under the name of evil; and what is disagreeable to nature is called good and virtuous; a strange confusion of ideas and affections arises in the minds of many; and an appearance of no small contradiction between their notions and their actions. There are many, who love virtue, and who detest vice, and this not from hypocrisy or affectation, who notwithstanding very frequently act ill and wickedly in particulars without the least remorse; because these particular occasions never came into view, when the passions on the side of virtue were so warmly affected by certain words heated originally by the breath of others; and for this reason, it is hard to repeat certain sets of words, though owned by themselves unoperative, without being in some degree affected, especially if a warm and affecting tone of voice accompanies them, as suppose,

Wise, valiant, generous, good and great.

These words, by having no application, ought to be un-

operative; but when words commonly sacred to great occasions are used, we are affected by them even without the occasions. When words which have been generally so applied are put together without any rational view, or in such a manner that they do not rightly agree with each other, the stile is called bombast. And it requires in several cases much good sense and experience to be guarded against the force of such language; for when propriety is neglected, a greater number of these affecting words may be taken into the service, and a greater variety may be indulged in combining them.

SECTION IV
The effect of WORDS

If words have all their possible extent of power, three effects arise in the mind of the hearer. The first is, the *sound*; the second, the *picture*, or representation of the thing signified by the sound; the third is, the *affection* of the soul produced by one or by both of the foregoing. *Compounded abstract* words, of which we have been speaking, (honour, justice, liberty, and the like,) produce the first and the last of these effects, but not the second. *Simple abstracts*, are used to signify some one simple idea without much adverting to others which may chance to attend it, as blue, green, hot, cold, and the like; these are capable of affecting all three of the purposes of words; as the *aggregate* words, man, castle, horse, &c. are in a yet higher degree. But I am of opinion, that the most general effect even of these words, does not arise from their forming pictures of the several things they would represent in the imagination; because on a very diligent examination of my own mind, and getting others to consider theirs, I do not find that once in twenty times any such picture is formed, and when it is, there is most commonly a particular effort of the imagination for that purpose. But the aggregate words operate as I said of the compound abstracts, not by presenting any image to the mind, but by having from use the same effect on being mentioned, that their original has when it is seen. Suppose we were to read a passage to this effect. "The river Danube rises in a moist and mountainous soil in

the heart of Germany, where winding to and fro it waters several principalities, until turning into Austria and leaving the walls of Vienna it passes into Hungary; there with a vast flood augmented by the Saave and the Drave it quits Christendom, and rolling through the barbarous countries which border on Tartary, it enters by many mouths into the Black sea." In this description many things are mentioned, as mountains, rivers, cities, the sea, &c. But let anybody examine himself, and see whether he has had impressed on his imagination any pictures of a river, mountain, watery soil, Germany, &c. Indeed it is impossible, in the rapidity and quick succession of words in conversation, to have ideas both of the sound of the word, and of the thing represented; besides, some words expressing real essences, are so mixed with others of a general and nominal import, that it is impracticable to jump from sense to thought, from particulars to generals, from things to words, in such a manner as to answer the purposes of life; nor is it necessary that we should.

SECTION V

Examples that WORDS may affect without raising IMAGES

I find it very hard to persuade several that their passions are affected by words from whence they have no ideas; and yet harder to convince them, that in the ordinary course of conversation we are sufficiently understood without raising any images of the things concerning which we speak. It seems to be an odd subject of dispute with any man, whether he has ideas in his mind or not. Of this at first view, every man, in his own forum, ought to judge without appeal. But strange as it may appear, we are often at a loss to know what ideas we have of things, or whether we have any ideas at all upon some subjects. It even requires a good deal of attention to be thoroughly satisfied on this head. Since I wrote these papers I found two very striking instances of the possibility there is, that a man may hear words without having any idea of the things which they represent, and yet afterwards be capable of returning them to others, combined in a new way, and with great propriety,

energy and instruction. The first instance, is that of Mr. Black-lock, a poet blind from his birth.* Few men blessed with the most perfect sight can describe visual objects with more spirit and justness than this blind man; which cannot possibly be attributed to his having a clearer conception of the things he describes than is common to other persons. Mr. Spence, in an elegant preface which he has written to the works of this poet, reasons very ingeniously, and I imagine for the most part very rightly upon the cause of this extraordinary phenomenon; but I cannot altogether agree with him, that some improprieties in language and thought which occur in these poems have arisen from the blind poet's imperfect conception of visual objects, since such improprieties, and much greater, may be found in writers even of an higher class than Mr. Blacklock, and who, notwithstanding, possessed the faculty of seeing in its full perfection. Here is a poet doubtless as much affected by his own descriptions as any that reads them can be; and yet he is affected with this strong enthusiasm by things of which he neither has, nor can possibly have any idea further than that of a bare sound; and why may not those who read his works be affected in the same manner that he was, with as little of any real ideas of the things described? The second instance is of Mr. Saunderson, professor of mathematics in the university of Cambridge.* This learned man had acquired great knowledge in natural philosophy, in astronomy, and whatever sciences depend upon mathematical skill. What was the most extra-ordinary, and the most to my purpose, he gave excellent lectures upon light and colours; and this man taught others the theory of those ideas which they had, and which he himself undoubtedly had not. But it is probable, that the words red, blue, green, answered to him as well as the ideas of the colours themselves; for the ideas of greater or lesser degrees of refrang-ibility* being applied to these words, and the blind man being instructed in what other respects they were found to agree or to disagree, it was as easy for him to reason upon the words as if he had been fully master of the ideas. Indeed it must be owned he could make no new discoveries in the way of experiment. He did nothing but what we do every day in common discourse. When I wrote this last sentence, and used the words *every day*

and *common discourse*, I had no images in my mind of any succession of time; nor of men in conference with each other; nor do I imagine that the reader will have any such ideas on reading it. Neither when I spoke of red, blue, and green, as well as of refrangibility; had I these several colours, or the rays of light passing into a different medium, and there diverted from their course, painted before me in the way of images. I know very well that the mind possesses a faculty of raising such images at pleasure; but then an act of the will is necessary to this; and in ordinary conversation or reading it is very rarely that any image at all is excited in the mind. If I say, "I shall go to Italy next summer," I am well understood. Yet I believe no body has by this painted in his imagination the exact figure of the speaker passing by land or by water, or both; sometimes on horseback, sometimes in a carriage; with all the particulars of the journey. Still less has he any idea of Italy, the country to which I proposed to go; or of the greenness of the fields, the ripening of the fruits, and the warmth of the air, with the change to this from a different season, which are the ideas for which the word *summer* is substituted; but least of all has he any image from the word *next*; for this word stands for the idea of many summers, with the exclusion of all but one: and surely the man who says *next summer*, has no images of such a succession, and such an exclusion. In short, it is not only of those ideas which are commonly called abstract, and of which no image at all *can* be formed, but even of particular real beings, that we converse without having any idea of them excited in the imagination; as will certainly appear on a diligent examination of our own minds. Indeed so little does poetry depend for its effect on the power of raising sensible images, that I am convinced it would lose a very considerable part of its energy, if this were the necessary result of all description. Because that union of affecting words which is the most powerful of all poetical instruments, would frequently lose its force along with its propriety and consistency, if the sensible images were always excited. There is not perhaps in the whole Eneid a more grand and laboured passage, than the description of Vulcan's cavern in Etna, and the works that are there carried on. Virgil dwells particularly on the formation of the thunder which he

describes unfinished under the hammers of the Cyclops. But what are the principles of this extraordinary composition?

> *Tres imbris torti radios, tres nubis aquosæ*
> *Addiderant; rutili tres ignis et alitis austri;*
> *Fulgores nunc terrificos, sonitumque, metumque*
> *Miscebant operi, flammisque sequacibus iras.**

This seems to me admirably sublime; yet if we attend coolly to the kind of sensible image which a combination of ideas of this sort must form, the chimeras of madmen cannot appear more wild and absurd than such a picture. "*Three rays of* "*twisted showers, three of watery clouds, three of fire, and three of the* "*winged south wind; then mixed they in the work terrific lightnings, and* "*sound, and fear, and anger, with pursuing flames.*" This strange composition is formed into a gross body; it is hammered by the Cyclops, it is in part polished, and partly continues rough. The truth is, if poetry gives us a noble assemblage of words, corresponding to many noble ideas, which are connected by circumstances of time or place, or related to each other as cause and effect, or associated in any natural way, they may be moulded together in any form, and perfectly answer their end. The picturesque connection is not demanded; because no real picture is formed; nor is the effect of the description at all the less upon this account. What is said of Helen by Priam and the old men of his council, is generally thought to give us the highest possible idea of that fatal beauty.

> " οὐ νέμεσις Τρῶας καὶ ἐϋκνήμιδας Ἀχαιοὺς
> τοιῇδ' ἀμφὶ γυναικὶ πολὺν χρόνον ἄλγεα πάσχειν·
> αἰνῶς ἀθανάτῃσι θεῇς εἰς ὦπα ἔοικεν.*
>
> *They cry'd, no wonder such celestial charms*
> *For nine long years have set the world in arms;*
> *What winning graces! what majestic mien!*
> *She moves a goddess, and she looks a queen.* POPE.*

Here is not one word said of the particulars of her beauty; no thing which can in the least help us to any precise idea of her person; but yet we are much more touched by this manner of mentioning her than by these long and laboured descriptions of Helen, whether handed down by tradition, or formed by fancy, which are to be met with in some authors. I am sure it

affects me much more than the minute description which Spenser has given of Belphebe;* though I own that there are parts in that description, as there are in all the descriptions of that excellent writer, extremely fine and poetical. The terrible picture which Lucretius has drawn of religion, in order to display the magnanimity of his philosophical hero in opposing her, is thought to be designed with great boldness and spirit.

> *Humana ante oculos fœdè cum vita jaceret,*
> *In terris, oppressa gravi sub religione,*
> *Quæ caput e cæli regionibus ostendebat*
> *Horribili desuper visu mortalibus instans;*
> *Primus Graius homo mortales tollere contra*
> *Est oculos ausus.*——*

What idea do you derive from so excellent a picture? none at all most certainly; neither has the poet said a single word which might in the least serve to mark a single limb or feature of the phantom, which he intended to represent in all the horrors imagination can conceive. In reality poetry and rhetoric do not succeed in exact description so well as painting does; their business is to affect rather by sympathy than imitation; to display rather the effect of things on the mind of the speaker, or of others, than to present a clear idea of the things themselves. This is their most extensive province, and that in which they succeed the best.

SECTION VI
POETRY not strictly an imitative art

Hence we may observe that poetry, taken in its most general sense, cannot with strict propriety be called an art of imitation. It is indeed an imitation so far as it describes the manners and passions of men which their words can express; where *animi motus effert interprete lingua.** There it is strictly imitation; and all merely *dramatic* poetry is of this sort. But *descriptive* poetry operates chiefly by *substitution*; by the means of sounds, which by custom have the effect of realities. Nothing is an imitation further than as it resembles some other thing; and words undoubtedly have no sort of resemblance to the ideas for which they stand.

SECTION VII

How WORDS influence the passions

Now, as words affect, not by any original power, but by
representation, it might be supposed, that their influence over
the passions should be but light; yet it is quite otherwise; for
we find by experience that eloquence and poetry are as capable,
nay indeed much more capable of making deep and lively
impressions than any other arts, and even than nature itself in
very many cases. And this arises chiefly from these three causes.
First, that we take an extraordinary part in the passions of
others, and that we are easily affected and brought into
sympathy by any tokens which are shewn of them; and there
are no tokens which can express all the circumstances of most
passions so fully as words; so that if a person speaks upon any
subject, he can not only convey the subject to you, but likewise
the manner in which he is himself affected by it. Certain it is,
that the influence of most things on our passions is not so much
from the things themselves, as from our opinions concerning
them; and these again depend very much on the opinions of
other men, conveyable for the most part by words only
Secondly; there are many things of a very affecting nature,
which can seldom occur in the reality, but the words which
represent them often do; and thus they have an opportunity of
making a deep impression and taking root in the mind, whilst
the idea of the reality was transient; and to some perhaps never
really occurred in any shape, to whom it is notwithstanding
very affecting, as war, death, famine, &c. Besides, many ideas
have never been at all presented to the senses of any men but
by words, as God, angels, devils, heaven and hell, all of which
have however a great influence over the passions. Thirdly; by
words we have it in our power to make such *combinations* as we
cannot possibly do otherwise. By this power of combining we
are able, by the addition of well-chosen circumstances, to
give a new life and force to the simple object. In painting we
may represent any fine figure we please; but we never can give
it those enlivening touches which it may receive from words.
To represent an angel in a picture, you can only draw a

beautiful young man winged; but what painting can furnish out any thing so grand as the addition of one word, "the "angel of the *Lord?*" It is true, I have here no clear idea, but these words affect the mind more than the sensible image did, which is all I contend for. A picture of Priam dragged to the altar's foot, and there murdered, if it were well executed would undoub'edly be very moving; but there are very aggravating circumstances which it could never represent.

> *Sanguine fœdantem* quos ipse sacraverat *ignes.**

As a further instance, let us consider those lines of Milton, where he describes the travels of the fallen angels through their dismal habitation,

> ——*O'er many a dark and dreary vale*
> *They pass'd, and many a region dolorous;*
> *O'er many a frozen, many a fiery Alp;*
> *Rock, caves, lakes, fens, bogs, dens and shades of death,*
> *A universe of death.**

Here is displayed the force of union in

> *Rocks, caves, lakes, dens, bogs, fens and shades;*

which yet would lose the greatest part of their effect, if they were not the

> *Rocks, caves, lakes, dens, bogs, fens and shades——*
> ——*of Death.*

This idea or this affection caused by a word, which nothing but a word could annex to the others, raises a very great degree of the sublime; and this sublime is raised yet higher by what follows, a *"universe of Death."* Here are again two ideas not presentable but by language; and an union of them great and amazing beyond conception; if they may properly be called ideas which present no distinct image to the mind;— but still it will be difficult to conceive how words can move the passions which belong to real objects, without representing these objects clearly. This is difficult to us, because we do not sufficiently distinguish, in our observations upon language, be- tween a clear expression, and a strong expression. These are frequently confounded with each other, though they are in reality extremely different. The former regards the under-

standing; the latter belongs to the passions. The one describes
a thing as it is; the other describes it as it is felt. Now, as there
is a moving tone of voice, an impassioned countenance, an
agitated gesture, which affect independently of the things about
which they are exerted, so there are words, and certain dis-
positions of words, which being peculiarly devoted to passionate
subjects, and always used by those who are under the influence
of any passion; they touch and move us more than those which
far more clearly and distinctly express the subject matter. We
yield to sympathy, what we refuse to description. The truth is,
all verbal description, merely as naked description, though
never so exact, conveys so poor and insufficient an idea of the
thing described, that it could scarcely have the smallest effect,
if the speaker did not call in to his aid those modes of speech
that mark a strong and lively feeling in himself. Then, by the
contagion of our passions, we catch a fire already kindled in
another, which probably might never have been struck out by
the object described. Words, by strongly conveying the passions,
by those means which we have already mentioned, fully com-
pensate for their weakness in other respects. It may be observed
that very polished languages, and such as are praised for their
superior clearness and perspicuity, are generally deficient in
strength. The French language has that perfection, and that
defect. Whereas the oriental tongues, and in general the
languages of most unpolished people, have a great force and
energy of expression; and this is but natural. Uncultivated
people are but ordinary observers of things, and not critical in
distinguishing them; but, for that reason, they admire more,
and are more affected with what they see, and therefore express
themselves in a warmer and more passionate manner. If the
affection be well conveyed, it will work its effect without any
clear idea; often without any idea at all of the thing which has
originally given rise to it.

It might be expected from the fertility of the subject, that I
should consider poetry as it regards the sublime and beautiful
more at large; but it must be observed that in this light it has
been often and well handled already. It was not my design to
enter into the criticism of the sublime and beautiful in any art,
but to attempt to lay down such principles as may tend to

ascertain, to distinguish, and to form a sort of standard for them; which purposes I thought might be best effected by an enquiry into the properties of such things in nature as raise love and astonishment in us; and by shewing in what manner they operated to produce these passions. Words were only so far to be considered, as to shew upon what principle they were capable of being the representatives of these natural things, and by what powers they were able to affect us often as strongly as the things they represent, and sometimes much more strongly.

The END.

ascertain, to distinguish, and to form a sort of standard for them, which purpose, I thought, might be best effected by an enquiry into the properties of such things in nature as raise love and astonishment in us, and by shewing in what manner they operated to produce these passions. Words were only so far to be considered, as to shew upon what principle they were capable of being the representatives of these natural things, and by what powers they were able to affect us often as strongly as the things they represent, and sometimes much more strongly.

THE END

EXPLANATORY NOTES

1 *Even Longinus*: Longinus: thought to be the author of the famous Greek treatise *On the Sublime*. While evidence suggests that it was written in the first century AD its actual date and authorship are unknown. The oldest surviving MS (tenth century Paris) attributes it to 'Dionysius or Longinus'. The standard English translation during the eighteenth century was by the Revd William Smith, which was first published in 1739 and reached a 5th edition in 1800. Burke's first reference to Longinus, in a letter to his friend Richard Shackleton (24 Jan. 1746), probably refers to Smith's edition: 'I could not get e'er a Second hand Longinus but rather than you should want it I bought a new one—2s. 2d. Tis I think a very good translation and has no bad notes.'

2 *finished*: the 1st edition was published 21 Apr. 1757 by Robert and James Dodsley. In the same year Hume published his *Four Dissertations* ('The Natural History of Religion', 'Of The Passions', 'Of Tragedy', and 'Of The Standard Of Taste').

3 *this edition*: published 10 Jan. 1759.

4 *forming it*: Burke is referring here to reviews in the *Critical Review*, 3 (1757) and the *Literary Magazine*, 11 (1757). See the Introduction to J. T. Boulton's edition for a summary of Burke's reactions to the reviews. For something more thorough and ponderous see H. A. Wichelns, 'Burke's Essay on the Sublime and its Reviewers', *Journal of English and Germanic Philology*, 21 (1922).

5 *naturæ*: 'to consider and to contemplate nature is the essential food for our spirit and intelligence'. Burke is misquoting from Cicero's *Academica Priora*, ii, 127. Marcus Tullius Cicero (106–43 BC), the renowned Roman orator and statesman, wrote the Academica in 45 BC, an account of the work of those Academic philosophers committed to the scepticism in Plato's thought.

11 *on Taste*: Burke added the Introduction on Taste to his 2nd edition (1759); it can be usefully read as a reply to Hume's essay 'Of The Standard of Taste', published in Hume's *Four Dissertations* (see above, n. to p. 2). Hume acknowledges that 'we are apt to call barbarous whatever departs widely from

our own taste and apprehension; but soon find the epithet of reproach retorted on us'. Characteristically generous in his sympathies, Hume is nevertheless keen to assert that despite his strong sense of the plurality of differences there are standards of taste. 'It appears, then,' he writes, 'that amidst all the variety and caprice of taste, there are certain general principles of approbation or blame, whose influence a careful eye may trace in all operations of the mind.' See also on the subject of Taste Addison's formative essay in *The Spectator*, 409 (Thursday, 19 June 1712). Assured of his standards, knowing who the 'greatest Writers' are, Addison proposes methods for acquiring a polite refinement. Burke and Hume, in different ways, are alive to the implications of the impossibility of consensus.

12 *operis lex*: 'we will be delayed throughout this worthless and expanding world where shameful behaviour and disagreements prevent progress'. Burke misquotes here from *De Arte Poetica*, ii. 132, 135 by the Roman poet Horace (65–8 BC).

16 *bolus of squills*: pill made from the sea-onion (Urginea), used as a diuretic and expectorant.

17 *differences*: see *An Essay Concerning Human Understanding* (1690), II. xi. 2 by John Locke (1632–1704).

19 *very well known*: Johnson tells this story in *The Rambler*, 4 (31 Mar. 1750). It can be found in *Historia Naturalis*, xxxv. 84–5 by the Roman writer Pliny the Elder (AD 23/4–79), translated into English by Philemon Holland in 1601.

20 *imagination*: the source of this story about the painter Gentile Bellini (*c*. 1421–1508) is Carlo Ridolfi's *Le Maraviglie Dell'Arte* (1648). Burke omits to mention that the Turkish Emperor proved his point by having a slave beheaded so Bellini could see the shrinking of the skin.

Don Bellianis: the hero of a Spanish romance, *Historia del valeroso é invincible Principe don Belianis de Grecia* (1547–79). This was translated by 'L.A.' and collected in 1673 by Francis Kirkman under the title *The Famous and Delectable History of Don Bellienis of Greece*.

Pilgrim's Progress: (1678) by John Bunyan (1628–88). In 'Of The Standard Of Taste' Hume writes: 'Whoever would assert

an equality of genius between Ogilby and Milton, or Bunyan and Addison, would be thought to defend no less an extravagance, than if he had maintained a mole-hill to be as high as Teneriffe, or a pond as extensive as the ocean. Though there may be found persons, who give the preference to the former authors; no one pays attention to such a taste.'

Bohemia: an illusion to Shakespeare's *Winter's Tale*, III. iii. 2. Shakespeare substituted Bohemia, which famously has no sea-coast, for the Sicily of Greene's *Pandosto*.

22 *instruction in them*: see *De Arte Poetica*, ii. 309.

24 *semper amem*: 'my heart is tender and open to trifling darts, and always with good reason: so always, let me love'. Burke is misquoting here from *Heroides*, xv. 79–80 by the Roman poet Ovid (43 BC–AD 18).

spectator: 'the spectator, definer of beauty': from *Eunuchus* (161 BC) by the Roman comic playwright Terence (195 or 185–159 BC).

30 *definition*: see Locke's *Essay*, II. vii. 1 for these 'simple ideas'.

32 *Iliad. 24*: Hom. *Il.* xxiv. 480–2.

wonder: *Il.* xxiv. 590–3, transl. Alexander Pope (1688–1744). The second line should read: 'Pursued for murder, flies his native clime.'

35 γόοιο: Hom. *Od.* iv. 100–3.

grateful tear: *Od.* iv. 127–30, transl. Alexander Pope.

36 *in France*: on 5 Jan. 1757 Robert Francis Damiens (1714–57) attempted to kill Louis XV and was put to death, after being viciously tortured, on 28 March.

39 *supposes*: in *The Spectator*, 413 (Tuesday, 24 June 1712) Addison wrote: 'He has made everything that is beautiful in our own species pleasant, that all Creatures might be tempted to multiply their Kind, and fill the World with Inhabitants; for 'tis very remarkable that where-ever Nature is crost in the Production of a Monster (the Result of any unnatural Mixture) the Breed is incapable of propagating its Likeness, and of founding a new Order of Creatures; so that unless all Animals were allured by the Beauty of their own Species, Generation would be at an end, and the Earth unpeopled.'

41 *reasoning*: in *Poetics*, iv, Aristotle writes that man 'differs from other animals in that he is the most imitative of creatures, and he learns his earliest lessons by imitation. Also inborn in all of us is the instinct to enjoy works of imitation. What happens in actual experience is evidence of this; for we enjoy looking at the most accurate representation of things which in themselves we find painful to see, such as the forms of the lowest animals and of corpses' (transl. T. S. Dorsch, London: Penguin, 1965, p. 35). In *The Spectator*, 418 (Monday, 30 June 1712), Addison writes, on the same subject, that 'not only what is Great, Strange, or Beautiful, but any Thing that is Disagreeable when looked upon, pleases us in apt Description'.

42 *unhappy prince*: a reference to the death of Alexander the Great and the consequent disintegration of the Macedonian Empire. Alexander died of fever at Babylon in 323 BC at the age of 32. His closest comrade Hephaestion had died the previous year.

fable: as recounted by Homer in the *Iliad* and *Odyssey*.

virtuous characters: Publius Cornelius Scipio Africanus (236/5–183 BC) conquered the Carthaginians by defeating Hannibal at Zama in 202. Burke fails to mention that later in his career Scipio, on trial for corruption, 'contented himself with reminding the people that the day [of the trial] was the anniversary of Zama and bidding them to follow him to the Capitol to offer thanks to the gods. Public opinion turned in his favour and the charge was not proceeded with' (*Oxford Companion to Classical Literature*, Oxford, 1937). Marcus Portius Cato (95–46 BC) was the upright man and 'conscience of Rome' who was severely critical of Caesar and the Triumvirate. His last days and eventual suicide after defeat at Utica were dramatized in Addison's tragedy *Cato* (1713).

46 *less necessary*: see, e.g., n. to p. 41 *reasoning*.

47 *sublime*: see *On the Sublime*, vii.

49 *fibrâ*: 'how the secret entrails lie unfathomable'; from *Satires*, v. 29 by the Roman poet Persius (AD 34–62).

55 *crown had on*: Milton: *Paradise Lost*, ii. 666–73; line 5 should read 'For each seemd either; black it stood as night'; and in the penultimate line Milton has 'a dreadful dart'.

56 *fidelibus*: 'slowly, through the news put before the eyes of a good man, the fate of those downcast arouses pity': *De Arte Poetica*, 180–1.

criticism: Burke is referring here to *Réflexions Critiques Sur La Poesie et Sur La Peinture* (Paris, 1755), i. 416.

Chevy-chase: Addison referred to Chevy-Chase in *The Spectator*, 70 and 74. 'The old song of Chevy-Chase', Addison writes in 70, 'is the favourite Ballad of the common People of England; and Ben Jonson used to say he had rather have been the Author of it than of all his Works.'

57 *monarchs*: *Paradise Lost*, i. 589–99.

58 *by several*: for the opposition Burke refers to see contemporary reviews in *Monthly Review*, 16 (1757), and *Literary Magazine*, 2 (1757).

than God: Job 4: 13–17.

59 *St. Anthony*: a popular subject for European painters in the sixteenth and seventeenth centuries, with examples by Salvator Rosa, Breughel, Teniers, Ribera, among others. For an interesting account of the subject see the introduction to Kitty Mrosovsky's edition of *The Temptation of St. Anthony* by Flaubert (London: Penguin, 1983).

Virgil's Fame: *Aeneid*, iv. 173.

Homer's Discord: *Il.* iv. 440–5.

60 *trumpet*: Job 39: 19, 20, 24 (misquoted).

61 *his pasture . . . sight of him*: Job 39: 5–8 (misquoted) . . . Job 39: 9, 10, 11; 41: 1, 4, 9.

62 *hid themselves*: Job 39: 7–8.

emotion: the reviewer in the *Monthly Review*, 16 (1757) had written: 'It is certain we can have the most sublime ideas of the Deity, without imagining him a God of terror. Whatever raises our esteem of an object described, must be a powerful source of sublimity; and esteem is a passion nearly allied to love: our astonishment at the sublime as often proceeds from an increased love, as from an increased fear.'

63 *am I made*: Psalms 139: 14 (misquoted).

spectent: 'the initiated, who are without fear, watch this sun, these stars and moments of decline at particular times'; *Epistles*, I. 6. 3–5.

retecta: 'with these things a certain Goddess of pleasure drew me to you, and what horror now to see your true nature revealed, lying open and visible from every side'; from *De Rerum Natura*, iii. 28–30 (misquoted), by the Roman philosophical poet Lucretius (*c*.99–*c*.55 BC).

64 *of the Lord*: Psalms 68: 8 (misquoted).

fountain of waters: Psalms 114: 7–8 (misquoted).

fecit timor: 'fear brought the first gods into the world'; from *Thebaid*, iii. 661, by the Roman poet Statius (AD *c*.40–*c*.96).

65 *inania regna*: *Aeneid*, vi. 264–9 (misquoted).

Pitt: *Aeneid*, vi. 371–8, transl. (1740) by Christopher Pitt (1699–1748).

Dryden: *Aeneid*, vi. 378–9, transl. (1697) by John Dryden (1631–1700).

68 *imagination*: *The Spectator*, 409, 411–21.

72 *fiery Pegasus*: 1 *Henry IV*, IV. i. 97–109 (misquoted). Burke omits line 105: 'His cuishes on his thighs, gallantly armed.'

73 *their hands, &c.*: Eccles. 50: 5–13 (misquoted).

his throne: *Paradise Lost*, II. 266–7 (misquoted). The quotation should read '. . . Covers his throne'.

74 *skirts appear*: *Paradise Lost*, III. 380 (misquoted). The quotation should read: 'Dark with excessive bright thy skirts appear.'

75 *fuscous*: brown, dingy.

riant: laughing, gay.

77 *iter in silvis*: 'just like a journey through the woods can be, through the uncertain moonlit night, under its fitful light'; *Aeneid*, vi. 270–1.

affright: Spenser, *Faerie Queene*, II. vii. 29 (misquoted). The last line should read: '. . . and sad affright.'

luporum: 'the roaring and fury of the lions fighting rope and chains and bars can be heard through the night; wild boars

and bears rage in their caves and the shadows of huge wolves
howl'; *Aeneid*, vii. 15–18.

78 *Mephitim*: 'and so the concerned king goes to the oracle of his
ancestors, prophetic forest god, for signs; and he consults the
gods of the sacred groves at the mouth of the Tiber, and he
worships at the most holy spring of the forests; and so he
scourges the evil spirits and the fierce powers of the goddess
Malaria'; *Aeneid*, vii. 81–4 (misquoted).

ferebat: 'it was a deep cave, huge with an enormous opening,
edged with rough stones and protected by a black pool and
surrounded by dark woods over which no birds can fly; such
were the fumes pouring from the mouth of the cave and rising
to the sky'; *Aeneid*, vi. 237–41. Acheron was one of the rivers of
Hades in Greek mythology.

79 *amore*: 'but nevertheless it does pass, time passes irrevocably
by; it breathes upon us and then drifts past while we stay put,
held captive by successive passions.' Virgil: *Georgics*, iii. 284–5
(misquoted).

87 *a priori*: reasoning from cause to effect.

89 *the fair sex*: the reviewer in the *Critical Review* (see n. to p. 58 *by
several*) had written of the 1st edition that '. . . contrary to our
author's opinion, we insist upon it, that the well proportioned
parts of the human body are constantly found beautiful'.

91 *human body*: this idea is from *De Architectura*, III. i. 3 by the
Roman writer and soldier Vitruvius Pollio (*c*.50–26 BC).

92 *aptitude*: see Plato's *Gorgias*.

96 *Venus and Hercules*: Venus was originally a Roman goddess of
gardens who became the goddess of Love. Hercules was a
legendary Greek hero of extraordinary strength.

97 *raised it*: this example can be found in the essay 'Of Vaine-
Glory' (No. 53) by Francis Bacon (1560/1–1626). The essay
begins: 'It was prettily Devised of Aesop; The Fly sate upon
the Axle-tree of the Chariot wheele, and said, What a Dust doe
I raise? So are there some vaine persons, that whatsoever goeth
alone, or moveth upon greater Means, if they have never so
little Hand in it, they thinke it is they that carry it.'

98 *Graham*: George Graham (1673–1751), the great English clock and watch maker whose inventions included the mercurial pendulum.

101 *Sallust . . . perniciem*: *ignoscendo, largiundo*: sometimes to overlook is the first step to generosity. *nil largiundo*: mean-spirited. *miseris perfugium*: a shelter for the wretched. *malis perniciem*: preferring danger. Sallust (86–35 BC) was a Roman historian much admired by Burke. This contrast between Cato and Caesar was exemplary in the eighteenth century and can be found in Addison's *The Spectator*, Hume's *A Treatise of Human Nature*, and elsewhere. The quotations are from Sallust's *Bellum Catilinae*, liv (misquoted).

102 *iov*: little.

105 *Hogarth*: see *Analysis of Beauty* (1753) by William Hogarth (1697–1764), chapters 4, 9–10.

106 *barb*: gennet: a small Spanish horse; barb: a Barbary horse.

juventae: 'the glowing light of youth'.

109 *quoi*: literally 'I don't know what', implying something mysteriously elusive, beyond words.

111 *harmony*: Milton: *L'Allegro*, 135–42 (misquoted). Burke omits two lines: '. . . Lydian Aires / Married to immortal verse / Such as the meeting soul may pierce / In notes . . .'

112 *sweet music*: *Merchant of Venice*, v. i. 69 (misquoted).

114 *black and white*: Pope: 'Essay on Man', II. 213–14 (misquoted).

117 *Newton*: *Philosophiae Naturalis Principia Mathematica*, II. 393 (English translation 1729) by Sir Isaac Newton (1642–1727). Newton believed it was the medium of aether that made motion possible. But what Burke calls this 'subtle elastic aether' was an unobservable explanatory hypothesis. 'Is not Animal Motion', Newton wrote, 'perform'd by the Vibrations of this Medium, excited in the Brain by the power of the Will, and propagated from thence through the solid, pellucid and uniform Capillamenta of the Nerves into the muscles, for contracting and dilating them?' For this quotation and a lucid discussion of the aether question see James Sambrook, *The Eighteenth Century, 1700–1789* (London and New York: Longman, 1986), chapter 1.

120 *Spon . . . Campanella*: Jacob Spon (1647–85) was a physician and archaeologist. In his *Recherches Curieuses d'Antiquité* (Lyons, 1683) he explored the use of medals as guides to the appearance of the monarchs inscribed on them. Tomasso Campanella (1568–1639) was a Dominican monk and philosopher.

130 *troublesome*: Locke's *Essay*, II. vii. 4.

imagination: Locke's *Essay*, II. xxxiii. 10.

καὶ ὄλεσσον: 'Father Zeus, just rescue the sons of Achaea from the gloom, give us clear weather, and let us see with our own eyes. As long as it is in the light of day, even destroy us.' Hom. *Il.* xvii. 645–7. This is quoted by Longinus, *On the Sublime*, ix.

131 *Cheselden*: Burke is referring here to 'Account of some Observations made by a young Gentleman, who was born blind, or lost his Sight so early, that he had no Remembrance of ever having seen, and was couch'd between 13 and 14 years of age' (*Philosophical Transactions of the Royal Society*, 35 (1729), 447–50), by the great English surgeon William Cheselden (1688–1752).

132 *nisus*: striving, impulse.

136 *by pleasure*: the reviewer in the *Critical Review* (see n. to p. 58 *by several*) had wondered 'but how will this theory agree with those tumults and transports that beauty so often excites?'

Optics: in *Opticks* (3rd edition, 1721), Newton had written: '. . . although the arguing from Experiments and Observations by Induction be no Demonstration of general Conclusions; yet it is the best way of arguing which the Nature of Things admits of, and may be looked upon as so much the stronger, by how much the Induction is more general. And if no exception occur from Phenomena, the Conclusion may be pronounced generally. But if at any time afterwards any Exception shall occur from Experiments, it may then begin to be pronounced with such Exceptions as occur.'

137 *vellicate*: to pluck or twitch.

138 *papillæ*: the tiny elevations in the skin where a nerve ends.

143 *Polyphemus, Cacus*: for Polyphemus, see *Od.* ix; the son of Poseidon, he was one of the Cyclopes and was blinded by Odysseus. For the giant Cacus, son of Vulcan, see *Aeneid*, viii;

having stolen cattle belonging to Hercules and hidden them in his cave, he was found and killed by Hercules.

Simoisius: see *Il*. iv.

untimely fate: Iphidamas, who was killed by Agamemnon; *Il*. xi. 221–31.

144 *Priam . . . Achilles*: Priam: King of Troy during the Trojan war. Hector: son of Priam and leader of the Trojan army. Achilles: the hero of the Greek army in the Trojan war who killed Hector. Agamemnon: leader of the Greek army in the Trojan war.

151 *Locke*: Locke's *Essay*, III. v. 15; III. ix. 9.

ductile: yielding, easily led.

154 *from his birth*: Thomas Blacklock (1721–91) was a Scot who became blind through smallpox at six months old. He was, nevertheless, educated at Edinburgh University and published *Poems* in 1746. Hume introduced the poems to Joseph Spence, former Oxford Professor of Poetry who in 1754 published his *Account of the Life, Character and Poems of Mr. Blacklock* which became the Preface to the 2nd edition of the *Poems* in 1756. See Boswell's *Life of Johnson* for Johnson's scepticism about Spence.

Cambridge: Dr. Nicholas Saunderson (1682–1739) was also blinded at an early age through smallpox but went on, thanks to his considerable talent, to study mathematics at Cambridge in 1707, becoming in 1711 Lucasian Professor of Mathematics.

refrangibility: capable of refracting, or deflecting rays of light.

156 *iras*: *Aeneid*, viii. 429–32.

ὦπα ἔοικεν: *Il*. iii. 156–8.

Pope: *Il*. iii. 205–8.

157 *Belphebe*: *Faerie Queene*, II. iii. 21–31.

ausus: 'let human life be cast cruelly before our eyes; everywhere, life bent by heavy religion which the king of the heavens required in all countries, crushing upon mortals with horrible visions from above; Gaius is the first man who dared raise mortal eyes against him'. *De Rerum Natura*, i. 62–7 (misquoted).

lingua: 'deeply moved, he delivers the message'; Horace, *De Arte Poetica*, 111.

159 *ignes*: 'fires which he had sanctified with his own blood'; *Aeneid*, ii. 502.

death: *Paradise Lost*, ii. 618–22.

THE WORLD'S CLASSICS

A Select List

HANS ANDERSEN: Fairy Tales
Translated by L. W. Kingsland
Introduction by Naomi Lewis
Illustrated by Vilhelm Pedersen and Lorenz Frølich

JANE AUSTEN: Emma
Edited by James Kinsley and David Lodge

Mansfield Park
Edited by James Kinsley and John Lucas

J. M. BARRIE: Peter Pan in Kensington Gardens & Peter and Wendy
Edited by Peter Hollindale

WILLIAM BECKFORD: Vathek
Edited by Roger Lonsdale

CHARLOTTE BRONTË: Jane Eyre
Edited by Margaret Smith

THOMAS CARLYLE: The French Revolution
Edited by K. J. Fielding and David Sorensen

LEWIS CARROLL: Alice's Adventures in Wonderland
and Through the Looking Glass
Edited by Roger Lancelyn Green
Illustrated by John Tenniel

MIGUEL DE CERVANTES: Don Quixote
Translated by Charles Jarvis
Edited by E. C. Riley

GEOFFREY CHAUCER: The Canterbury Tales
Translated by David Wright

ANTON CHEKHOV: The Russian Master and Other Stories
Translated by Ronald Hingley

JOSEPH CONRAD: Victory
Edited by John Batchelor
Introduction by Tony Tanner

DANTE ALIGHIERI: The Divine Comedy
Translated by C. H. Sisson
Edited by David Higgins

VIRGIL: The Aeneid
Translated by C. Day Lewis
Edited by Jasper Griffin

HORACE WALPOLE: The Castle of Otranto
Edited by W. S. Lewis

IZAAK WALTON and CHARLES COTTON:
The Compleat Angler
Edited by John Buxton
Introduction by John Buchan

OSCAR WILDE: Complete Shorter Fiction
Edited by Isobel Murray

The Picture of Dorian Gray
Edited by Isobel Murray

VIRGINIA WOOLF: Orlando
Edited by Rachel Bowlby

ÉMILE ZOLA:
The Attack on the Mill and other stories
Translated by Douglas Parmée

A complete list of Oxford Paperbacks, including The World's Classics, OPUS, Past Masters, Oxford Authors, Oxford Shakespeare, and Oxford Paperback Reference, is available in the UK from the Arts and Reference Publicity Department (BH), Oxford University Press, Walton Street, Oxford OX2 6DP.

In the USA, complete lists are available from the Paperbacks Marketing Manager, Oxford University Press, 200 Madison Avenue, New York, NY 10016.

Oxford Paperbacks are available from all good bookshops. In case of difficulty, customers in the UK can order direct from Oxford University Press Bookshop, Freepost, 116 High Street, Oxford, OX1 4BR, enclosing full payment. Please add 10 per cent of published price for postage and packing.